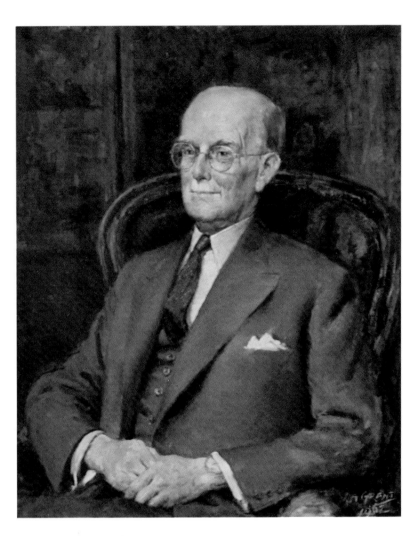

SIDNEY JAMES PERRY

Phillips & Drew

PROFESSIONALS IN THE CITY

W. J. Reader & David Kynaston

ROBERT HALE · LONDON

ISBN 0 7090 6292 3

Robert Hale Limited
Clerkenwell House
Clerkenwell Green
London EC1R 0HT

2 4 6 8 10 9 7 5 3 1

The frontispiece shows the portrait by James A. Grant RP of
S.J. Perry which was commissioned in 1960 after his retirement.
It was presented by the Union Bank of Switzerland to
the Institute of Actuaries, and is reproduced
by kind permission of the Institute

Typeset by
Derek Doyle and Associates, Mold
Printed in Great Britain by
St Edmundsbury Press Limited, Bury St Edmunds
and bound by
WBC Book Manufacturers Limited, Bridgend

Contents

Acknowledgements

I am grateful to the Bank of England for allowing me to consult the firm's 1930 circular on War Loan (Gl/504, fo 36); to Mark Harding and Paul Hare at UBS for giving me access to some relevant records; to the National Life Story Collection at the British Library National Sound Archive, for permission to quote from the interviews with George Nissen and George Birks in the 'City Lives' collection; to Ranald Michie for allowing me to consult his forthcoming history of the Stock Exchange; to Martin Gibbs for allowing me to quote freely from his most enjoyable as well as instructive privately published autobiography, *Anecdotal Evidence*; and to Austen Bird, Henry Cottrell, Martin Gibbs, John Marsh, Peter Parker and Anthony Twist for lending me records of the firm's history. It is hoped that in due course the records of Phillips & Drew will be deposited at the Guildhall Library in London.

A book like this relies heavily on oral reminiscence, and the following kindly talked to one or other (occasionally both) of the authors: Bernard Bavister, Paul Bazalgette, the late Arthur Beard, Austen Bird, George Birks, David Borrett, Tim Brown, Terry Cann, Michael Cohen, Crispian Collins, Bryce Cottrell, Henry Cottrell, the late Jos Drew, Hugh Eaves, Bernard Fison, Martin Gibbs, Bill Hall, Michael Hall, Howell Harris Hughes, Peter Harrison, Will Hutton, Charles Larkin, John Lewis, the late Ian Macaulay, Paul Neild, the late William G. Nursaw, Peter Parker, Keith Percy, Dougie Phin, Roger Pincham, the late Jonathan Rashleigh, Geoffrey Redman-Brown, Paul Smallwood, Ray Snuggs, Harry Sparks, the late Peter Swan, John Taylor, Anthony

Twist, David Walton Masters, Denis Weaver, Jack Wigglesworth and Philip Williams. None of the above will agree (or would have agreed) with every word in this book, but their help is warmly acknowledged.

I am also grateful to Emma Vick at the Stock Exchange for her help; to Bank Cantrade for making meeting rooms available for interviews; to Amanda Howard for typing up my tapes; to all those involved at Robert Hale; to Bryce Cottrell and Peter Parker for their patience and detachment; and, last but not least, to Ann Reader for her encouragement and support.

David Kynaston

Preface

In 1983 the eminent business historian W.J. Reader was commissioned to write a history of Phillips & Drew. He duly completed a draft, taking the narrative up to the end of the 1970s, but for various reasons it proved impossible to proceed to publication. Bill Reader himself died in 1990. Two years ago I was asked by Bryce Cottrell and Peter Parker, former partners of Phillips & Drew, to take on the job of revising, expanding and updating the typescript, including covering the more recent years – though not in such detail. This I have been very pleased to do, not least because of my warm memories of Bill and my high regard for him as a professional historian. A decade after he was working on the history, I have been able to conduct additional interviews, have access to new material, and perhaps also write rather more frankly than was possible for him at that time. Inevitably, the shape of the book is dictated by the available records: patchy up to and including the 1950s; excellent for the 1960s; and then becoming rather patchy again. Nevertheless, what follows is, I believe, an adequately full account of the history of a notable stockbroking firm. I am sure that Bill would have been delighted to see this history at last publicly recorded. I know that I am.

David Kynaston
November 1997

[1]
A Family Firm

'Stockbrokers are generally honest but not particularly brilliant . . . especially if they confine themselves to investment business there is little scope for the development of the brain.' This was the opinion of H. Osborne O'Hagan, a company promoter of wide experience who was writing in the late 1920s and had known London stockbrokers well since the 1880s. By the time he offered this view, Phillips & Drew had been in business on the Stock Exchange for some thirty years, one of several hundred small stockbroking firms operating there. During the fifty years and more that followed O'Hagan's unflattering estimate, the firm would make a unique name for itself by demonstrating precisely that 'the brain' *could* with advantage be applied to investment. That is the overriding theme of this book.

If there was indeed 'little scope for the development of the brain' between the late nineteenth century and the 1930s, this was in part because there was little reliable information for the brain to work on. Under company law as it existed until 1948, when at last consolidated accounts became mandatory, the balance sheets of public companies, including the most reputable, were apt to be works of mystery and imagination. Companies were required to give only the barest minimum of information and the scope for concealment, especially of the true value of assets, was immense. Holding companies that held the shares of other companies were not required either to reveal which companies they owned or to publish any information about their subsidiaries' finances, with the

1

result that no outsider could do more than guess at the true value of the capital employed or the profits earned by the largest industrial groups. As for turnover, that was a matter traditionally shrouded in the deepest secrecy, and in their annual addresses to general meetings, chairmen of public companies were inclined to tell their shareholders only what they thought it was good for them to know, and as little as possible of that.

Commercial and industrial shares did not provide the largest part of Stock Exchange business – in 1933 they accounted for about 30% of the nominal value of quoted securities – but they were attractive to the more daring investors and speculators among stockbrokers' clients (usually individuals rather than institutions), to say nothing of stockbrokers themselves, dealing on private account. Ordinary shares were widely regarded as a very risky form of investment, if potentially highly profitable. Accordingly, anyone who had access to inside information, permitting penetration behind the baffling curtain of published accounts, might expect a welcome in a stockbroker's office, the more so if he also had social or sporting connections – the two often went together, especially in field sports – that would give him the ear of wealthy clients. To set up in business as a broker, either on his own or in partnership, the only more or less indispensable requirement was membership of the Stock Exchange.

The Stock Exchange itself may have claimed otherwise, but between the 1890s and the 1930s its essential character was that of a club for gentlemen interested in making money, much as the Jockey Club was for gentlemen interested in racing and the MCC was for gentlemen interested in cricket. In all these clubs there were expert practitioners of the arts which the clubs existed to promote – in the case of the Stock Exchange, investment and speculation – but professional qualifications were in none a requirement for admission.

Instead, gentlemen seeking membership of the Stock Exchange, as of other desirable clubs, principally required personal connections and money. Personal connections were needed to find a nomination (by which a new member replaced a retiring one) and three sureties – each by the mid-1930s putting up £500 in case of default, equivalent in

modern values to some £15,500. Money was needed to buy
the nomination (about £300 at the time); to buy three shares
in the ownership of the Stock Exchange (about £210 each);
and for the entrance fee of 600 guineas (£630). Then there
would be an annual subscription of 100 guineas (£105).
Joining expenses varied widely with the circumstances of the
day. In 1904, for example, the price of a nomination was put
at £1,800, but at the outbreak of war ten years later, as confi-
dence in the future vanished, it was reputedly possible to buy
one for a packet of Players. Crucially, even if all these prelim-
inaries were satisfied, admission was not guaranteed. It
depended on the goodwill of members of the Stock
Exchange Committee, and that might be granted or withheld
for reasons quite unconnected with business. The face had to
fit, in other words, and in the old Stock Exchange the great
majority of members had been educated at English public
schools – a fact that helped to account for the often boister-
ous atmosphere on the market floor in Capel Court.

The stockbroking firms themselves were dominated by the
proprietary partners, led by an often autocratic senior part-
ner. They owned the capital, took the profits, and controlled
policy. Very commonly they would belong to one family or a
group of families; and in one firm (Foster & Braithwaite) the
deed of partnership, from 1867 to 1971, limited the choice of
partners to the descendants of a Kendal dry-salter who had
died in 1861. In some cases there were also salaried partners.
These were often experienced 'confidential' clerks – raised,
as it were, to the peerage but without voting power and with-
out security of tenure. Finally, in addition to the long-suffer-
ing clerks as a whole, poorly paid and under the iron rod of
the office manager, there was in most firms a sprinkling of
what were known as 'half-commission men'.

The half-commission man perfectly embodied the spirit of
the pre-1939 Stock Exchange. Usually he was more than half
an amateur, making his living by skilful trading on his
sources of information and his connections. He would almost
invariably be of good social standing with a public-school
background – otherwise he would be unlikely to form the
necessary connections – and he might employ a clerk or two.
He need not necessarily be a member of the Stock Exchange.
The basis on which he worked was that he was allowed space

and services in a stockbroker's office and, within limits, the benefit of the firm's name and goodwill, in return for which he passed to the firm half the commission on any business which he brought in. Some, even inside the Stock Exchange, regarded the 'half-comm man' as a parasitical lounge lizard, belonging to the West End club rather than the City parlour; but for many firms he was an important source of business, especially in this period when institutional investors were much less important than individual investors and speculators.

In all, the old Stock Exchange was an agreeable, club-like way of life, perhaps particularly for the brokers who, unlike the jobbers, did not have to stand on their feet for much of the day. Whom one knew mattered far more than what one knew, and with a pleasant manner, a network of reasonably well-heeled friends and acquaintances, and a plausible line in assessing and justifying the market's most immediate movements, a broker could make a good if rarely spectacular living. In 1912 a member called Norman Stickland contributed 'A Broker's Epitaph' to *The Stock Exchange Christmas Annual*. Almost certainly there were any number of real-life candidates:

> Still do I mourn my broker and my friend.
> I loved his florid cheeks and portly size;
> I loved the slow, wise smile that lit his face
> When asked if this would fall or that would rise,
> His pros and cons, his ready flow of speech
> Would leave you quite convinced he really knew;
> Yet never once did he commit himself –
> He merely took commission out of you.

We know frustratingly little about Phillips & Drew's founder. George Allen Phillips was born in about 1862 and became a member of the Stock Exchange in 1885. Over the next five years or so he participated in a series of short-lived partnerships – with Lewis Levy, with Charles Gill, and with E.S. Revett – but by the early 1890s was operating as a sole trader under his own name. His telegraphic address was 'MISTERM, LONDON', the telephone number was 11234, and the address was 2 St Michael's House, St Michael's Alley,

Cornhill. By 1892 at the latest, Phillips had taken on as his chief clerk Harvey Richard ('Dick') Drew. The new recruit came from the jobbers Huggins & Clarke, was in his early twenties, and had originally hoped to be a solicitor. In 1895 Drew became not only a member of the Stock Exchange but also a partner of Phillips, and the firm's name became G.A. Phillips & Co.

Drew's father was a not particularly prosperous architect, who in about 1880 had had to retire from London to Torquay through ill health, and this partnership was an important step. 'We have got our hands full now and are going to make hay while the sun shines,' Drew wrote from the City to his younger brother Geoffrey in September 1895. The Kaffir boom, in South African gold-mining shares, was at this point in full swing – although, according to subsequent Drew family folklore, the downside of any boom was that the office faced some very late evenings because of Phillips's infuriating habit of keeping the jobbing book in his pocket all day and not letting the poor clerks know what business had been transacted until he returned to the office in the late afternoon, or even later if there was an after-hours street market. But Drew himself, as a partner, presumably no longer suffered, and even if he did the Kaffir boom would have produced some very handsome compensating profits.

Two other early partners were George Farnham, for a few years around the turn of the century, and James Fawcett, from 1902 to 1905, by which time the firm had moved to 4 Bishopsgate. A more lasting figure was Geoffrey Drew. After leaving Haileybury, he had had a fruitless spell with a commodity firm in Mincing Lane and a more profitable time with the jobbers Laurence Brothers, during which he had become a member of the Stock Exchange. He moved over to broking in 1905 and joined his brother Dick. 'When his partner George Phillips decided to retire,' Geoffrey Drew would recall, 'he offered to take me into partnership, and the £2,000 I had saved came in very useful to buy out George Phillips, and help contribute to the necessary capital I had to find.' At the same time, the firm's name was changed, as logic dictated, to Phillips & Drew. Phillips himself apparently took the decision to retire on the grounds of ill health, but by 1907 he seems to have been back in the fray. Two others became

partners in 1910, namely Norman Walters and Kenneth Dingwall, both probably on a half-commission basis. 'I never heard that he brought more than a tea-cup of business,' Dick Drew's son David (later in the firm) would recall of Walters, a well-to-do bachelor who lived in Old Burlington Street and was always immaculately turned out. However, as a qualified accountant with considerable personal knowledge of South African mines, he may have been of more use in his early years with the firm. Dingwall, a relation of Geoffrey Drew's wife and a former officer with the Gordon Highlanders, was a more attractive character, though remembered less for his stockbroking skills than as a collector of jade. At least one half-commission man was not a partner, and that was the genial man of letters E.H. Lacon Watson, who as a friend of Geoffrey Drew struck up an association with the firm in about 1910 following the failure of a publishing and book-selling venture. Over the years, his clients included Sir Arthur Conan Doyle and H.A. Vachell, like him both members of the Authors' Club; and towards the end of his life he confessed that, after 'dividing my time more or less equally between literature and writing letters to clients', the hard truth was that literature 'generally proved the less profitable proposition of the two'. Presumably this even included his novel about the City, *Cloudesley Tempest*, published in 1914.

The firm's business in the Edwardian period was without doubt focused almost entirely on private clients, but few traces survive. 'We had a very thin time for several years, and in 1907 actually made a loss,' Geoffrey Drew would recall of his early years at Phillips & Drew, adding however that with the start of the rubber boom 'things began to look up'. By 1911 the City's favourite flavour had become anything Canadian, and in June that year there was a revealing snatch of correspondence between Phillips and George Miles-Bailey, a fellow-member of the Stock Exchange. 'My dear Phillips,' wrote Miles-Bailey on the 16th from his home at Abbess Grange near Stockbridge in Hampshire:

Its jolly good of you to have Marjorie. I'm writing largely for Florence who is pretty bad today. I've written to Marjorie & given her her train back on Monday 26th. 2.40 from Edenbridge town. 3.40 Victoria. I will meet her at Victoria.

Look here. Would you like to be in a thing in Canada with us. Mackenzie & Mann [a Toronto firm of brokers] bought something in Canada themselves only, just as I was coming away & I got them to let me have some for Morrison £10000, Farrar £5000 & myself £5000. Its quite clean, only the five of us in it – & we three are on absolutely the ground floor with M. & M. . . . I don't know if they would part with any more but if they would, I would try to get £5000 for you.

You would be in very good Company & it would be a good introduction. . . You wouldn't fall down over it!

The offer involved Canada Iron Mines (6% bonds, with an option on common stock), and on the 19th Phillips replied from 4 Bishopsgate to 'Dear Bailey':

I think that it is very very good of you to think of me for the Canadian Venture, not only because it will be a profitable one but because you are good enough & nice enough to bring me in touch with your own strong friends. I appreciate this muchly & shall not forget it.

I shall of course be delighted to come in in such Company, not forgetting the fact that you are one of them, for that weighs with me considerably, but I should, if it could be allowed, like the amount to be £2500. Not because I should mind being in to the tune of £5000 or more but simply because, as you will well understand, I have to use free money, at times, pretty liberally in various ways. I hope that this will not interfere with my having an interest.

Miles-Bailey agreed to the reduced participation ('You are wise to split up liabilities over many things in small amounts & other things may come along'), and the two men agreed to have lunch at Miles-Bailey's club, the Junior Constitutional in Piccadilly, to finalise arrangements. The episode is a tantalising but illuminating glimpse of how, in Edwardian gentlemanly capitalism, the social and the business strands could mesh almost seamlessly together.

Phillips himself was living by this time at Leydens House in Edenbridge, where he became a prominent local figure. A vice-president of the local Conservative Association, as well as chairman of the Gardening Society, he was a staunch

opponent of Home Rule for Ireland and spoke publicly on that theme several times during the winter of 1913/14. That spring he decided to spend Easter in Southsea, where on the Tuesday in Easter week he was taken ill with pneumonia and pleurisy, dying at a nursing home in Southsea on 20 April. He was only 52 years old and was buried in Petworth alongside his parents. Mourners, according to the *Kent & Sussex Courier*, included his two sons Alec and Ralph (neither of whom went into the firm), the Drew brothers, the Hon. P. Bowes Lyon, Captain Dingwall, Miles-Bailey, G. Passey ('deceased's chauffeur'), and W. Marchant ('his game-keeper'). There were many wreaths, including one from Norman Walters and another 'in sorrow from the staff at Palmerston House', the building in Old Broad Street to which the firm had recently moved. 'His genial and kindly presence will be greatly missed in Edenbridge,' the same paper asserted; but according to Dick Drew's son David, writing many years later, Phillips 'was a difficult man to work with, and towards the end, my Father never knew when to expect him or even where he was'. Either way, he was the firm's founder, and deserves some posthumous honour for that reason alone.

Later in 1914 the outbreak of war caused the Stock Exchange to be closed for the last five months of the year, though some business continued to be done. 'If a client wishes to continue without paying 10% difference,' the firm asked the Stock Exchange Committee in November in the context of the emergency rules in operation, 'may his broker himself provide margin and charge the higher rate?' The answer was moderately helpful: 'Must obtain their client's consent'. Too old to fight, Dick Drew was senior partner and a constant presence, though strictly on a ten-to-four basis, until he retired from active business in about 1929. He remained a partner, however, until 1933, when he was replaced by his son David. Geoffrey Drew did fight, but returned and was a partner throughout the inter-war period, though suffering a heart attack in 1933 that kept him out of the office for almost a year. No one would have called him a big hitter, but he was shrewd enough as well as very careful with his money. Walters and Dingwall, meanwhile, continued as partners during the inter-war years – Walters rarely smil-

ing and nicknamed 'the screaming skull' by irreverent staff, and Dingwall, 'the Dingo', increasingly eccentric and much affected by his return to Army life during the war, who eventually left the firm in 1933.

Two new partners were made in the mid-1920s. Henry Gadsby was on a half-commission basis and stayed for only five years, largely because he did not get on with Thomas Reeves, the other new partner. Reeves, 'a great big tall domed chap', was a remarkable man. He had originally been office manager for another firm, Smith, Rice & Co, and then come to Phillips & Drew before the war in the same capacity. He was a hard worker, had managed to build up a useful connection, and is remembered as someone who would tolerate no rival. Indeed, as a result of the partnership restructuring in 1933, he became senior partner, holding almost half of the firm's capital of £9,000. In addition, of course, there were still on the scene the half-commission men who were not partners. These included Lacon Watson, E.J.M. Lascelles (of the well-known family, and whose clients Reeves inherited when he died), George Street, J.E.C. Eaton (a bow-legged countryman who did not do much but was a friend of Dingwall), and the Hon. Alexander Archibald Douglas Wolston Dixie, a 'gay butterfly' of the 1930s who owned one of the original SS Jaguars. There was also John Cecil Stafford Charles, who belonged to a family of surveyors and property dealers, came to the firm as a half-commission man, and became a partner in 1936. He was renowned less for his stockbroking than for his skill at field sports, especially shooting. 'Very toffee' is how he has been recalled, and with his domineering instincts, he could be exceptionally rude to the clerks.

It was a small firm in an era when small firms were still the City norm. At the Christmas dinner in 1926, held at Odone's Restaurant and with attendance compulsory for anyone connected with the firm, twenty-four were present. They included Tommy Tomkinson, who had joined the firm in 1905 and was the sole telephone operator as well as being responsible for the post and the jobbers' books; W.J. Veal (known as 'V'), who had come in the same year and did the contracts and ledgers; Reeves's successor as office manager, Tom Seller, who for some reason was always referred to behind

his back as 'Elfie boy'; the authorised clerk Bill May, very upright and always perfectly turned out in black coat and pin-striped trousers; and the portly, long-serving Cliff Dorrington, responsible for bearer bonds. Six years later, in 1932, the firm recruited a new office boy, at 12*s* 6*d* a week, to help sort out the filing system and do general messenger duties. This was Dougie Phin, who half a century on still had vivid memories of life at Palmerston House, 34 Old Broad Street:

> It was a real Victorian pile – great echoing halls, scrappy old offices – it was a real Dickensian office. You went up in a great hydraulic lift where you had to pull the rope, and a young chap there in a scruffy old uniform, and then you went in the office, and it was a great old coal fire at one end – sixpence a bucket was the coal, and the office boy had to go down and get it from the dungeons. . . . It was very dark – dark paint and dark mahogany desk – and the usual slit in it where the boys put their stock in, and then they scribed on it, 'Died waiting, 1934', and then the office manager would see you and come round and clip your ear. . . . Our desks were the old-fashioned sloping desks with the big brass rails across the middle. You sat on a very high stool, and believe it or not they were very comfortable because you had a foot-rest and a flap. . . . The first duty of an office boy was to fill up the ink-wells – blue, red, and copying [i.e. black] ink, because all the contracts were written by hand. . . . It's true to say that stock-broking never changed. A dealer could have left the firm, any firm, in 1880 and come back in 1945 and picked up his book and dealt, just the same.

Phin did not deny that there was some mechanisation in the 1930s – two typewriters (each with a lady typist), a Roneo copier (involving a waxed roller), and a cumbersome adding machine – but overall the tone and discipline of office life were still steeped in the nineteenth century, being indeed Dickensian. The great novelist would also have recognised the inegalitarian share of the spoils, with a ledger clerk on about £2 a week, for example, being below the average earnings of miners or other industrial manual workers. For most clerks, certainly those with family responsibilities, far too

much depended on the annual bonus – a capricious system, unhealthily dependent on the personal likes or dislikes of the senior partner of the day. As for pension schemes, they were unheard of in stockbroking firms. Looking back, though fully recognising the 'charm' of the ruling family, Phin was not inclined to be unduly sentimental: 'On the whole, a damned happy old office, although the Drews were bloody mean and you were expected to work your guts out.'

The firm's volume of business now seems pitifully small. In the absence of proper records, the figures recalled by David Drew, who first went to the firm in 1927, are an adequate guide: 'If we could scratch £100 commission in a day we were well satisfied – £300 and we almost went out and celebrated. £1,000 in an account [i.e. over a fortnight] paid the expenses with quite a margin. If one could average that over the year we turned in a profit of £10,000.' Inevitably, however, the firm was hit hard by the Wall Street Crash of October 1929 and the sharp global economic downturn that followed – to the point perhaps of being in real danger. Salaries were reduced in 1931 by a quarter, a more severe reduction than in many other businesses or in the public sector. At least two members of staff were laid off (including the young Arthur Beard, who managed to be reinstated in 1933), and to the credit of the Drews no partner drew anything for three years, in other words until the salary cuts had been made good. We have figures for the year ending March 1936, after the worst of the slump was over. They show a net profit after costs of £7,651, divisible among five partners. The average per partner was therefore £1,530 – rather better, to put it mildly, than the relatively well paid Tomkinson on £4 5s a week, but nevertheless still equivalent to barely £45,000 in present-day terms.

Just as much as prior to 1914, the securing of commission relied almost entirely on connections with individual clients. The Drews had interests in sugar and tea planting that produced business. Dingwall brought in several distinguished Army officers, while occasionally (in a rare bit of institutional business) he was able to persuade one of the well-known Scottish trusts based in Charlotte Square in Edinburgh to weigh in with a decent order. Walters became chairman of Fortnum & Mason, which presumably did some

good to the firm. Gadsby had some top-notch industrial clients during his five years, including Hornimans Tea, Morgan Crucible and Chloride Electrical Storage; in most cases it was a director or a member of the family who dealt as an individual through Gadsby rather than the company itself. Finally, Reeves had a particularly helpful friend in the well-known jobber Bertram Bisgood, who introduced him to the solicitor C. Stanley Thomas, a trustee for various wealthy families including Spratts of the dog-biscuit firm.

But if personal connection was paramount, as undeniably it was, there was also – contrary to subsequent assumptions – just a *hint* of something more cerebral starting to emerge, at least on the part of Reeves. The evidence lies in a printed circular by him, dated 18 October 1930. Four pages long, and headed 'Five per cent. War Loan', it gave the history of earlier debt conversions (1844 and 1888), the history of 5% War Loan itself, and the probabilities and implications of conversion. The conclusion reached by Reeves at the end of his circular was that 'it may be judged that circumstances and conditions point to the strong possibilities that a scheme may be launched in the near future', and 'to those, therefore, who are prepared to secure possible advance gain, a sale of War 5% at this time and a purchase of longer dated or irredeemable Government securities is indicated'. In the event, the financial and political crises of 1931 delayed conversion until 1932, but it was still a sensible opinion based on a careful analysis of the available evidence. The copy of Reeves's circular that survives was originally sent by him to the stockbroking firm Cazenove & Akroyds, which in turn sent it to Edward Peacock of Barings, who in turn passed it on to none other than the Governor of the Bank of England, Montagu Norman. 'An interesting document has been issued by Messrs Phillips & Drew, who I do not know, regarding a conversion of the War Debt,' explained Peacock in his accompanying letter. Norman, typically, did not venture an opinion on the circular; but at least the City's oldest, most distinguished merchant bank, not to mention the Bank of England itself, now knew the name of Phillips & Drew.

Although Phillips & Drew, and numerous other similar firms, relied heavily on business from private individuals, there

were between the wars other stockbrokers, particularly the larger firms, that dealt not only with individuals but also with a very different class of client: the 'institutions', especially insurance companies. They did business also for banks, investment trusts and pension funds, though the pension funds' great growth did not come until after the Second World War. Institutions differed sharply from individuals in two principal ways, from the stockbroker's point of view. Firstly, they had far more money for investment than any private client. Secondly, their investments were increasingly looked after by in-house managers who, in contrast to the average stockbroker of the day, held professional qualifications, usually as accountants or actuaries. Their respect for the judgement of stockbrokers was therefore at best heavily qualified, since they were themselves at least equally capable of taking a view of the market. As early as 1912, during a discussion at the Institute of Actuaries, J.R. Hart of the Phoenix put it succinctly: 'He thought most of the members who had to do with brokers knew that their opinion from an investment point of view was not worth very much; they very seldom had the time or the organisation to analyse an investment in the way insurance companies required.' This view went unchallenged.

By 1935 the total assets of British insurance companies amounted to £1,587 m, and they were rising rapidly. Of that figure, 54.8% – nearly £870 m – was in Stock Exchange securities. Sixteen per cent of the insurance companies' assets were debentures, 7.5% preference stock and shares, and 8% ordinary stock and shares. Twenty-three per cent of their assets were in the form of British government securities – that is 'gilts'. The insurance companies' boards and investment managers were traditionally wary of ordinary shares – although they were starting to debate their merits – and no doubt became even more so after the experience of the early 1930s. Fixed-interest securities, in the days before continuous inflation, suited their purposes much better, especially those, such as fixed-maturity debentures, which could be relied upon to provide a certain sum of money at a certain date, thus meeting one of their prime requirements for life insurance and pensions. By contrast, large-scale holding of gilt-edged securities represented a sharp break with the insur-

ance companies' previous policy. In 1913 they had held less than 1% of their assets in gilts; but during the First World War, when government borrowing raised the National Debt from £700 m to nearly £8,000 m, all investors came under heavy pressure to take up War Loan and the insurance companies did their patriotic duty. By 1935, three years after the conversion of War Loan to a lower rate of interest, they had reduced their holdings considerably. Even so, 23% of their assets still represented a capital sum of £365 m: a very desirable dish indeed for stockbrokers to get their teeth into.

There was a wide variety of gilt-edged stocks, which included Corporation stocks and Colonial Government securities as well as those that came under the specific category of 'British Funds, etc.'. For that latter class *The Times* of 1 March 1935 listed forty-one issues, headed by 2½% and 4% Consols. Then came War Loan, followed by 4% Victory Bonds. None of these stocks had any fixed redemption date. There were various funding and conversion loans bearing interest at rates from 2½% to 5% and due for redemption, according to the terms of the various issues, in almost all years between 1940 and 1990. Three per cent Treasury Bonds – 'Treasury Threes' – were redeemable between 1933 and 1942; 2% Treasury Bonds between 1935 and 1938; and 2½% Treasury Bonds in 1937. Seven India stocks were quoted, bearing interest at rates between 2½% and 5½% and redeemable, those that were dated, between 1936 and 1968. There were also a 3% Newfoundland stock redeemable in 1963, a 3% Transvaal stock 1925–53, and an undated 5½% Sudan stock. Besides these there were Local Loans, Irish Land Stock, Bank of England Stock, various loan stocks of the City of London, the Port of London and the Metropolitan Water Board – some dated, some not – and finally there was Central Electricity 3½% stock, undated, a herald of things to come when nationalisation got under way after 1945.

Most of these stocks had the credit of the British Government behind them. No one foresaw the havoc that would be wrought by unstoppable inflation among undated stocks, especially Consols and War Loan. Nevertheless, for the investment managers of the cash-rich insurance companies and pension funds, and for the boards and trustees to whom

they were answerable, these stocks represented a mathematical problem of considerable complexity. Rates of interest and dates of redemption had to be taken into account and considered in conjunction with constantly changing prices – hence constantly changing yields. The price range over a year might be wide, particularly for undated stocks. During the twelve months prior to March 1935, for example, the price of 2½% Consols had swung between $73^{15}/_{16}$ and 92½; of 3½% War Loan, between 101 and $109^{5}/_{16}$. For stocks nearing redemption the swing was narrower: between $99^{13}/_{16}$ and $100^{15}/_{16}$, for instance, for 2% Treasury Bonds 1935–38. The fact was that, quite apart from long-term investment, there was significant money to be made, if prices and yields were properly compared, by timely switching from one stock into another. The rate of profit on these transactions would be tiny; but for insurance companies, on the amount of stock which they held, the result, in absolute figures, would be worth having. So, for a stockbroker, would the brokerage.

This was the kind of problem that an actuary's training fitted him very well to consider. However, actuaries were distinctly thin on the ground in stockbrokers' offices in 1935 – indeed, there was only a handful of them. One, sitting in the office of David A. Bevan & Co, was S.J. Perry, the central figure of this book and one of the more remarkable operators in the twentieth-century City. Born in 1888, Sidney Perry recorded the outline of the formative part of his life story when in his mid-seventies.

My education was at a local private school, no doubt the best my parents could afford. I passed Oxford Junior and Senior examinations and in November 1903 was accepted by the Northern Assurance Company as a junior clerk (salary £25 p.a.). This company was no doubt selected by my father as at least giving me the prospect of secure employment with regular rises up to say £300 p.a. It involved the recommendation of a director and a minor examination.

My experience with the Northern consisted of about a year as junior in the Secretary's office followed by a year and a half in what was known as fires classification, an analysis of premiums and claims pertaining to the various classes of risk. During this latter period I had come to the conclusion that

15

the surest way of making progress was to take the actuarial
exams. I was transferred to the Life Department, probably in
1906. This was then a small department which gave me all-
round experience in the conduct of life business. In late 1912
I had passed three of the actuarial exams out of the four
sections and with the help of several extra rises due to pass-
ing the exams, had obtained a salary of £132.10.0d p.a. I was
then attracted by a job offered by the Phoenix Assurance as
accident department statistician at £200 p.a. which by reason
of overtime, on which they were fairly generous, brought me
in £300 in my first year. The job mainly dealt with motor busi-
ness which was even then giving the companies a good many
headaches. This job continued until war broke out in 1914. By
September 1914 I came to the conclusion that I should offer
myself for military service and after a good deal of trouble I
was accepted into the Queen Victoria Rifles.

In due course he obtained a commission with a battalion of
the City of London Rifles, which on the first day of the Battle
of the Somme lost ten officers killed, including Perry's
brother, out of sixteen. Perry himself, shattered psychologi-
cally though not physically, was sent home in October 1916,
and by the time the war ended he was an established civil
servant dealing with marine insurance. In 1922 he left the
public service and joined David A. Bevan & Co, 'on a modi-
fied half-commission basis to stimulate gilt-edged Stock
Exchange business'. It was not an easy time:

I had during the war period contracted a marriage which
turned out disastrously. After trying for ten years to make a
success of it, this marriage was brought to an end. In 1926 I
remarried, this time with complete success. Whilst the first
wife left me financially crippled, I gradually recovered during
the second period.

My period with David A. Bevan was on the whole a satis-
factory one. However, although I could sense the benefits
which could accrue through the greater coverage which could
be given by the employment of another person with similar
qualifications to my own and raised the question with the
firm, I could not persuade them to act. The most they would
do was to suggest that I took as assistant another employee of

the firm, and I selected Mr John Slater, a very accurate and trustworthy individual, completely loyal but with no formal qualifications. We worked with modest success but Slater at one time asked my advice as to whether he should seek another post because he was not making the progress to which he felt entitled; in fact he felt that his attachment to his department had led to his claims being disregarded when general rises were being considered, as he was no longer under the eye of the office manager. I dissuaded him from taking such a step in view of the obvious risks which a change in employment would entail.

At this time I used to travel fairly regularly in the train [from Brighton] with two brothers named Laurence who conducted a small jobbing business [the same firm for which Geoffrey Drew had once worked] in the Miscellaneous [i.e. industrial] market, with whom no doubt I discussed the dissatisfaction I felt with my employment with Bevan & Company. I may say that at this time my finances had been modestly restored by the death of parents and I had made myself a member in 1935. It was the Laurences who suggested to me that I might improve my chances with a smaller firm without institutional connections and first mentioned Phillips & Drew to me, which was confirmed by Billinghurst, then attached to Gordon & Cooke, Indian Railway Jobbers, later of C.J. Whittington & Company. P. & D. were described as a small firm with a good Stock Exchange reputation but without appreciable institutional connections and Laurence Bros. gave me an introduction to them. I went to see them. I remember Mr Geoffrey Drew particularly. He was senior partner but was apparently semi-retired. The active members of the firm were Messrs. David Drew and Stafford-Charles [i.e John Charles]. There was also N.C. Walters – not very active in the business – and Mr Reeves who had progressed from office manager but who was ill. My impression was that David Drew and Stafford-Charles apparently took turns at having time off, though sometimes they were in the office together.

The terms arranged were that my name should go on the notepaper as partner, but I did not want material partnership, as I should have a fairly free hand to build up a team, that the costs of any special expenses, including salaries of my team,

should be in first charges and that the balance should be divided 50–50, bonuses to my team being at my direction.

I joined P. & D. in March 1936.

Perry does not quite say so, but almost certainly it was only Reeves's sudden severe illness – he had a stroke at some point in 1935, while only in his mid-fifties – that made the opening at Phillips & Drew possible. In the words of Arthur Beard, who knew both men, Reeves otherwise would have 'vetoed any suggestion of G.H.D.'s [Geoffrey Drew's] to bring someone else in who might have contested his dominance eventually'. From the point of view of Perry, in his late forties, it was a case of thinking of the future. It was evident that Bevans were not only not going to make him a partner but also that they were unwilling fully to back him in his business. Already well connected with actuaries in insurance offices, he now wanted to develop that business by recruiting his own team of actuaries and accountants. They would be able to expand the kind of business he was doing and, in return for a generous share of his earnings, they might be willing to go on sharing with him when he no longer wished to be fully active. How to do it? Starting his own firm was one obvious possibility; but rather than get embroiled in all the problems of office staff, premises and so on he decided to look around for an already established firm that would be willing to accept him and the qualified team he intended to recruit – in other words, as a firm within a firm. The Laurences suggested Phillips & Drew, and the rest is history.

The story goes that when Perry left Geoffrey Drew after settling the terms of his agreement, Drew followed him into the general office at Palmerston House. Addressing the office manager, Drew said: 'Seller, that's Mr Perry, who will be joining us on 25 March. He says he makes £5,000 a year. Seller, we shall see!'

[2]
Perry and His Team

When Perry set up his desk in Phillips & Drew's office, he brought with him two companions. One was Slater, whom Perry had recently persuaded to stay at Bevans despite his discontent. Now Slater asked if he could accompany Perry in his move, and despite his awareness of Slater's limitations Perry felt he could hardly refuse – displaying that quality of loyalty to his staff which in turn would make his staff so loyal to him. A good clerk and accurate with figures, including the capacity to calculate yields, Slater had a slight stammer and an extremely obsequious manner: he would always leave a room backwards, bowing and scraping. Not surprisingly the juniors at Palmerston House quickly nicknamed him 'Uriah', and after some years he went to the Alliance. The other man Perry brought with him, though he did not arrive until 1937, was the very different Tom Ismay. Ismay's father was J.B. Ismay, chairman of the White Star Line and famous – or infamous – for surviving the loss of the line's *Titanic* in 1912. Tom Ismay's main purpose in life was looking after the investments of the family funds, and for that purpose he had acquired a desk at Bevans, where he had got to know and trust Perry, who in practice did much of the business for him. Like Perry he became a partner in Phillips & Drew, but neither had any share in the firm's capital. The business which Ismay's wealth attracted, without any effort on the part of Perry or of Phillips & Drew, was no doubt very welcome; and that must have been the only reason why he was associated with Perry, for he had none of the qualifica-

tions which Perry required for membership of the 'team' he was about to build up. Ismay accounted separately to Phillips & Drew for the business he did and had no share in the team's earnings. No great financial genius, he had a pleasantly dry sense of humour, to the point of keeping his records on black-edged mourning cards, and added to the flavour of office life.

More importantly in the long run, Perry made three major signings as he built up the nucleus of his team in the three and a half years before war broke out. The first, who joined him in October 1936, was Lionel Potter. He was distantly related to Perry, and no doubt that gave him an introduction, but what was probably more important was that he was an accountant. A quiet man who made few if any enemies, Potter had as his main brief the equity market, but he also helped to look after Perry's private clients. However, to train as his successor, and on far more generous terms than he was prepared to offer Potter, Perry intended to engage not an accountant but an actuary, in other words someone in his own image. Accordingly, he made a list of young actuaries who seemed to have some interest in investment and began to make contact with them. One, besides being an actuary, had a Cambridge degree in economics and was working in the investment department at the Pearl. But he turned down Perry's offer, reputedly remarking that he would be exchanging a debenture for an equity, a comment equally revealing of his opinion of the Stock Exchange and of insurance companies' investment policy. Another on Perry's list was an actuary in his mid-twenties, Denis Weaver, who was working with Govett, Sons & Co, a fairly large firm of brokers interested in the gilt-edged market. It had a wide connection among investment trusts and in America, and altogether was a firm different in every way from Phillips & Drew and of a pattern that Perry wished to follow. Moreover, Weaver himself was doing precisely the kind of work that Perry wanted his own team to specialise in. He had been engaged to provide Govetts with a daily list of gilt-edged yields and to seek 'anomaly yields', in other words, stocks out of line with the general level of the gilt-edged market which could be recommended to institutional clients for profitable switching against stocks they already held.

Perry evidently wanted Weaver badly, for in September 1937 he sent him a very frank memorandum. In it, he said that his own earnings had risen from £1,600 – 'a fair representation of average earnings' when he was working alone – to about £2,250, which 'as things stand today seems not unfair as a measure of my average earnings'. The inducement that he held out to Weaver was a salary of £400 plus 22% of any sum by which gross commissions exceeded £6,000. By the time gross commission reached £10,000, Perry himself would be receiving £3,085 and Weaver £1,280 – the latter in marked contrast to Slater's £500 and Potter's £600. Perry went on:

Whilst above is proposed as basis of immediate agreement the terms are amply generous. In return for this I naturally want a good man who is capable and willing to take responsibility; to develop into a 'principal' as opposed to a clerk; capable to interview clients and write letters which will carry for business. As soon as I am reasonably satisfied that the man is the right type I want to put him into the 'House' [the Stock Exchange] as 'unauthorised' clerk (say from 25th March next) and for him to prepare to make himself a member after four years (which will mean saving money).

I have in mind that my time in the City is limited. Under present conditions my connection would simply disappear. Taking in the right man now he will be able to preserve it, to his own advantage and mine. When I get substantially to the 'sleeping partner' stage I shall be prepared to make fresh arrangements giving a larger proportion of profits than now to him.

In matters of this kind not more than 'rough justice' can be done. It is impossible to see all future developments and I do not expect a man to be too aggressive over his own 'rights'. For example, still further additions to staff might become desirable when I should expect modifications of terms to be made generous to the then new man, but nevertheless advantageous to all parties.

Weaver accepted the offer, joining Perry's team in December 1937. 'The promise of a partnership when I had become a member of the House and the position of Perry's successor

21

attracted me,' he recalled almost half a century later. 'I do not think that present-day actuaries realise the hazards of such a decision. I had been rash in going to Govetts which was a relatively large firm with excellent City connexions but more than foolish in joining P. & D., then a small firm with only a private client business and no worthwhile City connexions. I was clearly backing S.J.P.' A Quaker, and politically to the left, Weaver possessed an inherent integrity and seriousness of purpose, as well as a very good brain; and at this stage he was unequivocally Perry's heir apparent.

Perry's third recruit was a young accountant called Charles Locatelli, at that time working on a temporary basis for the jobbers Hadow & Turner, who provided the introduction. In the course of taking up Locatelli's references, Perry had outlined the job specification:

> He will be expected to show capacity to examine and make suggestions for investment purposes, and to supervise and improve current lists of clients' holdings, mainly in the way of industrial shares and debentures. We want a man who is able to recognise the comparative intrinsic merit in securities rather than short-term speculative possibilities.
>
> The qualities of the ideal man would be a combination of ability with a certain amount of flair. Absolute honesty is, of course, essential.
>
> We realise that the above qualities are somewhat exacting, but I shall be grateful for any information you can give me.

A former employer, the accountant G.E. Rolt, replied that 'I should imagine that he would be well able to carry out the work which you suggest giving him, and from my knowledge of him he is absolutely honest,' and Locatelli joined Perry's team in July 1938. The son of an Italian cheese importer and an English mother, Locatelli was Italian in appearance, though blue-eyed, and had an extremely attractive personality. Despite limited investment experience, he also had (in Weaver's words) 'a great facility with figures and immense drive'. Complementing the less driven Potter and the more cerebral Weaver, he represented an exceptionally astute piece of recruitment on the part of Perry.

In terms of the business itself, we have no contemporary list

of Perry's institutional clients in his early days at Phillips & Drew. To judge mainly by Weaver's recollection, however, they included, among insurance companies, Atlas, London Life, Eagle Star, and Wesleyan & General; among friendly societies, Aberdeen & Northern; and among pension funds, the funds of the Bradford Dyers' Association, of Chivers, of British Belting & Asbestos, of Arthur Lee & Sons and of the Merchant Navy Officers. Much of this business had come to Perry through fellow-actuaries, in particular R.G. Maudling (father of the politician) of the consulting actuaries R. Watson & Son. The actuarial connection was a corner-stone of Perry's success, and indeed, shortly after he moved to Phillips & Drew, became even more significant. Weaver tells the story:

On most days Perry used to walk round the House but we never developed the daily 'milk round' of the banks and City houses which was then the standard practice of most brokers in the gilt-edged market. At this time we had a piece a luck that had an important influence on our development. Perry had among his private clients an actuary named C.W. Sanger. He had recently moved from the Eagle Star to the Royal London Mutual [another insurance company] and found himself in charge of the investments, an area in which he had little experience. The Royal London investments had not enjoyed any active supervision, new money being largely placed on underwriting terms with the issue of the moment and then left there. Sanger turned to Perry for help, we were given a full list of investments, and any suggestions we made for improvements were sympathetically considered. This relationship continued for many years.

To advise the Royal London and other such clients on gilt-edged switching, it was essential to find some common measure of comparison between the numerous stocks on the market. Weaver lucidly describes how it was done, as well as the changes he himself introduced:

When I arrived [i.e. in December 1937, by which time Phillips & Drew had moved from Palmerston House, which was being rebuilt, to Capel House in New Broad Street, a property

belonging to John Charles's family], Perry's team, as he loved to call it, occupied two smallish rooms. Perry sat in the middle of the larger room, I in one corner and Slater in the other. The other room was occupied by Potter [subsequently joined by Locatelli] who was mainly concerned with looking after the funds of Perry's private clients. I began to familiarise myself with Perry's method of monitoring Government stocks. It was his practice to adjust the price of each stock to what it would have been if it had a 4% coupon. These adjusted prices were graphed weekly and the lines inspected for divergencies. The yields were also plotted, all this work being done by Slater. For the Dominion stocks (these were then quite numerous) the prices were plotted on translucent paper, ruled logarithmically, and then compared by putting two together and holding them up to the light. I found this not much to my liking and got rid of all the graphs by taking logs of all the prices and calculating the difference between all possible pairs which gave a measure of the changing ratio of the prices. There are clearly limitations to this method but it remained the main method for monitoring gilt-edged prices up to the mid-1950s.

Patient, ingenious, laborious – especially before computers came in – these calculations never promised large returns in percentage terms, but if holdings were large and switches were frequent they might produce considerable sums of money. Moreover, if the real surge in gilt switching by Perry and his team would come later, it was already under way by the war. The first set of reliable figures we have for Perry's association with Phillips & Drew is for the year ending March 1939, a poor year on the Stock Exchange generally, as the European situation deteriorated. During it he earned gross commissions of £7,383, which after expenses and salaries yielded £5,892 for distribution between himself, 'the firm' (Phillips & Drew) and his 'team'. Phillips & Drew's figure for 'gross brokerage' in the same year was £21,012. That must have included commissions from Perry's business, and by the time his share had been paid to him, and interest charges had been met, the firm's net income was £12,539. Costs, which may have included a large element attributable to a bad debt, left net profit of only £2,702. In other words,

Perry by this time was doing much better than the host firm, and his gross earnings – even in a difficult year – were comfortably ahead of the figure of £5,000 which Geoffrey Drew had greeted with such scepticism. Perry himself was a singularly unstriking, uncharismatic figure. Small and sandy-haired, with gold-rimmed glasses, his appearance would hardly change between middle age and old age. He looked, according to one member of staff, 'like a rather prosperous retired pork butcher'. Another thought he looked more like a grocer. Yet, with his gentle voice and quiet manner, he inspired affection as well as respect among those who worked for him, puzzled though some of them were to know where the fire and drive had come from to give him success in business. His principles in dealing with his team were set out in a document soon after the war, but they seem to have been consistent throughout his career:

> We are pleased to have a well-paid staff, feeling that in return this entitles us to look for full efficiency and goodwill from them. Efficiency and goodwill on the part of everybody concerned, from partners to office boy, should enable the business to progress and high earnings to be maintained.... One of our aims is that the staff should be practically self-governing. This does not mean that there can be more than one Office Manager or that the Partners resign any of their rights of direction. It does mean that, with everyone pulling his weight to the best of his ability, staff troubles and internal jealousies should be negligible.... We want to have a body of contented employees of long standing. We aim to attract the more serious-minded efficient type of individual, who when he joins values prospects rather than immediate advantages.... We shall do our best to give comparative justice to all, but where all get more than justice none should have cause for complaint.

Furthermore, with no children from either of his marriages, there was little or no pressure on him to establish the kind of family firm which still predominated on the Stock Exchange. In picking his 'team', therefore, he could concentrate single-mindedly on the ability – nothing else – of the candidates who presented themselves. There was, it should be empha-

sised, nothing of the academic purist about Perry. Back in 1925, reviewing in the *Journal of the Institute of Actuaries* a book about foreign exchange, he referred to 'practical operations being the goal to which all theory should be directed'. Few got to know him better than Weaver, who in 1967 would write Perry's obituary in the *Journal* (as well as in *The Times*):

> He possessed considerable gifts of exposition and could arrange facts with clarity and economy into a convincing argument, but he would never try to prove too much by figures. The unexplained had to be accepted as unexplained – a facet of the integrity which distinguished all his dealings, with people as well as with figures. On first acquaintance he tended to give the impression of being over-precise which perhaps owed something to his rationalist philosophy. But there was no doubt as to his fundamental generosity as exemplified in his dealings with his partners, in the two educational trusts which he founded and to which he devoted his personal fortune, and in his long services to Freemasonry.

The two trusts were the Covenantors' Educational Trust and the Perry Foundation (one formed during the war, the other after, and from 1971 coming together under the umbrella of the latter), and Perry's purpose in starting them was to put his wealth to good use by supporting the provision of education in the widest sense for those otherwise unable to afford it. Living modestly, and with less than no desire to become a country gentleman, he typically wanted to put his growing wealth to good use. A final personal assessment comes again from Weaver, more informally and long after Perry's death: 'He was extremely honest, kindly and generous but it all seemed to come from his head and not from his heart. He was a complete agnostic and to me, he seemed devoid of any spiritual content. This side of his life he devoted to Masonry and the Covenantors' Trust.'

What did the partners in the old firm think of Perry and his team? Reeves was too ill to go to the office after Perry arrived in March 1936, but at Christmas that year he did send him a bottle of brandy with a letter of congratulations on

what he had been able to do. Reeves died in 1937, and that left the two Drews (Geoffrey and David) and Charles as the main partners of the non-Perry Phillips & Drew. Perry's own recollection of the relationship over the next decade or so is probably accurate:

> My personal connections with the Firm at that time were never very close – as a team we were busy developing our own side of the business and the Firm was content to leave it that way. My feeling is that they looked on us rather as magicians conjuring business out of thin air (especially the switching business which was at that time a very large section), and were perhaps a little suspicious of the permanency of it.

This lack of confidence no doubt underpinned the wish of Charles, following the outbreak of war and the immediate sharp reduction in Stock Exchange business, especially on the old firm's private client side, to enter into an office-sharing – and perhaps ultimately merger – arrangement with Nesbitt & Wilson, a rather larger firm of brokers. Charles's plan did not suit Perry's purposes. He had no mind to let the firm on to which he was grafting his own operations subside into suspended animation, and therefore he blocked it. Moreover, within Phillips & Drew, the balance of personnel was clearly moving Perry's way. On the one hand, Charles went into the Army soon after war began, David Drew (who prior to coming to the City had been a naval officer) went back to sea, and Geoffrey Drew no longer had much involvement in the business except to look after the interests of his absent partners; on the other hand, Perry himself was too old for war service, Potter had a crippled arm, Locatelli was out of the military frame because of his Italian background but saved from serious inconvenience through being half-English, and Weaver was not immediately liable for call-up. In other words, unlike the old firm, Perry and his team were scarcely affected by the outbreak of war, except insofar as it disrupted the firm's office organisation as a whole. This inevitably it did, and Bill May, who subsequently became a salaried partner (not in Perry's team) in 1943, proved a tower of strength in keeping things going on a day-to-day basis. Further disruption came with the bombing of Capel House

in 1940; but after a brief, very uncomfortable period of camp-
ing out in the offices of another firm, Phillips & Drew
(including Perry and his team) found vacant premises on the
second floor at Pinners Hall in Austin Friars, occupying the
very rooms in which that creative financier Clarence Hatry
had made such an impact on City life in the 1920s. Perry's
underlying rationalism was exemplified by his response to
the Luftwaffe.

'If the bombing gets bad,' he told Weaver, 'my wife and I
will go and live in Stratford. The Germans will never bomb
Shakespeare's birthplace.'

'Is that all the use you have for Shakespeare?' asked
Weaver.

Within a week, Perry had bought a book on Shakespeare.

Faced by something of a vacuum, Perry by 1940 was start-
ing, in effect, to run the firm as a whole. A memorandum by
him in April that year makes suggestive reading:

My understanding with the Firm was that I should have a
reasonably free hand to take on staff on the basis that I paid
half the cost, and I think it must be admitted that my results
since I have been with the Firm have justified my policy.
Although my business is mainly gilt-edged, I must be the
'complete stockbroker', prepared to provide opinions on any
section of the market. . . . My object in making the sugges-
tion to work the Firm's clients was to help keep the Firm's
connection together and I think the general circulars on gilt-
edged and special ones on particular switches must have
helped to do so. I have secured Geoffrey's consent before
issuing circulars and on most other things, at any rate in prin-
ciple, so as to avoid sending out suggestions which clashed
with the Firm's ideas. I think Geoffrey has been pleased to be
relieved of a good deal of detail, and that a great deal more
has been done than would have been possible for him to deal
with. I shall be perfectly content and pleased to leave the
care of all Firm's clients to David and Charles when they
return. Though the amount of business secured from my own
clients naturally varies, it is relatively very stable and even in
these times my connection grows. If the Government comes
along and takes my team I must suffer it, but I think it would

be foolish to consider dispensing with any member of it on my own account.

Perry, although a partner in Phillips & Drew, only knew his own figures, but by 1941/2 it was obvious to him that there was a difference between the firm's performance and the performance of his own team that ought to be recognised by revising the way in which the team's earnings were shared with the firm. His arrangement with Phillips & Drew up to 1941/2 was that the firm should have 50% of the first £4,900 of the team's 'gross actual' brokerage, less special expenses and salaries, and 40% of the surplus above £4,900. Perry's team was by this time earning at a rate of about £11,000 a year and it was foreseen that the figure might soon rise as high as £14,000. Accordingly, after not very determined opposition by Geoffrey Drew ('the rewards of Stock Exchange business are today so derisory that from my point of view they are no longer worth pursuing as a principal with his savings to lose'), the arrangement was revised in January 1942 so that the firm received only 33⅓% on any excess over £8,400. It was, especially from the point of view of Perry's main lieutenants, a timely development. By the end of 1942/3 the team's 'gross actual' figure was already £24,266 – 73% higher than the highest figure (£14,000) that had been envisaged when the new distribution arrangements had been worked out – and by the time the war ended, in the financial year 1945/6, the team's 'gross actual' figure was £46,537, yielding £44,821 available for distribution.

During the exchange of correspondence in January 1942 between Perry (writing from Peira-Cava, 18 Alexandra Villas, Brighton 1) and Geoffrey Drew (writing from Coldharbour, Bletchingley, Surrey), there was a particularly interesting passage in one of Perry's letters:

There seems to be an assumption that the business merely arrives because of my connections, whereas the actual fact is that practically all of it is specifically worked for, & secured by a close analysis of the fluctuations in the various price levels. Everybody contributes and Weaver especially to the continuous development of our methods. I am sure that you and David Drew and John Charles do not appreciate the

work which each one of my staff puts in. When I was earning £1,600 a year working alone I had twice the energy I have today. Now I am relieved of most of the detail, and it is clear that the business goes on in my absence, where previously it stopped dead, like that of the ordinary half-commission man, when I was away. Is it appreciated, too, that the Government is offering pretty freely, jobs of £550 to £800 a year to men of Potter's and Locatelli's qualifications? It is true that I lead, but I could not cope with the necessities of the business without my staff's enthusiastic co-operation Frankly, the more they earn the better I like it and as, at these high levels, twice as much additional accrues to the Firm as to me, I think you should like it, too.

Locatelli was about to become the key member of Perry's team, especially once Weaver was called up to work on the land from June 1942. In fact Weaver was in a reserved occupation as an actuary, but characteristically he had registered as a conscientious objector. Perry himself may have hoped that his role would be filled by H.E.W. Lutt, who had been Perry's old boss at the Northern and, looking for work, had been recruited by Perry as a personal favour in early 1942. Lutt, however, was too old to learn new tricks, and the departing Weaver successfully advised Clarence Sanger of Royal London to deal with Locatelli in the gilt-switching. Sanger and Locatelli clicked at once, the start of a very fruitful alliance. Indeed, Locatelli now had his hands on the gilt book as a whole, as he had wanted for some time, and it proved the making of him. Not only did he have an instinctive affinity for gilt-switching, but the general gilts climate was broadly propitious. War inevitably did few favours for the equity market, for a long time practically killing it, but it did see the National Debt virtually tripling from £7.1 bn to £21.1 bn. Admittedly a significant proportion of this potential new business by-passed the Stock Exchange, because of the way that the government managed to tap savings at source; but nevertheless there remained a very active secondary market in government debt, especially for the permanent and longer-dated issues. To an almost disconcerting extent, Royal London was *the* dominant client. In February 1944, for example, it yielded for the team a

commission take of £1,155, compared with only £321 from other insurance companies, £263 from the Merchant Navy fund, £545 from other pension funds, and £18 from 'sundries'. For the financial year 1943/4 as a whole, though the figures are slightly unclear, Royal London seems to have provided 66.3% of the team's commission. Without that connection, the impact of Perry and his team on Phillips & Drew would have been much reduced.

As it was, the comparative figures were striking indeed. Between 1939/40 and 1945/6 Phillips & Drew's gross brokerage, which included a large contribution from the team, grew by 370%, whilst over the same period the commission earned by Perry and his team rose by 609%. Perry still did not know the firm's figures, but by December 1945 he was determined on a major revision of the distribution arrangements. 'I feel,' he wrote, 'the time has now arrived when what are in effect two businesses run with a joint staff should get down to terms on a basis of equity and equality of standing.' Broadly speaking, his contention was that his contribution to the firm's income covered the cost of running their office, so that 'looked at in this way the Firm's business is wholly profit'. Perry put his case with a brutal frankness. His average bargain, he asserted, was 'so much larger than the Firm's [that] the real cost of running my business is less rateably than the cost of running the Firm's business'. He declared that his business 'besides being progressive . . . is likely to be much more stable than that of the Firm and a source of strength to them'. He went further: 'My business has raised the prestige of the Firm very appreciably and because of this the Firm is getting additional Bank and possibly other business.' This last was a very sharp thrust indeed. No longer, if Perry was right, was he relying on the goodwill and high standing of Phillips & Drew to support his business. Phillips & Drew, on the contrary, was coming to rely on the goodwill and high standing of Perry and his 'team'. Perry drove one final point home: 'Up to the present my figures have been completely open to the Firm whilst I have had only a general idea of theirs. As I have now so much at stake I think there should be complete disclosure on both sides.'

All this was most disagreeable to John Charles, newly returned from the war. He challenged Perry's assertion that

his contribution, in effect, paid all the firm's office expenses, leaving their brokerage as pure profit, and he unwisely refused to open the firm's books to Perry. Perry's response was devastating:

> This is not treating with me on a basis of equality, but rather at 'arm's-length'. Is it due to an (in my view old-fashioned) instinct for secrecy (leading to suspicion & discontent) or does the Firm hesitate to disclose how dependent they have been on my business? It is the future we have to look to, not the war-time past. I am seeking a basis of equity & equality – one that will stand for an indefinite future; which is satisfactory psychologically & which at any rate will remove financial reasons as the basis for any desire to set up a separate firm. I feel that a basis under which I pay a sum approximating to the whole expenses of running the office is amply generous.
>
> Clearly on such a basis the Firm are 'in velvet'. Clearly we are not that much extra trouble to an Office which has to be run in any event. Clearly we make a contribution to the common stock of ideas & clearly we could run our own office for considerably less than the amount I propose to pay. The 1942 adjustment . . . paid both parties handsomely. We work hard & take our business seriously. With similar work & in association with us the Firm is in a position to retain as profit 100% of their own business. Can more reasonably be asked?

Apparently not, for Perry had his way. A new agreement, reached in August 1946, provided that from 25 March that year the firm should have 50 per cent of the first £5,000 of the team's gross commission less salaries and special expenses. After that, the firm's share was to drop to 40%, 30% and 25%, as gross commissions rose in steps of £5,000, until on any excess over £20,000 the firm was to have 20%. Correspondingly, the share allotted to 'S.J. Perry and his personal staff as directed by S.J. Perry' rose from 50% to 80%. The new terms were set out in a letter from Perry to Phillips & Drew's other main partners (Geoffrey Drew, Charles and May, with David Drew having decided to retire from the City). These partners signed it. There could hardly have been a clearer demonstration of who was the master now. Presumably in all good faith, Perry in this letter indi-

cated that henceforth he would ask no more of the firm. 'The financial arrangements now set out,' he declared, 'are intended to be permanent in the sense that for myself and my personal staff I visualise working on them indefinitely without further revision.'

The post-war City was not a happy place. Internationally the dollar reigned supreme; vast debts had been incurred in fighting the war; many foreign investments had been liquidated; the domestic industrial base was ravaged; and within the Square Mile itself, not only were several of the main markets (including foreign exchange and gold) likely to remain closed for several years, but also the continuing existence of the Capital Issues Committee meant that for a long time to come the floating of foreign issues in London would be severely restricted. Nor was the mood music helped by the landslide election of a Labour government committed to a programme of widespread nationalisation that, in a series of strokes, would seriously diminish the scope of the stock market, removing major categories of popular investment. Inevitably, with personal rates of taxation rising markedly, it was the downturn in private client business that most adversely affected stockbroking firms – of which there were still as many as 300 or so, the great majority with only a few partners, perhaps a dozen staff, and little capital. By the late 1940s many of these firms faced an uncomfortable combination of falling volume and rising costs.

However, for those firms, such as Pember & Boyle, with a good institutional gilt business, the immediate post-war climate was significantly less gloomy. Not only had war enormously enlarged the gilt-edged market (so that whereas in the 1930s 'British Funds' had represented about 35% of the nominal value of quoted securities, by 1946 the proportion had risen to 56%), but the very process of nationalisation accentuated the trend, as fixed-interest stocks were plentifully issued alongside traditional gilts in order to compensate the former owners of the Bank of England, civil aviation, the coal industry, cables and wireless, electricity, gas, the railways and a good deal of road transport. Even in 1945, turnover on the Stock Exchange comprised roughly 85% (£4 bn) in British Government stock, compared to only 15% (£0.7 bn)

in non-government securities. In sum, there was greatly increased scope for the insurance companies and other institutions as investors in the gilt-edged market – and greatly increased scope for any stockbroker who was competent to take their business.

In practice, not very many were competent, and in particular gilt-switching remained an arcane mystery to most on the Stock Exchange. Lewis G. Whyte, in his seminal *Principles of Finance and Investment*, written at the end of the 1940s, sought to explain matters. He identified four main types of switching. 'Anomalies' was the first. 'This applies to stocks which are similar in most material respects, but where one shows a better yield than another and where such anomaly can be expected to disappear in course of time.' The second was 'Taxation', which 'relates to exchanges from one security to another in order to obtain a better *net* yield to redemption'. This net yield was 'calculated according to the investor's basis of taxation', with 'such gain in yield being due solely to the incidence of taxation'. For example, '3% National Defence Loan 1954/58 may give the same gross yield to redemption as 2½% National War Bonds 1954/56, but to a bank the former, if quoted at a premium, would give better value, since the loss on redemption would rank as a deduction for tax purposes'. The third type of switching was 'Contingent Gain'. This, according to Whyte, referred 'to exchanges where no increment in yield is achieved but where an advantage (as regards relative prices) can be expected in the event of yields moving in a certain direction', with comfortingly ' no loss being incurred should they move in the reverse direction'. Finally, there was what Whyte rather chastely called 'Taking a definite view'. Namely 'if the opinion is formed that long-term yields are likely to fall, then it should prove profitable (if the view is correct) to exchange from short-dated into medium-dated stocks or *a fortiori* into long-dated or irredeemable stocks.' The fourth approach to switching, he added, was the likeliest to produce 'large gains or large losses'.

This was the mental world that Locatelli inhabited – and, no doubt, discussed with Sanger of Royal London during their almost daily lunches. It was a connection that remained as crucial as ever to the financial well-being of Perry's team.

In the financial year ending March 1947, for example, business for Royal London produced commission of £37,489 – just over 65% of the team's total commission. What would happen if, for any reason, the Royal London business was lost? It would have been uncharacteristic of Perry not to have contemplated the possibility and, accordingly, to have wanted to broaden his client base.

This was surely the context in which, in March 1947, an apparently unlikely recruit was brought into Perry's team. This was an Australian called Neville Williams, already in his early fifties. He had been on the Stock Exchange since 1931, working at first for Bevans, where he got to know Perry. Indeed, it was quite possibly the fact that he became a partner ahead of Perry that was the final straw in prompting Perry to look elsewhere. Williams left Bevans in 1942 ('They were too Etonian for me,' he recalled), spent some time on half-commission with a small firm called Hodgson & Co, and then later in the war joined the medium-sized brokers Norris Oakley. Williams effectively ran the firm for the rest of the war, but subsequently fell out with the partners returning from active service. At this point, it seems, Perry asked Williams if he would like to join his team, though accounts differ as to who approached whom.

Over the years the dapper Williams was by no means everyone's favourite person, tending as he did to blow hot and cold about people as well as believing in an old-fashioned way that execution was a mere appendage to the real business of stockbroking, which was the securing of clients, usually through a social introduction. Nevertheless, he did bring two vital things to the team and therefore to Phillips & Drew. The first, most tangibly, was his list of clients, of which the one that really mattered was Colonial Mutual, a big Australian insurance company. Others included Australian Mutual Provident and London Electric Wire.

The impact on the balance of the team's business was immediate. For the financial year ending March 1948, Royal London's share of commission was reduced to 39.2%, while the clients that Williams had introduced were responsible for 27.3% (£18,304). From April 1948 Williams's clients were integrated into the dealings of the team as a whole, as he himself became a partner in the firm; and the team's

commission take for the year ending March 1949 showed Royal London ahead on 36.6%, followed by other insurance companies (23.3%), pension funds excluding the National Coal Board (21.2%), and the National Coal Board's pension fund (7.4%). Royal London, in other words, was still the single most important client, but the balance was now far healthier. The other important element that Williams brought was in its way equally vital, if less tangible. His arrival, in Weaver's subsequent words, 'helped to improve our image. We had none of the connexions of the princely firms such as Pember & Boyle, Rowe & Pitman or Hoare & Co and at that time were something of a shabby poor relation compared with the large long-established firms. Williams had an attractive and intrusive personality and his connexions helped to raise our status.' Certainly, the sociable and gregarious Williams, with a very desirable flat behind Harrods, prided himself on his range of contacts, both social and business. That, after all, was how stockbroking traditionally worked, and he was a pretty good exemplar of the rather better sort of old-style stockbroker.

Perry's juniors would not have been human if they had not nursed some misgivings about Williams's arrival. To quote Weaver again: 'This caused some heart-searching on our part, for Williams was older than the rest of us and had built up a fair volume of business, so it seemed that he was coming between us and the succession to S.J.P.' For the moment, though, the succession question could wait.

There were during these years three other significant recruits to Perry's team, each of whom had a long-term future at Phillips & Drew. Jonathan Rashleigh, who came early in 1947 to help Potter on the equity side, was typical in that he was a qualified accountant, unusual in that he had been to public school (Lancing) and had some private money behind him, his family having once owned Menabilly. Already in his mid-thirties, he had qualified shortly before the war and then gone straight into the RAF on a short-service commission. After the war, mainly spent as a pilot in India, he had had a spell in industry and a refresher course in accountancy, before successfully answering an advertisement to be Potter's research assistant, reputedly getting the job ahead of the Prime Minister's nephew.

The second of the trio had also been a pilot in the war. An Australian who had served in the RAF, most notably as a member of the Pathfinder Force, Wing Commander Peter Swan, DSO, DFC and Bar, was only twenty-five when the war ended. His intention was to return to Melbourne, where before the war he had started to train to become an accountant, but his plans were altered by meeting his fellow-Australian Neville Williams at a dinner party. The two hit it off, and in due course Williams got Swan a berth at Norris Oakley. When Williams moved to Phillips & Drew in spring 1947, Swan followed that summer, joining Potter and Rashleigh on equities. He was seemingly as much a fish out of water in Perry's team as Williams himself, but in fact he had already started part-time at the London School of Economics, after four years achieving an economics degree and thus bringing himself more or less into line, in the matter of professional qualifications, with the other young or youngish members of the team. He also had such a warm and outgoing personality that he tended to make the matter of qualifications seem irrelevant.

The third new man, by contrast, was an archetypal Perry recruit. Henry Cottrell, in his mid-twenties when he joined in August 1948 (starting on the debentures book), was the son of a clerk, was educated at a grammar school, and became an actuary in 1947 after service in the RAF. Prior to coming to Pinners Hall he had brief spells in insurance and industry, working as an actuary for the GEC pension fund, and significantly he had met both Perry and Weaver through an economics study group run by the Institute of Actuaries – suggestive of the value to an ambitious young man of professional as well as social connections. Like Rashleigh, he came to Phillips & Drew in response to an advertisement, in Cottrell's case in the insurance press; and both men were attracted away from the security of a professional career and towards the perils of stockbroking by the generous bonuses that Perry offered them.

Perry's pre-war trio were, meanwhile, entering their prime. Pending the enactment and enforcement of the 1948 Companies Act, equity analysis was still at best embryonic and Potter, who was in charge of equities, relied heavily on the Stock Exchange's *Year Book* for 1933. His test of

whether Phillips & Drew would recommend buying an equity was whether the company in question had managed to get through the slump of the early 1930s without passing its dividend, and the book told him the answer to that fundamental if not exactly forward-looking question. It was an approach quite unlike that of the mercurial Locatelli, who kept more or less everything in his head and had a telephone as well as a personal manner that few clients could resist. For Weaver, these were the years in which he should have come into his own, but he was not quite able to do so. The problem was his wartime record as a pacifist, which meant that the Stock Exchange in the years immediately after the war refused to accept his successive applications to become a member. As a result his position became somewhat uncomfortable, since membership of the Stock Exchange was an essential prerequisite of being made a partner. For some time he worked on the gilts side in daily contact with clients – including Colonial Mutual's very active investment manager, John Riley – but it was an ominous moment when one of the newer clients refused his advice on the grounds that his name was not on the notepaper. For Perry himself, who loathed bigotry, this refusal of the Stock Exchange to make Weaver a member must have been a disturbing development; but at this stage neither he nor Phillips & Drew as a whole had the City weight to be able to persuade the Council to change its mind. The difficulty over Weaver may also have had the effect of persuading Perry to delay his own retirement, while he waited to see how things worked out.

Operating from separate rooms, the 'team' continued to co-exist rather uneasily with 'the old firm'. In the latter, Charles was effectively senior partner in the post-war years; Geoffrey Drew did not want much more than a quiet life. Even more autocratic and disliked than he had been before the war, Charles did bring in one significant business-getter for the future, in the person of H.R. ('Bill') Hall. He had worked for a small firm of brokers (Moritz & Blyth) before the war and served with Charles during the war in Antiaircraft Command (Hall a young captain, Charles a rather elderly second lieutenant and not best pleased). In 1946, in his late twenties, he had come to Phillips & Drew on a half-commission basis, determined to build up his own private

client business – not an easy thing to do in the prevailing climate. By this time, with May having become an office-based partner during the war, the firm had two dealers on the floor of the House, where they did business for Perry's team as well as for the firm. One was Beard, whom Perry increasingly managed to draw into his own orbit; and the other was Geoffrey Drew's son, Jocelyn, a much more avuncular figure than his father and known to everyone as Jos. The salary as a dealer was only £550, roughly half of what Drew had been getting as a major during the war, but he managed to get a rise from Charles by persuading Norman Smithers of the jobbers Akroyd & Smithers to offer him a job at £750. Still, even £550 a year was a pretty good salary in comparison with what was on offer to the clerks in the general office. The experience of Phin was probably fairly representative when, still in uniform, he went to Pinners Hall at the end of the war to discuss his prospects. He could return to his job, he was told, and was offered £3 10s a week, which with bonuses would probably get up to £5. 'Even for those times,' he recalled, 'it was bloody rotten wages.' Phin, however, accepted, well aware – having lived through the 1930s – that a job was a job.

Charles apparently used to refer to Perry's team as 'the circus', and by the autumn of 1949 there seems to have been ill will on both sides. Against a background of his team's net total of commissions, after expenses, running at some £85,000 a year, over four times the firm's comparable net figure of £20,526, Perry was minded to bring matters to a head. Williams would later claim that it was he who pushed Perry to do so, while it seems that the immediate occasion – or perhaps pretext – was the firm's decision to make Jos Drew a partner, after Potter but ahead of Locatelli, Rashleigh, Cottrell and of course Weaver. Presumably in response to mutterings from Perry and perhaps also his associates, Charles wrote to Perry that October in largely negative terms:

While I am far from suggesting that P. & D. is incapable of improvement, I cannot accept serious criticism of the organization, of the House, or routine, which is after all that upon

which your business has been built up. These are minor points easily capable of solution within the existing framework if you desire it. . . . It seems clear, however, that what you really have in mind is to obtain complete control for large scale expansion, and while I appreciate that this experiment would certainly stand a greater chance of success under our name, it seems to me, and to my Partners, that it is to nobody's advantage to undertake it at the present time. . . . I would only stress that what you are seeking to obtain is the name, goodwill and reputation, of the Firm, which is largely an intangible asset, or, in other words, that no offer based strictly on the figures is at all likely to be acceptable to me.

Perry replied in November with a direct challenge to Charles and the firm:

I agree that the building up of my business has depended on there being a House and routine organisation behind it and it could not have been done without it. But the actual building up has been the work of the team. The House and routine organisation was more or less adequate whilst our volume of business was smaller, but it has not kept pace with requirements. We do not think anything less than a thorough-going re-organisation will create conditions where the inefficiencies are abolished and do not re-emerge. We must fit the underlying organisation to the business and not the business to the organisation. We think that for the volume of business we now do, the indirect management arrangements have become unsuitable; that management will work permanently only with a staff directly responsible to us and for whom we are directly responsible. While the inefficiencies of the present organisation are the immediate cause for raising the question of control, they do not touch the fundamental point that one-quarter of the business controls the organisation and in some ways affects the development of the other three-quarters.

What we have in mind is the expansion of our business which is natural to it in its present stage. In addition to the natural growth which the insurance and pension fund business seems to possess, as a separate firm with control of the bank balances we reckon we should have, for instance, considerable chances of adding a much more substantial

bank business than the Firm now gets. We are not out to
experiment but to build up good business cautiously on the
strength of, and in extension of, our existing connections.
There would clearly be advantages in continuing our business
under the Firm's name, but in our view it is not fundamental
to do so. To me, personally, I agree there would be negligible
net advantage (and possibly disadvantages) in any changes
made but I cannot balk the ambitions of the rest of the team,
to whom there would be considerable eventual advantages.

There followed some detailed proposals about the financial
arrangements that would be involved in Perry and his team
gaining control over the firm as a whole. He then concluded:

In putting forward these proposals I am very sensible of the
fact that the organisation owned by the Firm provided a basis
on which it was possible to develop our business. I agree that
the name, reputation and goodwill of the Firm were always
satisfactory, but we have contributed very substantially to
raising its status and earning power, which would fall again
correspondingly if it were impossible to come to terms. To us
it has been gradually becoming evident that eventually we
should have to face the question of having our own organisa-
tion and that the difficulties of making a change would not
decrease as our business grew. Further, I have little doubt that
the future lies with the big firm doing an institutional busi-
ness, with lessening prospects for the smaller firm catering for
private clients. I doubt whether the Firm's profits without us
would average £10,000 per annum in future. If this summing
up is accepted I think the proposed terms must be considered
generous, which is what I intend them to be.

There was little more to be said. Broadly accepting Perry's
offer, Geoffrey Drew and Charles arranged comfortable
terms for themselves, protected the interests of May and
others for whom they felt responsibility, and eased them-
selves out. Nominally they remained partners for a little
while longer, but in practice 'the firm' was gone, while 'the
team' remained. From the start of the new decade, Perry and
his associates were in full control of the business which still
went under the name of Phillips & Drew. It had been an

increasingly absurd situation, in which the tail had been wagging the dog ever more vigorously, and the prevailing mood in Pinners Hall at the start of 1950 seems to have been a judicious mixture of relief and optimism.

[3]
Perry's Firm

The 1950s was the decade in which Britain, along with the rest of the capitalist world, began to experience the biggest boom in modern history. It was set going by unprecedented technological progress, by a much freer system of world trade than had existed in the 1930s, and by the economic power (undamaged by war following the end of the Korean War) of the United States. The boom was to last, with minor fluctuations, for almost a quarter of a century. As always with a boom it took some time for the fact to be appreciated, but in 1957 the Prime Minister of the day, Harold Macmillan, expressed famously what was about to become the conventional wisdom when he declared that 'most of our people have never had it so good'. Inevitably the City of London benefited from this boom, whether in terms of the equity market, or of corporate finance, or of trade finance.

Nevertheless, as a place, the Square Mile seemed, broadly speaking, to be stuck in a time warp for much of the 1950s. Family, social connection and access to inside information still carried by far the greatest weight; there was little sign yet that London was going to claw back from New York its lost influence as an international financial centre; and dynamic newcomers like Siegmund Warburg were treated with a mixture of alarm and condescension. 'Nobody in the City of London will listen to you until you're forty,' Antony Hornby, senior partner of Cazenove's, explained to one of his young partners in about 1957, and that may have been an underestimate. Nor, in terms specifically of stockbroking, was the prevailing ethos very far removed from that of, say, the

Edwardian era. It was an ethos vividly evoked in the recollections of George Nissen, recorded in the National Life Story Collection of 'City Lives'. He went to Pember & Boyle as a young man in 1953 and became a partner three years later:

> Speculation and making money was the name of the game. The idea of dealing PA [for personal account] was totally accepted and there was very little control over what you did for yourself. Nobody thought that it was a disgraceful thing if you got a tip from somebody who really knew something about what was going on in a company; there was nothing disgraceful about helping yourself to a few shares if you possibly could. . . .
>
> The Stock Exchange was its own little world. There were all sorts of jokes and pranks. Occasionally there was a small amount of rough-housing, but not much. There was an enormous amount of flicking of paper darts, quite childish in a way. On Fridays, there was one old boy who used to come in after lunch and a great sort of shouting went up and everybody starting singing. By the time I got there, the House closed at 3.30. At 3.15 a rattle started and smoking was permitted and everybody lit up. . . .
>
> As a Blue Button I was the lowest of the low. You were expected to pick everything up and the idea of being taught was not accepted. You had to try and persuade your seniors in the dealing Box to tell you which jobbers dealt in which shares and then you tried to remember who worked for Akroyd & Smithers or Bone Oldham or whoever so that you didn't make a fool of yourself going to ask the wrong person. It didn't help the competitive process at all. The people who felt they would probably spend their life on the floor accepted these conventions and probably never really questioned them. . . .
>
> Drinking was very much part of life. There was a huge amount going on all over. I don't think it led to horrendous errors although I'm sure it affected people's mental agility. On the Stock Exchange floor you were expected to go across to the bar and have several drinks at 12 o'clock in the morning and then have a heavy lunch. There was a lot of drinking in the lunch-room. Some people were known to enjoy several

glasses of brandy after lunch, having had two gin and tonics before and several glasses of wine. That was pretty standard.

It was an agreeable life, then, in an agreeable, slowly declining club. It was the very reverse of the ethos that permeated the ambitious firm located in Pinners Hall.

Perry was effectively in charge of Phillips & Drew from the start of the decade, and formally senior partner by 1952 at the latest, but during the 1950s he manifested few visible signs of working hard at the job. He would come up by train from his flat in Hove, get to the office between 10 and 11 a.m., deal with some correspondence, and then settle down to the crossword in *The Times*, usually with Williams, who sat opposite him at the desk at the end of the long room. On most days he and Williams would also lunch together at the Gresham Club, and Perry would then return to the office until leaving at about 4.30.

Although he did little business himself, however, he kept a pretty close eye on what was going on. Above all, in his quiet and decisive way, he did not waiver from his goal of continuing to build up a team that would not only develop the business but which he could safely entrust with it when he decided to retire. It was in accordance with that goal that, in order to leave more for the junior partners and also to be able to recruit staff as the firm grew, he took out from the profits a maximum of £15,000 a year, although he was entitled to much more. In addition, determined that Phillips & Drew would not become the typical Stock Exchange family firm, and having no children of his own to sway him, he introduced the cardinal rule early in the 1950s that no member of the firm was to be allowed to bring in a relation. The contrast with the rest of the City at that time could hardly have been more striking, and it was this almost revolutionary refusal to countenance nepotism that did much to shape Phillips & Drew's distinctiveness as a firm over the next thirty or so years. Instead, he wanted the best-qualified people. Significantly, this was not only because he believed that this was where the future of stockbroking lay, but also because of his concern that, should the firm fail, it might be difficult for unqualified people to find jobs elsewhere. The supreme qual-

ification, in Perry's eyes, remained the actuarial one, and he solemnly told Cottrell that he should never give advice to clients unless he would be prepared to defend that advice to his professional colleagues in the Hall of the Institute of Actuaries. Stockbroking, Perry believed (with Weaver in full agreement), should become a genuine profession in its own right, to be run along scientific and meritocratic lines. This is not to say that he despised the profit motive – far from it. Rather, he had a vision of stockbroking's future, and he wanted Phillips & Drew to be in the vanguard of it.

One of the first things that Perry did on taking control was to sort out the staff arrangements, in particular putting salaries and bonuses on a rational, well-understood basis. Helped by Cottrell, he also tackled the pension situation. Hitherto the firm had subscribed to the Stock Exchange's scheme which guaranteed £100 a year, which even then was not very much. The firm's own, more generous pension scheme came into force in 1952, and four members of the staff who were due to retire in the course of the decade were each promised two-thirds of their final salary. In general, Perry took an enormous amount of trouble over both partnership and staff arrangements, and he was always particularly concerned that would-be recruits should know exactly what the score was as they decided whether or not to come to the firm. When Bernard Bavister, for example, was on the point of being recruited in 1951 from another stockbroking firm, Shaw, Loebl & Co, in order to do basic figures for the partners, he was told that, not being professionally qualified, he could never become a partner – although in the event, Bavister did become a partner after Perry's retirement. And in October 1952, when Cottrell put forward the claims of a Scottish actuary called Ian Macaulay who for the past four years had been working for the pension fund of the Merchant Navy Officers, Perry, ahead of the interview, drew up some points to put to the potential new recruit to the gilts desk:

Rewards and Risks of S/E Work as compared with present post:
 Considerably greater earnings on a strictly competitive basis
 Probably greater and uneven physical and mental strain
 Necessity to save:
 1. for provision of capital for business

2. for old age
3. against general risks of instability or cessation

Health:

Question of ability to stand stresses and strains
Advisability of giving up a 'Deb' for an 'Ordinary' if health gives reasons for doubt

If he still proposes to change to a stockbroker's life we hope he will join us.

The team has been hand-picked, works well, is paid well, merit having been proved. The atmosphere is one I am proud of.

Members, as they have joined, have taken the risks of the then future and are reaping the rewards of successful adventure. He must not be envious of the takings of the earlier entrants – he also is likely to be well paid as he proves his merit.

Our suggestion is £1,500 per annum till end-March 1954 – one year's probation – and if we cannot pay him £2,000 from end-March 1954, it would not be worth his while to stay.

We do not want to take on anyone unless they have a full intention to stay with us for good.

With business growing and the firm expanding, Perry was keen by 1954 to get the whole administrative process, including recruitment, onto a more orderly and 'civil service' basis. With that end principally in mind, the firm that year took on as 'General Consultant' a well-known actuary called Fred Menzler. He had just retired from London Transport, where he had enjoyed a wide range of important responsibilities and introduced the practices of what was known as 'operational research' into the planning activities of the board. At a time when management was extremely haphazard in most stockbroking firms, this was a significant appointment, though arguably it introduced into the firm a rather stronger strain of the civil service culture than was healthy. Under Menzler, recruitment of those who might be viewed as ultimately having partnership prospects broadened out to Oxbridge graduates, though still with a strong sprinkling of actuaries and accountants. Indeed, two Oxbridge graduates, neither with a professional qualification, were already on the

strength by autumn 1954. One, John Taylor, had read mathematics at Oxford before going to Equity & Law, where he started taking his actuarial exams, though with little success. His father, however, was an actuary who knew Perry, and that helped to secure him a berth at Phillips & Drew. This in fact was arranged before Menzler's arrival, whereas the other young 1954 newcomer, Anthony Twist, was a Cambridge graduate (economics) who had worked at London Transport under Menzler, who now brought him along to the firm as his intended assistant.

Yet for Perry himself, even after the advent of Menzler, staff questions continued to be a major preoccupation. In spring 1955 there was circulated a 'Memorandum to the General Staff from Mr Perry':

The Partners are very concerned at the way routine office work is lagging behind schedule; with an apparent lack of efficiency and interest in their work shown by a number of individuals. It is lamentable that since last summer it has not been possible to balance accounts without substantial external help; errors have been made in ledger postings which have not been traced and rectified, wrong 'pick-ups' passed etc. . . . The Partners on their side have taken care to see that salaries have been maintained at a good standard; pension arrangements have been improved and bonuses have been good. We are disappointed that there has been so little response to the offer of salary increases for those who obtain certificates for knowledge of Stock Exchange working. . . . The Staff should know that while we receive many appreciative comments on the quality of our investment advice and service we have recently been receiving an increasing number of complaints regarding the routine side, and there are doubtless further errors and deficiencies which are not reported to us. . . . I am proud of the achievements of the business getting side of the organisation, which has largely been built up under my auspices. It is due to efficiency, keenness, a willingness to help one another and the avoidance of petty jealousies. I want to be equally proud of the routine side. When I first came to the firm I was impressed by the excellent staff spirit which then existed although salaries were on a relatively lower basis and (older members will remember) bonuses were also lower.

Today too many are imbued with a spirit of 'how little need I do and how much can I get' to their own detriment and that of their fellow staff members. In the improved conditions today one would expect that the staff spirit would be better, not worse, than it was then.

Perry genuinely saw himself as a father figure, for the most part with good cause, and it is unlikely that the disappointment was feigned.

The firm's net profit was broadly on the up in the early 1950s: £89,591 in 1950/1, £88,906 in 1951/2, £109,772 in 1952/3, £147,045 in 1953/4. These were the profits available to be shared between the partners, of whom there were nine by spring 1954 – Perry, Williams, Locatelli, May, Potter, Jos Drew, Rashleigh, Cottrell and Beard. Beard by this time was the senior gilts dealer and, a capable operator, did the firm a lot of good through his close relationship with Herbert Wilson of the jobbers Wilson & Watford, at that time behind only Wedd Jefferson, Akroyd & Smithers and Francis & Praed in the gilt-edged market. In that market there was no shortage of turbulence during the first half of the decade, as the Stock Exchange itself recalled soon afterwards in its evidence to the Radcliffe Inquiry into the monetary system:

For permanent investors in the gilt-edged market, the many years [going back to 1932] of 2% Bank rate and the long succession of the 3% issues had induced a feeling that 3% was indeed a basic interest rate. The re-introduction in 1951 of the Bank rate as a monetary weapon, therefore, came as something of a shock, and many institutional funds had to revise their portfolios drastically. The first half of 1952 accordingly saw markets in which large quantities of undated and long-dated stocks were jettisoned in favour of those with medium short maturities. Although the market recovered in due course, undated stocks had lost their attraction, and the emphasis was mostly on stock of middle date. So much was this the case that more than a year later the authorities took advantage of the improvement in the market to issue over a period of fifteen months a series of loans ranging (with one exception) over maturities between 1957 and 1969. Hardly, however, had this series been concluded than a new credit

squeeze hit the market with Bank rate rising rapidly from 3% to 5.5%, and heavy selling was encountered.

On this occasion the brunt of the selling fell on the middle-dated stocks which had so recently been put out by the Treasury. In the first six months of 1955, the investments of the Clearing Banks fell by £225 m.

Dealing in gilts, primarily for institutions, was now the main source of income for the firm, much as it had been for Perry's team since the late 1930s, and Locatelli in this post-1951 environment was in his element. Granted that he was probably earning at least two-thirds of the firm's total commission, it is worth reiterating his qualities. To his professional skill (based on his training as an accountant) he added great energy, a personality at once forceful and charming, and a memory for detail combined with arithmetical dexterity that enabled him to carry intricacies of the gilt-edged market in his head rather than on paper. He could, admittedly, be somewhat highly strung, and it has been claimed that he overdid the switching, even getting himself into something of a mess with Royal London, reputedly involving fictitious prices. Nevertheless, with his manifest brilliance, quickness and aggressive business-getting, he was a remarkable man and a huge asset. Locatelli's partners liked and admired him, while to the juniors his Italian flair was almost bewitching, as they listened to him on the phone. In the apt words of someone who joined Phillips & Drew in 1954, 'his spirit permeated the office'.

From the mid-1950s we have reliable figures for the business as a whole, and as one would expect over four-fifths of it was institutional. Which exactly were those institutions? It is impossible to give a complete answer, but if, for example, one looks at the monthly average of commissions earned and bargains done for the six months to March 1955, the overall pattern is clear: virtually three-quarters of the total monthly take of £20,956 came from a mixture of insurance companies and pension funds. Most of the remaining quarter came from a mixture of private clients and clearing banks (especially Barclays and Lloyds), with very little coming from such 'old City' sources as investment trusts or merchant banks. Of the £9,509 brokerage derived from insurance companies, over a

third (£3,504) came from Royal London, followed by Colonial Mutual (£1,803), Refuge (£1,161), and Australian Mutual Provident (£594). As for the pension funds, which contributed a monthly average of £5,588, there was no equivalent dominant client; the three leaders were the Merchant Navy Officers (£736), the Bradford Dyers' Association (£706) and London Electric Wire (£365). By this time the pension fund aspect of the investment scene was ripe with possibilities, as properly funded pensions, formerly rare, quite rapidly became a standard feature of salaried employment, and progressively of wage-earning employment also. For the smaller employers, life insurance companies would devise pension schemes, but the larger employers increasingly took to running pension funds of their own. These pension funds demanded very much the same kind of service from stockbrokers as the insurance companies did on their own account, and for stockbrokers able to provide the service they called for, the potential existed for pension funds to become a large source of business.

At Phillips & Drew, there were several key components that lay behind the firm's move into a field that was almost virgin territory in the first half of the 1950s. One was the typically energetic Locatelli, who spent an increasing amount of time on the road securing clients. Another was the less sustained but still useful role of Williams, who in particular made a visit to the United States in the course of which he met Forrest Mars and, he would always claim, managed to land the British part of its pension fund, although almost certainly a consulting actuary, Gordon Hosking, also played an important part in the story. And indeed, the third element, perhaps the most vital, was the input of consulting actuaries such as Geoffrey Heywood and Max Lander, who steered the trustees of many pension funds towards Phillips & Drew, in the knowledge that those funds would be serviced by a team of reliable actuaries and accountants, which would not have been the case at almost any other London stockbroking firm. 'The future lies with the big firm doing institutional business,' Perry had predicted in 1949, and the explosive growth of pension funds fitted foursquare into that vision.

Meanwhile, directly affecting institutional behaviour, there was starting to become apparent by the early 1950s the

phenomenon that would be tagged the 'cult of the equity' – a phenomenon that had been anticipated as early as 1927 in a paper given by H.E. Raynes to the Institute of Actuaries about the benefits of institutional investment in equities. At least four principal factors lay behind this phenomenon. One was nationalisation which, although it added to the size of the gilt-edged market, killed off such familiar and well-trusted securities as home railway debentures; another was the Companies Act of 1948, which much reduced the taint of riskiness traditionally attached to industrial equities and showed many shares to be substantially undervalued; a third was the government's relaxation of its policy of voluntary dividend restraint; while the fourth (and most important) was the larger economic background, with a mixture of high taxation and the beginnings of persistent inflation leading to a greatly increased investment appetite for capital gains.

There are various claimants to the title, but the man most commonly associated with implementing the cult was George Ross Goobey, who in 1948 was appointed as the first investment manager of the Imperial Tobacco Pension Fund. He put his fund into the shares of a long string of smaller companies and in the process attracted much publicity, which in turn helped to make the cult self-fulfilling. Other important and relatively early converts to the merits of ordinary shares included the Church Commissioners, whose wholesale switch into equity stocks was both widely publicised and widely copied. Many funds and trusts had rigid investment clauses built into their constitution, confining them to gilt-edged stock with trustee status, but in the course of the decade a significant proportion of those bodies was able to seek and obtain relief from such restrictions. As early as the mid-1950s, with the first of the post-war equity bull markets reaching a climax in 1955, it was obvious that, despite the tardiness of some institutions in making the move, ordinary shares had entered the very mainstream of investment. It was a trend confirmed by the changing shape of the domestic capital market. Whereas in 1950 some 56% of British company securities issued had been in the form of debt, compared to 36% in ordinary shares, by 1955 the position had been reversed, with 65% in the form of ordinary shares. Thus, as the price of Consols headed ever southwards,

traditional principles of investment, based on the assumption that money would hold its value, were stood on their head. The Stock Exchange disasters of 1929 and the early 1930s in New York and London faded – almost – from memory as ordinary shares, formerly regarded as the gambling counters of the rich, began to look like a safe home for small savings, especially if the risk was spread across unit trusts, life insurance or pension funds. The cult of the equity, in short, had come to stay.

Phillips & Drew, though remaining primarily a gilts firm, was somewhere near the forefront of all this. Potter – quiet, extremely competent, rather grey – was in charge of the equity department, but probably the more important figure in terms of responding to new possibilities was his research assistant Rashleigh, who became a partner in 1951. Almost certainly this was a reward for his pioneering work in the wake of the 1948 Companies Act. In particular, he began to produce a half-yearly publication, *Selected Industrial Ordinary Shares*. Attractively printed by the Curwen Press and with a layout that set the house style for many years, it showed returns on capital employed for leading companies over the previous ten years, which would have been impossible without consolidated accounts. Harold Wincott, Editor of *Investors Chronicle*, drew attention to this publication each time it came out. It was not then permissible for a Stock Exchange firm to have its name published, because of the ban on advertising, so Phillips & Drew had to be camouflaged as 'a leading firm of stockbrokers'. This was really the start of Phillips & Drew's wider reputation as serious scientific stockbrokers and was a major contribution on the part of Rashleigh. Not remotely an intellectual, but with a shrewd mind and determined personality, he was among the very first to exploit the 1948 Act and go way beyond the traditional approach of (in his own phrase) 'by guess and by God'. Moreover, after becoming a partner, Rashleigh also started producing regular publications that analysed the performance of investment trusts, using a pioneering system of evaluation that would hold good for at least two decades. This in turn led to the firm doing a lot of placings in investment trust shares, for both jobbers and institutions.

Rashleigh, however, was temperamentally no salesman,

unlike the other main presence on the equity table, Swan. It perhaps took Perry some time to appreciate the qualities of Williams's fellow countryman. 'We do not feel that he can be admitted to partnership yet,' he noted in March 1953, adding that 'he needs to learn much more yet & to mature in his judgments & approaches'. Swan himself found this hard to accept. His points were paraphrased by Perry in his notes on their talk: 'During his early years with us life had been tough & he had worked hard both to get his degree & in the business. He would like more opportunities to be given to him to prove his capacity. The going might not be so good in future years & in this case he might have had the hard years, missed the good ones & share fully in only leaner ones.' Perry did not budge, and Swan had to continue to prove himself.

There was one other important component to the jigsaw of the early to mid-1950s, and that was the changing role of Weaver. A year or so after Macaulay's arrival, he decided to take advantage of the opportunity to leave the gilts dealing team and instead move to a back room, where assisted by Bavister he would aim to build up a research capability. This decision partly reflected an innate preference on his part for research over dealing, but it also derived from the somewhat invidious *impasse* that had been reached in relation to his wholly understandable membership and partnership aspirations. To start with, Weaver's main focus was on gilts research, though he continued to act for some of his own clients (such as Atlas Assurance) and to teach young recruits about redemption yields, earnings yields and suchlike. Weaver and Bavister also took over the preparation of some of the publications that the firm had begun to issue and started the regular publication of a selection of the growing amount of statistical material becoming available. Not a partner (though treated by the partners as one) and no longer a business-getter, Weaver's position in the succession stakes now naturally receded.

Instead, the front runners, in most eyes, were Williams and Locatelli, the latter a partner from 1952 (a year before his gilts colleague Cottrell became a partner). With a far more obviously forceful personality than Perry's, Locatelli, it seemed to some, was fast emerging as the dominant force within the firm – a position backed, of course, by his prodi-

gious commission-earning capacity. Most days he would leave the office at about 4.30, and if a partners' meeting was suggested for that time or shortly afterwards, he would say, 'Well, if you want to have a partners' meeting – you know what I think.' In practice, any decision with which he disagreed would be reversed by about 9.45 the following morning. Equally typically, before going on holiday he would hand over to his dealer his list of outstanding swaps. On his return from holiday he would telephone that dealer on the Sunday evening to find out how much of his business had been transacted. It was an enormous blow to the firm, almost impossible to overestimate, when Locatelli, still in his forties, died suddenly on 22 March 1955. A few months later saw another blow, when May died of leukaemia, but the really serious loss was that of Locatelli. The *Financial Times* carried no obituary, there was not even an announcement in *The Times*, and this book is likely to be the only permanent record of a man who deserves to be remembered.

The impact was immediate, as the partners were told at their meeting in July 1955:

It was reported that following the death of C.H.I.L. our gilt edged business had been greatly reduced. H.C.C. [Cottrell] said that he thought had C.H.I.L. been still with us that more switching business would have been done and that the last few weeks had shewn that insufficient attention had been given to gilt edged business. On the other hand the current difficult markets had to be borne in mind and our principal rivals Grievesons [Grieveson Grant] were doing very little for Royal London.

By this time Donald Overy had succeeded Sanger at Royal London, and over the next few years he increasingly did take his business to Grievesons, where Andrew Rutherford was the key figure. 'In reviewing the commissions it was reported that we were meeting severe competition with Grieveson Grant in connexion with Royal London business,' noted a partners' meeting in May 1956, while four months later 'in the review of commission earned it was noted that while new investment was up switching was down'. Nevertheless, taking

the second half of the 1950s in the round, the reassuring fact was that the firm's position in the gilt-edged market as a whole was not permanently damaged by Locatelli's untimely death. This was due partly to the steadying efforts of Cottrell, who was in overall charge, and partly to the inspired recruitment of the young Twist, who had arrived at the firm as Menzler's dogsbody but within a year found himself thrown into gilts. He soon showed a natural affinity for them, and even if he was never in the Locatelli class for drive and salesmanship, his formidable powers of analysis came close to compensating for that shortfall.

It is, nevertheless, tempting to argue that, from a latter-day perspective, gilts switching itself was still pretty primitive in the 1950s, mainly predating as it did computers and more sophisticated techniques. In one sense that is obviously true, yet it is salutary to glance at a paper, headed 'Balance of Term Calculations', that the firm sent out to clients in November 1957. 'When considering the merits of an exchange from one stock into another,' it began, 'it is often useful to examine the position at the time when the shorter-dated stock is redeemed, especially when the terms of the two stocks differ appreciably. In such a case a comparison of redemption yields may be thoroughly misleading.' This was illustrated by a case study:

			CASE 1		CASE 2
Stock	Term	Price	Gross Redemption Yield %	Price	Gross redemption Yield %
3%	20 years	100	£3 0s 0d	70	£5 9s 9d
3%	40 years	90	£3 9s 3d	63	£5 4s 3d

In both cases one can buy £100 of the 40-year stock for each £90 of the 20-year stock (neglecting expenses) so that the two positions are equally attractive and yet in the former there is a gain in yield of 9s 3d% and in the latter a loss of 5s 6d%.

In all cases where an exchange alters the annual income receivable it is necessary to make an assumption as to the rate at which the surplus or deficit of annual income will be accumulated, but once this has been done the use of balance of term techniques enables the question: 'Is it better to accept £3 0s 0d per cent for 20 years or £3 9s 3d per cent for 40

years?' to be rephrased as: 'Will interest rates for 20-year 3%
stocks stand above or below (say) 4¼% in 20 years time?'
While, of course, this does not add any fresh information, it
does crystallise the assumptions underlying a proposed
exchange. The balance of term yield, on whatever basis it is
calculated, depends only upon the ratio of the two prices and
not upon the absolute market level (given the terms of the
two stocks and the rate of accumulation of income).

We now consider the various theoretical and practical
methods of calculating the balance of term yield (or written
down price from which it can be deduced with the use of
bond tables).

There followed some fairly abstruse mathematical squiggles,
and overall it was a good example of the gilts side proactively
devising investment opportunities in order to secure busi-
ness.

If Locatelli's death involved a rejigging in gilts, so too did
May's in private clients. A certain amount of increased
responsibility fell on the veteran half-commission man
George Street (who briefly became a partner), but much
more important in the long run was that Jos Drew was
brought up from the House and, in tandem with Bill Hall
(who also became a partner), took over what became the
private clients department. Drew and Hall were very differ-
ent men, but their qualities were broadly complementary and
together they forged a close-knit partnership that lasted for
almost twenty years. 'We never knew who was in charge,'
Hall recalled, 'but we thought he was in charge when there
was a barrage to be fired, which I usually prepared, and I was
to do the negotiating side.'

Drew was in many ways the archetypal country-dwelling
stockbroker: physically big, with a rather florid face, he
looked like an old-fashioned squire – an impression
compounded not only by his generally bluff manner but by
his habit of hollering in moments of excitement. In fact,
beneath the hunting and shooting exterior, he was a shrewd
operator, though distinctly a broad-brush man who left it to
the juniors to do the detail. He was immensely well
connected, had a rather more outgoing and generous dispo-
sition than his father, and built up and retained an impressive

list of clients, including some of the big names in Lloyd's. He would also pay regular visits to the floor of the House, where – unlike almost anyone else from Phillips & Drew – he could talk to the senior partners of the big jobbing firms and get the very latest market intelligence.

Hall, by contrast, had no such assured City background (his father was a prosperous butcher in Smithfield who had sent his sons to Dulwich College), and instead what really made his fortunes was first a very good war and then an increasingly close connection, through Tom Ismay, with the Ismay family as a whole. Much less of a network man than Drew, he was assiduous in looking for new business and would give his clients very careful, risk-averse advice. Ultimately, of course, the two men were on a losing wicket, as the individual shareholder gradually declined in importance relative to the institutions. Even so, although it did not require uncanny perception in the 1950s to anticipate that trend, the fact was that in 1957 as much as 65.8% of total holdings of ordinary shares (at market value) was in the hands of individual investors. There was still, in other words, a potentially fruitful field to till, but it was not one that Phillips & Drew as a whole was much interested in. Private clients represented the past, institutions the future, and neither Drew nor Hall could shake that fundamental perception on the part of Perry and his team.

There was a third element – and ultimately perhaps the most important – to the regrouping of the firm in the wake of the deaths of Locatelli and May. At the same partners' meeting in July 1955 that it was decided to bring up Drew from the House, Rashleigh observed that there was no one person in the firm responsible for pension funds. It was a timely point. There were by then close to 8 million members of occupational schemes, representing almost a third of the British workforce, and already the previous year the brokers Fielding, Son & Macleod (subsequently Fielding, Newson-Smith) had initiated a pension fund department. A few of the merchant banks, notably Helbert Wagg, were also starting to gear up to the possibilities of developing a considerable pension fund business. At Phillips & Drew, the man who came forward to do the job was Macaulay, temperamentally not a gilt-edged switcher, and from the autumn of 1955

(shortly before he became a partner) he began to build up a department that would act not for the pension funds of big industrial companies that had their own investment managers, but for medium-sized companies, the great majority with pension funds below £200,000. The December 1956 edition of the firm's brochure on *Pension Fund Investment*, first published in May 1943, explained what was on offer:

> We have found that a demand exists from funds for a more closely integrated advisory and management service than has been available in the past. We have been able to satisfy this demand and it may be of interest to Trustees to learn of the possible lines on which such a service might be developed.
>
> The aim of this service is to relieve the Trustees, to any extent that they may wish, of the day-to-day management of the investments. The policy of the fund is decided at regular intervals of, say, three months by meetings between our representatives and those of the fund. Following one of the regular meetings it is necessary only to advise us at regular intervals as money becomes available for investment. We then carry out the agreed policy, using our own judgement on the market timing, without further reference to the management of the fund except in the event of some unforeseen contingency.

Macaulay, as an actuary himself, kept closely in touch with consulting actuaries, and in February 1957 he was present at a meeting of the Edinburgh-based Faculty of Actuaries to hear a paper by K.M. McKelvey (an actuary working for the Scottish Amicable) on 'Pension Fund Finance'. He made a characteristic contribution to the subsequent discussion:

> It may be a rather foolish remark to make, particularly in the context of a meeting like this, but it seems to me that the theory of Pension Fund investments is a relatively simple one. As some speakers have already said, not only are the future liabilities in respect of existing members extremely long term, but in addition it is reasonable to expect a continuing or even increasing flow of new members, and an inflationary increase in salaries and wages. As a result one can conveniently ignore any question of matching, and invest the funds so as to secure the maximum rate of accumulation.

Charming, easy-going, self-effacing and open-minded, as well as very good at persuading trustees not to over-react to every change in the market, Macaulay proved the ideal man to build up the department. A significant recruit to it was Harry Sparks, who had come to the firm from Cambridge in 1957.

It was not long before the department was paying serious attention to the pension funds of not only industrial companies, but also local authorities. It was, in terms of connections, a business built in large part on the firm's role since 1952 in arranging short-term loans, as wartime restraints were eased on where local authorities could borrow. In 1954, for example, Chingford borrowed £50,000 from British Belting & Asbestos at 1⅞%, Wiltshire County Council borrowed £50,000 from British European Airways at the same rate, and Caerphilly UDC borrowed £60,000 from Birmid Industries Ltd at 2%. In each case Phillips & Drew acted as the middleman, taking a small brokerage. Up to about 1957 the business was largely done by Hall as a sideline, and it brought a significant range of local authorities into the firm's orbit. From an investment point of view, however, the decisive breakthrough came early in 1958 when Manchester Corporation, the first authority to seek private powers to invest its superannuation fund in equities, selected (on the recommendation of the District Bank and Geoffrey Heywood) Phillips & Drew and Grieveson Grant as its two advisers. It was a prestige appointment, and others quickly followed. In September 1958 the firm produced the first edition of a new booklet, called *Superannuation Fund Investment*. After a lucid discussion of the different policies available to those responsible for local authority pension funds, there followed a discreet sales pitch:

> A treasurer seeking advice on investment policy will frequently consult his local bank manager but, as the banks normally refrain from giving investment advice, the inquiry will be referred to one of the large number of stockbrokers with whom the bank has contacts. Casual inquiries hardly give the stockbroker – or the banker – a chance to produce satisfactory advice, but when a practice is made of regular consultation between treasurer, banker and the same stockbroker (being one specialising in superannuation fund prob-

lems) then a sound and consistent policy can be followed. In particular the treasurer should inform the banker and the stockbroker of the details of the existing portfolio, the rate of accrual of new funds for investment, the proportion of the fund's income which bears tax and, if appropriate, of any heavy calls that will necessitate realisation of securities. Within such a framework, it is sometimes helpful for the banker to call together the treasurer and the stockbroker for a discussion of any particularly awkward problem.

These were early days, with many superannuation funds still limited in what they could do, but almost certainly Phillips & Drew was at least as far ahead of the game as any other broker.

On 14 November 1958, on the occasion of the annual conference of the Association of Superannuation and Pension Funds, Phillips & Drew invited over a hundred guests to lunch at St Ermin's Hotel in Westminster. The line-up was all-male, on each of the thirteen tables there was a partner or senior member of the firm, and those present included Messrs F.W. Bacon (of the consulting actuaries Bacon & Woodrow), D.L. Brown (of Mars), F. Gaskell (of Manchester Corporation), G.H. Ross Goobey (of Imperial Tobacco), F.W. ('Robin') Goodfellow (of Lloyds Bank, an important source of trust business), J.A. Mulligan (of Courtaulds), C.M. O'Brien (of Royal National Pension Fund for Nurses) and B.A. Williams (of Bexley Corporation). Other companies or local authorities represented at the lunch included Charrington & Co, J.S. Fry & Sons, Babcock & Wilcox, Brooke Bond, British Glues & Chemicals, Scottish Agricultural Industries, Glamorgan County, Chivers & Sons, and West Midlands Gas Board. Some of the institutions represented would have done their dealing direct through the gilt and equity desks, whereas others came under Macaulay's umbrella.

Unfortunately, we have for the late 1950s no satisfactory breakdown of the firm's commission income, but the overall impression is clear enough of an ever-broadening institutional client base. Nevertheless, the life insurance companies – the traditional backbone of the business of Perry and his team – remained crucial. We do have some figures for

commission earned by the gilts department in the financial year 1958/9, showing that of the total take of £83,800, Royal London and Colonial Mutual provided £51,200 between them, with the latter connection now more profitable than the former. Overall, the firm's net profits were continuing to rise – up by 1958/9 to £161,593, an 80% increase on the £89,591 of 1950/51. These were hardly huge figures, even taking subsequent inflation into account, but the direction was all one-way.

It is impossible to know what the exact proportions were, but undoubtedly an increasing amount of the business done by the firm in the second half of the 1950s was in equities. Among City institutions, the merchant banks (which seldom dealt through Phillips & Drew) probably came over to the merits of equities earlier than the insurance companies; but even there, there was an undoubted shift of attitude, with over a fifth of the total value of British insurance companies' assets being invested in ordinary stock and shares by the end of the decade, compared to less than 10% soon after the war. Perry himself, in successive editions of *Pension Fund Investment*, had gradually pushed up the percentage of a fund that, in his view, might legitimately be devoted to equities: from 5% in 1943 to 10% in both 1945 and 1949, 20% in 1952, 25% in 1954, and 35% by December 1956. The general trend, he noted in that sixth edition, 'has of course been greatly stimulated by post-war inflation, but it is also due in some measure to a better understanding of the dependence of the economy for its prosperity on an expanding and efficient industry'. Inevitably, opinions varied. In his paper in Edinburgh soon afterwards, McKelvey suggested that pension funds 'should now be working upwards from some 40%'; and he argued that the outlook had become permanently inflationary, not only because 'the economy is strained and will in all likelihood continue to be strained by the struggle between West and East', but also because 'full employment, meaning in practice over-full employment, is enshrined in the domestic programme of each of the two main political parties'. In the discussion, Ross Goobey was typically trenchant: 'I think the niggers in the privately administered funds' wood pile are consulting actuaries who shut their eyes to inflation.' For him, the advantages of ordinary shares far

outweighed any of the pitfalls that the more cautious
McKelvey had adduced:

> Let us take take-over bids, for instance. We are getting them
> almost weekly these days. When somebody makes a take-
> over bid of 150 for 2½ Consols I shall change my view and
> think there might be something in gilts after all. I would like
> also to put this point of view to those people who are fearful
> of dividend limitation. We have had dividend limitation in
> gilts for the last 200 years.

Macaulay, equally typically, was more understated:

> I am very pleased that Mr McKelvey has come out so strongly
> in favour of equities. My own experience agrees with the
> result of his investigation, that the attitude of trustees has
> changed and is changing all the time, not, however, without
> some pressure in certain cases. We all know Mr Ross Goobey
> to be an out-and-outer in this matter. I know at least one
> managing trustee who would be the same if he could get away
> with it. But there are an increasing number who are happy to
> hold at least 50% in equities.

On the equities side at Pinners Hall, the driving force was
increasingly Swan, a partner from 1955. He had an aggressive
approach towards business, and at least twice a week would
have a Homeric row on the phone with the firm's senior
equity dealer, Hedley Norris, who by the mid-1950s was find-
ing it hard to cope with the rapid increase in institutional
equity business. Norris, always somewhat on the defensive,
gave the impression in the market of being a penny-pincher.
Eventually, in September 1957, Perry bowed to pressure
from Potter and Swan:

> Equity Dept feel they want a dealer to work specially with
> them – one who besides [being] capable of the mechanical
> side of dealing follows market movements & trends & has an
> understanding of the economic reasons underlying them –
> also who is recognised by the jobbers to have this kind of
> knowledge & part of whose duties will be to get early infor-
> mation of lines of shares available & which Equity Dept are

likely to be able to place.

We have come to terms with Bazalgette who will be joining us on 1st Octr. We feel dealing side wants strengthening with a dealer of this calibre.

Norris and Phin [who after the war had graduated to the floor of the House] will be relieved of a certain amount of dealing & Norris will be No 1 with Bank & private client orders coming from Mr Hall's table which will enable them to do that job better.

Paul Bazalgette, who had been educated at Dulwich College, was in his mid-thirties, had been at Messels for the past seven years, and generally cut a much more impressive figure than Norris. It would be fair to say that he revolutionised the firm's equity dealings in the House, especially through his ability to execute large orders, often on a personal basis with senior jobbers. It was a crucial attribute, even if it had nothing to do with actuarial skills, and his arrival was in part a reflection of Perry's increasing concern that the firm by now needed to get itself better known in the traditional City.

The cult of the equity found its strongest, most distinctive echo at Phillips & Drew, however, in the work that Weaver and his team began to do in 1955. The story is best told by Weaver himself:

A major development from the back room was the setting up of a group to do security analysis. We should no doubt have done this anyhow in a few years' time but the immediate impetus came about in this way. For some years we had been acting as brokers to the Mars Pension Fund, investing new money as it became available in whatever seemed attractive at the moment. Mars was part of a large American group which had a generous staff benefit scheme. The American management – i.e. Mr Mars himself – decided that the investments of the British fund should be run in a highly planned way which was the current American investment philosophy, with new money directed to securities which had been comprehensively investigated, including visits to the company, dividend forecasts and the whole set out in a document known as a security analysis. I went down to Slough with Fred Menzler and we met the British end of the manage-

ment. We were told that we could have the exclusive management of the pension fund investments if we would undertake security analysis on the American lines, and to this we agreed. Part of the bargain was that we should hire an American expert, Sidney Cottle, then a professor at Georgia University, to show us how it was done. Cottle duly arrived and although he was very pleasant to work with, I don't think he had much to teach us. The presentation of his work was very good (and expensive), something which was perhaps lacking in ours.

We then set about recruiting staff to specialise in this work. We finally chose Bill Nowell, a certified accountant, who had had a varied experience, including the dangerous work of auditing Italian companies, and Alec Fleming, a chartered accountant with a Cambridge degree. Fleming was born in Germany but on account of his Jewish connexions had had to leave as the Nazis came to power. Nowell, who arrived first, did an analysis of B.I.C.C. and then Fleming, who wrote very graceful English, did one on Marks & Spencer, which was the first time the word 'bra' had appeared in an investment document. At this time we had working with us an actuary, Brian Fowler, who had a degree in statistics from University College and had also industrial experience at United Steel. I put Fowler in charge of Nowell and Fleming, and from there on our security analysis department grew rapidly.

Cottle was the co-author of *Investment Timing: the formula plan approach* published in New York in 1953, but his tutorials at Pinners Hall did not last very long. 'It was agreed that there was no need to invite Professor Cottle again next year,' the partners decided in September 1956. 'It was felt that though he has some value as a contact . . . he now had little value as an instructor.' By this time Weaver's team had already completed several in-depth analyses of major industrial companies, in each case trying to arrive at a valuation of the shares that was independent of temporary market considerations. The first completed analysis was dated October 1955, and by the end of 1958, analyses of forty-two different companies had been completed, for carefully selected distribution.

Not long afterwards, Weaver and Fowler began to prepare a paper on 'The Assessment of Industrial Ordinary Shares'

for the Institute of Actuaries. Based on work done in the four
or so years up to October 1959, it was submitted in April
1960. It began with a quotation from the Duke of Wellington:
'All the business of war, and indeed all the business of life, is
to endeavour to find out what you don't know by what you
do; that's what I called "guessing what was at the other side
of the hill".' It was a nice touch, and something of Weaver's
approach and personality also comes through in his response
to the discussion provoked by the paper:

> The weakest part of the paper was the idea of capitalization
> rates, which perhaps had not been explained in sufficient
> detail. The method was to look at the ratio of the yield on the
> shares against the *FT* yield index year by year. Surprisingly
> enough, in many companies, that ratio was fairly constant.
> The level of the financial yield might change year by year, but
> the ratio by which certain shares were valued did not change
> to that extent. It gave some kind of line by which the capital-
> ization rate could be fixed. . . .
>
> The amount of work involved was, of course, heavy, but the
> authors were doing the kind of analysis described for
> between 50 and 60 companies. There were, of course, very
> many more shares that came before investment advisers but
> each of the shares for which a full analysis had been done
> could provide a touchstone by which to judge other shares in
> a similar line of business. In addition, a 'bonus' result was that
> when the shares had been dealt with for a number of years,
> the successive work of keeping them up to date was relatively
> a good deal easier.
>
> After ploughing through 10 years' company reports and
> chairmen's speeches, and having attempted to estimate and to
> see what the company had earned and what future profits it
> could earn and what future sales it could make, an investiga-
> tor knew a great deal more about the company. That was the
> kind of knowledge which such a detailed or fundamental
> approach provided and which represented a great part of the
> value of such analysis.

Heavy work indeed, but Weaver had found his true niche
doing it. An early member of the Society of Investment
Analysts, which was founded in 1955 and of which he would

become the first Fellow, his ambition was to place investment analysis on as rational and scientific a basis as possible.

For the firm as a whole, this detailed analysis of equities was a costly exercise, in effect subsidised by the commission on gilts. Inevitably, the pay-off was somewhat intangible: a way of reaching out, through its publications, to potential new clients; a way of vindicating investment managers who had chosen to bring business to the firm; perhaps above all, a visible manifestation of the firm's professionalism. Certainly, the research capability at Phillips & Drew in the late 1950s was far ahead of that of all stockbroking rivals – indeed, most firms still barely knew the meaning of the term 'investment analysis'. Or as Weaver himself privately put it in 1961, 'Nowadays when any report on any investment topic is mentioned it is generally assumed that Phillips & Drew wrote it.' The sobering fact was that for quite a long time – certainly well beyond the late 1950s and early 1960s – it was still perfectly possible to make a good living in the City on the traditional basis of whom one knew rather than what one knew. Quite apart from anything else, insider dealing was still very prevalent on the Stock Exchange, if by definition a poorly documented phenomenon. On a day-to-day, organisational basis, there was for Phillips & Drew the question of how to integrate equity research and equity sales, which tended to be two departments inhabiting two very different cultures. Put another way, the advent of systematic, high calibre research was by the end of the 1950s an enormous feather in the cap, but it did not necessarily signify an automatic open door to massively increased profits. Tensions remained – within the firm, and between the firm and the old City – that only time could resolve.

That said, there was no gainsaying the general sense of expansion in the second half of the 1950s, once the immediate blow of the deaths of Locatelli and May had been overcome. It was not an expansion that involved corporate finance – a reflection partly of the firm's private client roots, partly of anxiety that such an involvement would inhibit research – but three areas in which significant initiatives were now being taken were fixed-interest business, foreign business and pension fund administration.

It was Bavister who from late 1955 became the firm's

expert in non-gilt fixed-interest stocks, starting with only three clients and managing successfully to cultivate a market that other firms neglected because there seemed to be no turnover in it. Debentures were very different animals from gilts: much smaller issues, higher commission, stamp duty to pay, a much slower-moving market, and altogether requiring a different approach. Many investment managers knew comparatively little about fixed-interest stocks, and though it was laborious, unglamorous work, in which Bavister developed a system of getting lists of debenture holders and then arranging sales and purchases to suit them, there was considerable business ready to be tapped. 'There was an enormous amount of stock just lying in portfolios getting dusty,' he recalled.

On the foreign side, there was little prospect of any real growth until sterling became fully convertible (at the end of 1958), but already there was an important recruit in the person of Charles Larkin, an experienced operator who had worked for several firms (including Ullmans, Vickers da Costa, and Helbert Wagg) before coming to Phillips & Drew in March 1958. A proficient arbitrageur and foreign-exchange dealer, Larkin already had a good grasp of overseas dealing, settlement procedure, shipping and currency control requirements, and initially his main task was to build on the firm's American connections, including those that had come through Cottle.

The third area of growth involved a young actuary called Bernard Fison, who on arrival at Phillips & Drew in January 1958 found himself charged with the day-to-day running of a new creation, Throgmorton Management. This was an idea of Williams's, and the basic concept was that it would be a servicing company for pension funds, thereby relieving employers of their administration. Williams also hoped that it would expand into investment management as such. Essentially it was a joint venture between the firm and the consulting actuaries Lane, Clark & Peacock. It managed the Mars fund and at times generated some useful income, but it never quite acquired sufficient clients and over the years tended to cause more problems than it was worth, and was finally sold off in the early 1970s.

Another idea of Williams's had a more direct bearing on

the firm. 'The question of the relations between partners and staff, N.H.W. feeling that there was insufficient contact,' noted the succinct minutes of the partners' meeting in July 1955, three months after Perry's vexed memorandum about the failings of the staff. Within weeks, W.E.H. Grayburn MC, FCA, was engaged for the new position of comptroller. Capable and strong-minded, it was he who over the next few years did much to upgrade the overall workings of the general office, moving from ledger books to machine accounting and complementing Menzler's work on making promotion, salary scales and suchlike more systematic. Almost inevitably, given the steady expansion of business, there was a continuing space problem, even after the take-over in 1956 of a small broking firm (E.A. Bennett & Co) that occupied an adjacent office in Pinners Hall. By the end of 1956 there were some seventy people working for the firm, including partners and back office, and Phillips & Drew was becoming one of the larger firms in the Stock Exchange. Something of the standing that it was starting to attain in the outside world is conveyed in a circular that the Secretary of the Oxford University Appointments Committee wrote about it in 1956, in the context of a 'vacancy for someone mathematically inclined':

> The firm's business is largely of an institutional character, and they operate mainly with insurance companies, pension funds and similar bodies. They are, indeed, almost uniquely qualified to do so. There are two Fellows of the Institute of Actuaries among the partners, a Fellow of the Scottish Faculty of Actuaries and two Associates of the Institute of Chartered Accountants, and their advisory staff includes four more actuaries and four more graduates in economics or mathematics.
>
> One of these advisers is my present correspondent, Mr F.A.A. Menzler, CBE, BSC, FIA, whom I last heard as a guest of the Institute when he delivered his presidential speech on taking over that office from HM Government's Chief Actuary. I doubt whether one could find in the City any other similar firm which has such a remarkable collection of professional advisers. Mr Menzler makes a point to me that what attracted him to this firm was its 'team' of professional men –

'in our studies of the field of investment there is a "research" atmosphere which I think should be congenial to the good honours graduate'.

Peter Parker (who had read mathematics at New College) took this berth, a year after Bryce Cottrell (PPE at Corpus, and no relation to Henry) had joined the firm via the same route. The Appointments Board at Cambridge also provided recruits in these years, including Sparks in 1957 and Austen Bird the following year, as one of two graduate trainees in 1958. The firm would also advertise particular jobs in the press, which was how Bazalgette and Larkin came, as did George Birks (in September 1957, from de Zoete's, initially to supplement the equity dealing side) and Michael Cohen (in March 1958, having taken a degree in commerce at Liverpool University and qualified as an accountant before spending a few years in industry). Few came as the result of an old-style personal introduction or connection. The major exception in the late 1950s was Peter Vanneck, whose father, Lord Huntingfield, was a director of Colonial Mutual and a friend of Williams. The overall thrust, however, was strongly in the other direction towards the intended creation of a meritocracy. It would not necessarily be a cloth-capped meritocracy: Bryce Cottrell, for example, had been educated at Charterhouse, Parker at Winchester, Taylor at Sherborne, Twist at Radley, and Sparks at Bradfield.

But whatever their background, few if any graduate newcomers could avoid the fundamental rite of passage of spending a few months in the 'Drapery'. This was the province of Pauline Draper, who had come to the firm in 1954 as a 16-year-old and, at first working under Weaver in the back room, had been taught yield calculations and such investment arithmetic as adjusting equity records for rights and bonus issues. Her grasp of all this was excellent, and within a few years she had her own separate department in the basement, formally known in due course as the computing group but referred to by everyone as the 'Drapery'. In a room where the only light seemed to come from the white-glazed tiles, new graduates would go to her to gain a knowledge of the basic arithmetic of investment, in the course of which they learned how to calculate yields and use

arithmometers. It was probably not quite what they had expected on leaving the dreaming spires.

Almost certainly, however, there prevailed a more stimulating, open-minded atmosphere than in practically any other stockbroking firm. There was, for a start, relatively little unthinking Toryism: that was guaranteed by the presence of Weaver and Menzler, both socialist in outlook. It was refreshing to be treated as a grown-up – as Cohen discovered quite early on when he temporarily got behind with his records and was not made to feel small – and to acquire responsibility quickly, as Birks soon found in welcome contrast to his previous firm de Zoete & Gorton. It was not exactly Wilfred Pickles, but there was undoubtedly a general feeling of people being encouraged to 'have a go' at things – for example, Macaulay with pension funds – and see how they worked out. The lavatories, it is true, were divided into those for 'principals' and those for 'clerks', but in general the firm was far less stuffy and hierarchical than the great majority of organisations in Britain in the 1950s. Perry himself remained the guiding spirit. 'I take it that on balance you cannot be sorry to be associated with a progressive business rather than a moribund one,' he told his staff and fellow-partners at a dinner and dance held at the Connaught Rooms in November 1955, the firm's first big 'beano' since shortly after his arrival in 1936.

> And though so many of the newspapers tell us what parasites we are, if you would try to make even a rough guess of the number of policy-holders of the insurance companies & the number of members of the pension funds which we serve they must run into many millions & represent a fair proportion of the population of the Country. It is not true that we predominantly cater for the rich. It is the ordinary man's interests which we serve.

Meanwhile, his approach to bringing people on was as rigorous as ever. The following April, when a junior equity dealer, P.R. Middleton, complained that despite being a graduate he was not being paid as one, Perry carefully read his letter, underlined two spelling mistakes, and in his tiny handwriting pencilled on the letter's top the draft of his response:

Graduates in qualifications specially valuable to us.

Not recruited as an Econ or Maths Graduate – he is not that.

Recruited on basis that History degree indicated that his education was well above average, that after training in general office he might be valuable – perhaps in House which is one direction in which 'better than average' people are given an opportunity & can be very valuable.

He is young [26] – we like him – but frankly he hasn't shown quite the promise in the House which we hoped, so for time being we are giving him an opportunity to learn more in Stats Dept. If he can grasp that opportunity & shine there he can be paid accordingly – we have to recognise the value of people in terms of ability & efficiency in the work we can offer. But we cannot at present classify him as a 'research' worker. If he can attain that status we shall be only too happy to recognise it.

Nevertheless, he is being paid well in advance of his age as compared with others of lesser education, & of course we expect from him accordingly.

Perhaps above all, Perry was determined that his firm should never slip from the highest standards of probity and service. Roger Pincham, who arrived in 1956 after completing his National Service and was put into private clients, soon learned this. The issue of a big ICI loan stock had led to a lot of business for the department, and Perry overheard Pincham remarking on this fact with some glee in his voice. He took him aside: 'Pincham, I never want to hear you talk about commission again. Look after the clients, and the commission will look after itself.'

Within the partnership, there were two main dramas played out in the closing years of the Perry era. One involved Rashleigh, the other Williams. Rashleigh's drama – undocumented in the firm's records – took place in about 1956. Already on his second marriage, he became involved with a stockbroker's wife whom he subsequently married, and indeed was cited in that stockbroker's divorce proceedings. His name appeared in a paragraph in the *Evening Standard*, and there was something like uproar in Pinners Hall.

Rashleigh himself was suspended for several weeks while the partnership agonised over what to do. Drew and Williams seem to have been the most fearful of the effects that the episode might have on City opinion, and they were supported by Swan and Henry Cottrell. Eventually, after a series of meetings, a vote was taken at which only Perry, Weaver and Potter supported Rashleigh's staying in the firm. Nevertheless, the minority won the day and Rashleigh stayed – a decision with important long-term consequences. Almost certainly, his crime was less that of adultery and divorce in general than the fact that he had gone off with the wife of another stockbroker – one who, to compound the felony in some eyes, had a child to whom Rashleigh was godfather. Should one be surprised by Perry's support of Rashleigh in this situation? He was, after all, hardly one of life's cavaliers. Perhaps, however, his own marital difficulties had broadened his human sympathies, and he was not inclined to be overly judgmental. If so, it is surely to his credit. In any case, the event as a whole serves as a telling reminder of how very different the world of the mid-1950s was from that of twenty or even ten years later.

The Williams drama is much more fully documented. Never particularly popular with the younger partners, towards some of whom he could be fairly aggressive after lunch if he had drunk too much, his relations with them further deteriorated in the course of 1957 – not helped by the habit he had developed of taking long, mainly non-working, trips abroad at the firm's expense. Perry noted in May 1957:

During the last few months, NHW has brought up the following points:

a. His doctor diagnosed that he was suffering to some extent from an anxiety complex regarding the economic prospects of the U.K. and the position if a Labour Government was elected, giving him a desire to return to Australia.
b. Mrs Williams inclined to suffer from bronchitis and the Australian climate would suit her better as she gets older.
c. Expressed fears of a clash at some future date between himself and HCC [Henry Cottrell] should NHW stay on longer than I do. In this connection he was very dissatisfied

with decision re Twist [that he should shortly become a partner, in the event deferred], reckoning I had let him down and given way to HCC.

d. A very recent comment that he 'could not be subject to a hierarchy of actuaries'.

In his own mind no longer assured of the succession, Williams was, as far as one can tell, trying either to force the issue or to get out on the best possible terms. A less than enamoured Perry made various other points:

Human nature being what it is, my view is that NHW values introductions too highly – others are perhaps inclined to value the working of the clients too highly. I have tried to keep a balance between the two views. . . . At the time of his joining us I made it clear to him that I was proud of the atmosphere and team spirit then existing and rather than that a disturbing influence should be introduced, I would rather he did not join us. . . . He represented then that his gross commissions were of the order of £30,000 per annum. Perhaps owing to conditions becoming less favourable they did not in his first years measure up to this and Locatelli felt NHW had overstated his position. . . . Locatelli more than once indicated to me that while all would accept my leadership while I remained, NHW would not succeed to it. . . . There is also the point that his business has to a great extent been built up on the work of the team. It is improbable that he would have anything like approached it in other conditions.

Two months later, on 27 July, Williams had his formal say in a long letter to Perry ('My dear Jimmie', as Perry was known to those close to him) that made much of their friendship going back some twenty-six years. In regretful tones he stated that since Locatelli's death Perry had not accorded him 'the support which I consider to be my due', declared that 'a situation has been developing over the past three years which makes it doubtful whether I would be acceptable to all the partners as your successor in the event of your retirement', summarised in fairly glowing terms all that he had achieved for the firm, and outlined in detail the financial

arrangements that he wanted to come into effect on his intended retirement in May 1958. This would involve a lump sum of £20,000, as well as an annual pension of £5,000 for which he would do a certain amount of rather ill-defined consultancy work, mainly in Australia. 'Furthermore,' he added characteristically, 'it would not be my intention to cut off my contacts with either the United States or the United Kingdom and here again I think that there is excellent scope for ambassadorial work.' Perry's reply, four days later, lacked little in frankness:

As I have got older and my energy less I have been anxious to leave more and more to you and to hold not much more than a watching brief. One thing I feel now is that having a number of new developments in course you wish to withdraw before they are matured, without sufficient cause.

You indicate yourself that had Charles L. lived you would have reckoned with him to be able to exercise a joint control of the firm in the event of my death or retirement. In these circumstances I do not think you would have attempted sole control and the position is not in reality that much different now. My feeling is that when I go no one will have quite the same place as I have held. This is not a position which has developed during the last three years. It has existed all along.

The feature of the firm is its technical approach and actu-arial connections and my feeling is that the technically quali-fied partners will always, and rightly, demand a say. Though they would be loath to throw in such lucrative hands, should I go they would demand more voice vis-à-vis yourself than with me and left to yourself you would attempt to give them less. But though the one you are frightened of [Henry Cottrell] might try to obtain power and probably will in the end, during your time I think he might be kept in hand by DW [Weaver] and Uncle Fred [Menzler]. You can be diplo-matic enough and play your cards well in most circumstances. I do not see why you are so frightened of this.

I am not conscious ever of having treated you other than as the partner most senior to myself. Other than the recent occasions I cannot think of any time when you have not concurred, even if left to yourself you might have acted differently.

Nor was Perry much impressed by Williams's proposed financial arrangements. The capital sum, he argued, 'in effect means the transfer of reserves from juniors to yourself', while 'not many concerns I should say would suggest even £5,000 pension to a partner retiring at full age'. Eventually, although the documentation peters out, Williams decided to delay his retirement.

Shortly before Christmas 1958, Perry let it be known that he definitely intended to retire the following May. In the New Year, on 19 January, Perry, Williams, Weaver, Potter and Beard met to discuss the implications. The agenda was some written thoughts that Perry had prepared:

> I have increasingly during the last few years handed things over to NHW to deal with and if NHW did not stay, someone else would have to take things on similarly.
>
> Any doubts or misgivings with regard to NHW as senior partner should be cleared up now.
>
> We could not meet NHW's retirement proposals two years ago. In carrying on he has maintained his drive on behalf of the Partnership. I believe he still has in mind to return to Australia while he is of an age to take up some business activities there and he is near 63 now, i.e. the move must be within two or three years at most.
>
> He has indicated at times a view that senior partners' interests have been sacrificed in favour of junior partners. A doubt whether generosity towards junior partners and potential junior partners will be maintained is a cause of much of the misgivings. . . .
>
> NHW has mentioned amalgamation [with another firm] from time to time. His attitude to this should be made clear. I am certain the general feeling would be against this except on such terms that we were left complete masters of the situation. The possibility of it should not weigh against our policy of introducing new junior partners.

At the meeting itself, where Weaver took the notes, most of the running was made by Williams:

> NHW wishes to remain as senior partner. He expressed the intention of being recognised as senior partner. On being

pressed he said he did not intend to act as dictator but would also follow the wishes of the partnership. He disliked being presented with a 'fait accompli' as a result of action by individual partners as has happened on occasions in the past.

He spoke of being willing for the new partnership to run for three years, at the end of which he would presumably retire. Later he mentioned that he was willing to retire at the end of five years with an option to do so at the end of three years. This position I think still requires clarification. . . .

NHW agreed that we should not make a policy of looking for amalgamations. . . .

It was suggested by SJP that the partners other than himself and NHW should discuss the position at a meeting among themselves.

This they did, at a meeting of eight partners at which Weaver (of necessity a bystander in the unfolding debate) summarised the gist of their thoughts. Four of them – Hall, Beard, Swan and Drew – were explicitly against having Williams as senior partner. 'Too much No. 1,' asserted Hall; 'We should be unhappy with NHW,' thought Beard; 'Does criticise his partners to outsiders,' remarked Swan, adding that there was 'no community of interest with rest'; and Drew simply said that he 'would not like him dictating policy'. Rashleigh was more willing to countenance Williams as senior partner, provided that his powers were strictly circumscribed, and Cottrell broadly accepted that strategy, though remarking that Williams was 'not respected'. Macaulay was broadly neutral, though insisted that 'bringing up young partners is important'; while Potter had 'no special views', but was 'willing to give a go' with Williams. The overall view, as expressed in a memorandum by Weaver on 28 January, was that they were broadly willing to work under Williams as senior partner – but only provided that the distribution of shares in the firm was made more equitable, that Williams committed himself in writing to retire no later than May 1964, and that he agreed to be bound 'by a majority decision in the case of any division of opinion'.

This was not good enough for Perry, who in a memorandum on 3 February declared that 'if NHW remains as senior partner he will expect to be given consideration as such and

for his views to be given weight accordingly in the same way as mine have in the past', adding that 'NHW would not wish to stay where he is not wanted'. Perry also scribbled a post-script:

> Everybody has pulled his weight in building up.
> The earnings and prospects for everyone are so good that no one should have an eye on money.
> NHW did tend and perhaps still tends to overvalue intro-ductions and others to undervalue them. The truth lies between.
> NHW's prestige value and general commercial instinct.

The situation, at the last, was going away from Perry. It was against all the inner logic and rationale of his career that at this valedictory point he supported the claims of Williams; yet for some reason – possibly out of sentiment – he did.

The following day, 4 February, Drew made a decisive inter-vention. 'The conditions under which N.H.W. states he is prepared to stay as senior partner,' he wrote to Potter, 'differ so much from the earlier memo submitted by the remaining partners, that as they stand, they are not acceptable to me.' The eight assembled again, possibly at the Great Eastern Hotel, and this time reached a 'unanimous' decision that the only possible solution, granted Perry's unhappiness with the conditions under which Williams might become senior part-ner, was that Williams should retire now on the same terms as those of Perry. 'Distressing meeting to me,' noted Perry on 9 February after being told of the decision. 'Certain in my own mind what would be best for firm, and everyone should I think be clear on my views.' The Perry era was ending in some bitterness, and with Williams accepting that he had to go all that remained was to choose someone other than him as the successor in Perry's stead.

Weaver, the once-intended, was still effectively barred from membership of the Stock Exchange and therefore could not be a candidate. Potter was next in seniority to Williams: quiet-spoken, and crippled in his left arm by polio, he was scarcely forceful, and his health was poor. The two partners next in line – Rashleigh and Cottrell – had qualities that Potter lacked, but each would have resented the other's

preferment, and neither could decently be brought in over Potter's head. Potter was therefore appointed, though apparently on the understanding (probably at the instigation of Weaver) that Rashleigh was in reserve if his health finally broke down. In a sense, though, what really mattered far more was the basic fact that it was not Williams who succeeded Perry, but instead a fully fledged member of Perry's team, which over the past twenty years or so had introduced an entirely new approach to stockbroking. Williams came from a quite different strain of stockbroking, and it might have had some very damaging effects if he had become senior partner of Phillips & Drew on the verge of the 1960s. British society was about to become more meritocratic, and this was no time for the firm to be backtracking on its fundamental principles. Even if Perry could not quite bring himself to acknowledge it, that was the underlying justification for what was, however undramatic, a palace revolution.

[4]
Expansion in the 1960s

The social history of the two decades may have been very different, but in certain key respects the 1960s were in stock-broking terms not greatly dissimilar from the 1950s: markets were mainly bullish, the cult of the equity still flourished, and the institutional shareholder was ever more important (by the end of 1969 holding some 52.6% of British ordinary shares, at market value). For Phillips & Drew this was the decade of visible take-off. 'A long discussion took place on the question of new offices,' the partners' minutes noted in January 1960. 'The balance of opinion was against accepting the offer of the space available in the old Bank of England offices in Finsbury Circus and it was decided to seek a proposition of a modern building.' Even before the main move, shortage of space had compelled the general office and the research department to move out, to nearby St Alphage House, before the whole firm was reunited in March 1963 in the more expansive context of the fourth to seventh floors of Lee House, a new steel-and-glass building just to the north of London Wall.

Progress was remarkable. At the start of the decade, eleven partners and about 150 staff had earned less than £500,000 commission in a year; by 1965, eighteen partners were employing some 205 staff, producing upwards of £1 m commission; and by 1969, twenty partners and 338 staff were bringing in commission of nearly £2.6 m. Put another way, in ten years of comparatively mild inflation (certainly by the standards of the ensuing decade) a rise of 125% in the

number of people employed produced a rise of 420% in the commission earned. With only one or two brief dips on the way, profits naturally climbed: in gross terms, from £498,994 in the year ending May 1962, to £804,629 by 1964/5, and to £1,890,251 by 1968/9.

The senior partner who presided over this growth was Rashleigh, who had assumed the position after the unfortunate Potter had been diagnosed with stomach cancer and became unable to attend meetings from spring 1960. 'I can't believe it,' Swan remarked to Rashleigh with Australian directness at the time of his elevation. 'One moment you were being threatened with eviction from the firm, the next you are senior partner.' As senior partner, Rashleigh benefited from having no close friends among the other partners on account of his 'drama', and this allowed free play to his forceful personality, which was expressed with great clarity supported by a mordant sense of humour and tempered by generally liberal views. He worked short hours and did most of his thinking, he once remarked, between 2 a.m. and 4 a.m. Overall, he had a good strategic grasp of the shape of the business, built up a sensible, not overclotted committee system to enable him to delegate, and did not encourage oratory at the monthly partners' meetings. Force of character is arguably a senior partner's only weapon, and Rashleigh wielded it to great effect. Strong-willed (with an obdurate Cornish streak), independent-minded, and possessing a much better brain than he sometimes let on, he was in the opinion of some the best senior partner that Phillips & Drew ever had.

The gilt-edged department remained the indispensable core of the firm's business. Almost invariably it produced about a third or just under a third of total commission; yet gilt salaries stayed consistently at less than a tenth of total salaries. Take the quarter ending May 1967. The department earned revenue of £158,144, paid out salaries of £7,201, and therefore produced a gross margin of £150,943. Obviously there were other costs involved – notably dealing and administration – but these were very healthy figures, largely reflecting the specific nature of the business. On the Stock Exchange as a whole, between 1964 and 1967, the average

value of a bargain in gilts was £49,100, compared to the average value of a bargain in ordinary shares of £1,100. The difference reflected the predominance, among buyers and sellers of gilts, of large institutional investors. Although dealings in ordinary shares (on the Stock Exchange as a whole) earned far more commission than dealings in gilts, the economies of scale are obvious. For Phillips & Drew, with its well-developed institutional connection in gilts, they were particularly alluring. Gilt commissions were lower than equity commissions, but this was more than made up for by low manpower costs (even by the end of the decade, there were only fourteen staff in the department under the supervision of four partners) and the average value of its bargains in gilts (in November 1965, for example, it ran at £94,387, well above the Stock Exchange average).

For most of the decade, as Henry Cottrell increasingly turned his attention to matters of administration and keeping detailed tabs on the business as a whole, the partner effectively in charge of gilts was Twist. A good dealer and a generally smooth operator, who maintained an easy rapport with the big institutional clients such as Colonial Mutual (subsequently the responsibility of Frank Leonard), he was also a kindly and encouraging figure within the department. In technical terms, however, the initiative was increasingly being taken by Bryce Cottrell, despite his lack of formal training as a mathematician. 'He has a first-class flow of ideas which usually need little tailoring,' Twist reported to his partners in 1961, 'and gets on well with many clients, his main fault being that he is sometimes carried away by his own intelligence and so puts suggestions in a complicated way.' Twist added that Cottrell had 'done a great deal of pioneering work, much of it pretty thankless, and the name P. & D. as switching brokers is now much more widely known'. The other main gilts partner for much of the decade was Fison. A partner from 1964, after three years in the pension fund department, he possessed boundless energy and resource. Together, concentrating mainly on long gilts, they made a very effective team.

By the mid-1960s gilts still represented over three-quarters of Stock Exchange turnover. In June 1966 de Zoete & Gorton published a short book on *The Gilt-Edged Market*.

Its author, the firm's economist E.B. Chalmers, declared that
'the British gilt-edged market is somewhat unique in charac-
ter' and went on:

> Although on the basis of value of government stocks dealt in
> it ranks second in the world after the United States, it takes
> first place as far as ease of dealing and variety of investment
> possibilities are concerned. At the present time the gilt-edged
> market in this country has a total nominal value of nearly
> £22,000m and a market value of just over £17,000m. By far
> the greater part of this (90% of total nominal value) consists
> of British government stock including issues by public boards
> and nationalised industries. . . . British government securities
> alone have a value two and a half times that of the govern-
> ment stocks of all the Common Market countries combined.
> Although the United States has a population three times that
> of the United Kingdom and a gross national product seven
> times as great, its outstanding central government debt is only
> twice that of Britain. It is not only in the size of supply of
> government stocks that the U.K. gilt edged market is unique:
> it is also one of the few where it is possible to make a really
> long-term fixed-interest investment. In America, the bulk of
> the issued government stock is within the five to ten year
> maturity range. Although in Germany, on the other hand,
> most of the stocks are in the long-term category, there being
> virtually no short or medium term market, on many of these
> stocks the debtor has 'recall' rights. This means that in prac-
> tice the lender has no guarantee of any one rate of interest
> over a long period of time.

On the market floor itself, the two leading jobbing firms were
still Wedd Jefferson (which in 1968 merged with Durlachers
to become Wedd Durlacher) and Akroyd & Smithers, and
the single great colossus – the leading jobber of his genera-
tion – was Dick Wilkins of Wedds. Only an unwise broking
firm ignored his wishes. Normally a warm and gregarious
man, at one time he took a particular dislike to the dealing
partner of Messels. He informed the senior partner of that
firm that he would no longer deal with it unless that dealer
was sacked, and the unfortunate offender duly walked.
Beard, Phillips & Drew's senior dealing partner, also fell out

with Wilkins, though less dramatically, and that may have
been a contributory factor to his early retirement in 1963.
While Bazalgette continued in charge of equities, Birks
became the senior gilts dealer in place of Beard and did
much to repair the key relationship with Wedds. Ten or even
twenty years younger than most senior gilt-edged dealers in
other firms, Birks subsequently explained (to an oral history
of the jobbing system conducted by Bernard Attard on
behalf of the Centre for Metropolitan History) something of
how he operated:

*Is it possible to identify certain qualities that one needed to be
a good dealer?*
I always felt that the first and most important thing is not
to be hypnotised by a price: a price is only a figment of
anybody's imagination at any particular time: because they
were calling a stock a certain price, didn't mean to say that in
the end you needed to deal within that price. A lot of people
felt that that was the price and that was all they were going to
get. And in many ways, by asking a jobber what the price was,
you gave him the initiative because he said what his price was.
I think a broker's role was to know the price, or to know what
to expect the price to be. If the market was falling the right
price might have been quite a bit below what they were actu-
ally calling them and therefore if you were a buyer there was
no reason to feel that you had to deal within the price they
were quoting, you might well finish up getting it cheaper than
that. So I always felt that if you asked a jobber a price you
might well hear something you didn't want to hear and it was
far more important, in my book, to know what the situation
of jobbers' books was in the market, both as a whole and in
individual stocks. And you gleaned this by experience and
being trusted by them. If you got an order, very often the way
to do it was to say, 'I'll give you so much for such and such a
stock', and forget what they were calling them. Because if you
were a buyer and they wanted to sell stock, okay they couldn't
put the price up against you because they were your way; if
on the other hand you were a buyer and they were short of
stock, well then, that is a different situation entirely and you
have to be careful and you have to obviously ask for the price
and pin them down on what they were calling the stock. But

if you were doing what they wanted to do – that is, buying stock when they wanted to sell it – then there was much more scope for stating what your price was.

So you would in effect go and bid them?

Yes. But again, there were ways of doing it. I can't say that you would necessarily often do it but there was a great advantage to having a shrewd idea what the situation was in the market, and a lot of brokers I don't think applied themselves to knowing that as much as they might have done.

Can you recall any particular examples? Were there jobbers who didn't like being dealt with in that way?

Well, there were some jobbers that you wouldn't naturally be able to do that with because you didn't necessarily have the relationship with them. . . . It was because of the aspect of a lot of Phillips & Drew's business that we obtained quite a lot of business with a view to undoing jobbers' positions and they were, therefore, very often prepared to tell us which way they were in certain stocks because they could rely on us, to some extent, being able to undo their positions. There were obviously times when we obtained business which was against the way the market was and they accepted that. There were a few occasions when they led me to believe that they had a position in perhaps less stock than they did have and that could lead to a few ructions on occasions. I well remember a case when Dick Wilkins said they'd got 5 million Funding 4s and after a lot of trouble we found a buyer for 5 million Funding 4s and then I discovered that they'd actually got 15 million of them, which didn't please me very much.

Can you elaborate a bit on that side of Phillips & Drew's business, being able to undo the jobbers' positions?

Well, we had a number of insurance companies. Some of them adopted quite an active switching policy, and therefore they would exchange stocks one for another with the prospect of making quite a small profit, reversing the switch for quite a small profit. Now with most gilt-edged switches, the client would not open the switch unless he could be reasonably sure of getting at least a half per cent net of expenses: so after having paid our commission reversing the switch, he would want to get back into his original position having made a half per cent. If one of the larger jobbers had, say, bought a large line of a certain stock, he would have

already obtained that stock at a price below the market price, because one of the large jobbers would have naturally made a price in any gilt-edged stock in, say, half a million, but if the broker said, 'Right, I want a price in two and a half million', then he would have widened his price, so the jobber would have obtained the stock on some occasions quite considerably cheaper. Now, if we bought that stock at something near that margin cheaper, already there was the prospect of a profit in a switch transaction. So we did these switches for a number of clients with the prospect of that client making quite a small profit. But because the clients were prepared to be active we did a vast amount of business on this basis.

Birks had a sound, pragmatic grasp of these complexities, as well as possessing the qualities of a bluffer requisite in any good dealer; and for someone having come from the autocratic de Zoete & Gorton, it was a gratifying moment when one day, during a turbulent session after a Bank Rate change, Miles de Zoete asked Hugh Merriman of Akroyds for a price, whereupon Merriman pointed above him, said 'It's on the board', and then turned to Birks and said in an obliging voice, 'What can I do for you?'

The firm's market share in long gilts rose steadily – from around 5% in 1964 to a peak at one stage in 1969 of 12.15%. Given that official holders (including the Bank of England and government departments) of long gilts tended to give their business to the older gilt brokers, notably Mullens, the market that Phillips & Drew essentially aimed at was the 'institutional' holders, in particular banks, discount houses, insurance companies, pension funds, building societies, and investment and unit trusts. In terms of that 'institutional' turnover, the firm's market share was 16.1% in early 1967, rose to 20.9% in the second quarter of 1968, and closed the decade at 16%. Increasingly, as far as this market was concerned, the firm's principal rival was Greenwells. As early as 1961, Henry Cottrell noted that that firm had 'for some time been mounting a full scale attack on Colonial Mutual switching with a considerable amount of success, although their success so far has been largely at the expense of Colonial Mutual's other brokers rather than ourselves'. It was probably fairly soon afterwards that Charles Frappell

moved from Grieveson Grant to Greenwells, where he made a well-balanced team with Gordon Pepper, who by the end of the decade was becoming the guru of the gilts market. One way and another it was becoming an increasingly competitive milieu, especially if one did not have the free rides that the older firms of brokers still tended to enjoy. Phillips & Drew and Greenwells relished each other's rivalry, and both firms had a strong actuarial presence that combined commercial instincts with high standards of expertise and innovation.

The technical nature of much of the work was exemplified by the brochure that Phillips & Drew published in August 1962 on the gilt-edged market. Subtitled 'Some Switching Methods', it sought – in the general context of a broadening range of coupons and increasingly volatile levels of interest rates – to provide surer guidelines than hitherto existed. 'In so far as there is anything original in our approach,' the introduction noted, 'it perhaps lies in our emphasis on the assessment as far as possible of the risks that are taken in the course of making gilt-edged switches; we believe that in the past many switches have been made which have been unsuccessful because of a lack of appreciation of the risks involved, and these switches have sometimes been between the most innocent and apparently similar pairs.' The concept of the term index, measuring volatility of a stock and published weekly, was at the heart of this approach, being an idea that Bryce Cottrell had picked up from Pember & Boyle and successfully developed. 'Two stocks have the same index of volatility or term index if they have the same difference in performance over two years between a fall of one per cent in the yield and a rise of one per cent,' the brochure explained. Elucidation also followed after a two-page chart headed 'Term and Coupon':

> The chart is drawn so that all stocks on the same vertical line have the same term index and its use as a switching tool comes from the fact that it is broadly (but not precisely) true to say that stocks on the same vertical line will react in the same way to a change in interest rates. Thus if we believe that there is an anomaly between two stocks on the same vertical – let us say a 2s 6d per cent difference in yields between a pair

which usually stand on the same yield – then any change in overall market levels before the two stocks again offer a common yield should not wipe out the switching profit. Put another way, switching between pairs on the same vertical line minimises the risk of error. . . . It should not be inferred that we are in any way opposed to the taking of risks when carrying out switches: all we are intending to do is to ensure that they are 'calculated' risks as far as possible.

A further use of the term and coupon chart was to enable the selection of double switches, in other words switches from one stock into two others or from two stocks into one. In recent years the firm had been doing profitable double switches for Clerical Medical, and the brochure repudiated 'the commonly held view' that such double switches were inherently 'unsatisfactory':

It is often argued that double switches are a compromise and that one leg will be relatively successful and the other relatively unsuccessful and this is, of course, nearly always true but it is also irrelevant because a double switch is of its nature a compromise but a more or less riskless one, having been designed to be unaffected by changes in market level: if one is sufficiently sure of future market movements to wish to move into longer or shorter stocks then one should do so, but if one believes that a stock is exceptionally dear or exceptionally cheap without being confident about coming market movements and without a single stock being available for the other side of the switch, then there is a case for a double operation.

The chronology is somewhat uncertain, but almost certainly by the end of the decade there were three other significant concepts in existence and available for use by interested clients. Two were largely Bryce Cottrell's: that of 'break-even yields', again using a chart and developing Henry Cottrell's earlier idea of balance-of-term yields; and 'average yields', which involved looking not at ranges, but rather deviations from a central point. The third concept was Fison's, building on thinking by Twist, and this was the use of 'zig-zag charts', in effect a series of break-even lines between

two yields that enabled a price history and a yield history to be plotted on the same picture, thereby enabling a single chart to contain the totality of information about a switch. All these charts and technical innovations had a twofold advantage. They had a particular appeal to some of the more sophisticated clients, such as the World Bank; and they enabled the department to produce very quick assessments, especially if the market had opened to Birks and there was a possibility of a major switch. One potentially significant development that, however, somewhat flattered to deceive was that of 'automatic' or 'systematic' switching. This came into commercial use from 1964 and was (in the words of publicity material the following year) 'a scheme, comprising a complete set of rules, which we have developed so that an investment manager, local authority treasurer or trustee can be relieved of the need to identify and scrutinise each possible gilt-edged anomaly switching opportunity as it arises, while being satisfied that his fund will take advantage of all appropriate market movements'. This was mainly Weaver's idea, and 'the principle is that dealings in the portfolio's stocks take place whenever there are deviations, between actual yields and the normal pattern, of adequate extent within the rules of the system'. Some clients did use the system, to reasonable effect, but by the late 1960s it was clear that it would be only a minority taste.

Finally, in terms of innovation, there was the whole question of 'policy' switching – that is, in order to take advantage of an expected change in interest rates or an expected difference between the behaviour of two stocks over a considerable period of time, whereas 'anomaly' switching was in anticipation of a minor relative movement. By 1966 – partly in the context of the negative impact of the previous year's Finance Act on traditional anomaly switching, partly also perhaps as a reflection of a desire to match the intellectual pace being set by Greenwells – there was increasing emphasis on policy switching. Henry Cottrell, in a memo in November that year, noted Rashleigh's 'astonishment to learn that business was not exclusively of an anomaly nature' and called on the firm to begin taking a broader view on interest rates and 'the gilt-edged outlook', in the same way that it was starting to do on the equity outlook. The following year John Lewis, an actuary

who had joined in 1964, moved from research to gilts, largely to give effect to this desire, but in the event proved such an effective business-getter that the concept was temporarily shelved. Nevertheless, with interest rates ever more volatile and the Bretton Woods system coming under ever greater strain, this was an idea whose time would come.

By contrast, a type of gilt business more or less conclusively on the way out was so-called 'bond-washing'. Essentially, this was a lucrative manoeuvre that involved selling stocks full of dividend from high taxpayers to those who wanted their dividends gross, and then buying the stocks back for those taxpayers when they were ex-dividend. Unsurprisingly, the prospect of an untaxed capital gain was attractive to institutions as well as individuals, and Locatelli by repute had generated considerable commission through his adeptness at bond-washing, though there is no hard evidence either way. Eventually, in 1959/60, legislation made it far harder to indulge in this practice and stay within the law. It seems, however, to have continued in some quarters, and in 1966 the Stock Exchange Council suspended several members whom, following a lengthy investigation, they had found guilty of taking part in a bond-washing operation. That was the context in which, early in 1966, Twist examined the firm's own practices in ex-dividend dealings and found that the only vestiges in the past year of old-style bond-washing were certain operations done on behalf of Royal London. 'I think it is fair to say that neither B.A.M.C. [Bryce Cottrell], G.T.B. [Birks] nor I ever found these R.L.M. operations particularly palatable,' he observed, 'and it may now be appropriate to consider whether we should continue dealing in this way if we are invited to do so.' Procedures were tightened up, discussions were held with Overy of the Royal London, and (Henry Cottrell reported to the partners in February) 'the manner in which this Royal London business was handled had been submitted to the Stock Exchange Council and approval had been secured that our practice in no way contravened the Rules'.

Through the 1960s it was Colonial Mutual, with Riley still its investment manager, that was far and away the dominant client in gilts. 'The whole basis of Colonial Mutual switching was altered in July 1959,' noted Twist two years later, 'when

"special" switching started: this involves a more or less permanently active policy and has proved very successful to Colonial Mutual in terms of tax saving. Unlike the various species of "bond-washing", special switching involves the continuous taking of true market risks and so is not particularly vulnerable to changes in legislation.' Twist added, still with reference to Colonial Mutual, that 'the rise in commission earnings from 1959/60 [£67,000] to 1960/1 [£109,900] reflects principally a growth in confidence and expertise on the part of Riley and ourselves in handling special switches.' So it continued, despite competition from Greenwells in particular, and for example in the year ending May 1967 the £142,346 commission in gilts from Colonial Mutual was over £103,000 ahead of any other client. Royal London, once so important, was down in twelfth place on £10,299.

In general, there was in gilts as elsewhere an almost continuous process of examining which clients were generating satisfactory commission, which were not, and what could be done about it. The client review that Fison conducted in early 1968 was probably typical. Esso was a case of 'keep trying'; at Lazards, 'contact has left' and 'needs fresh start'; for Phoenix, the tactic was 'try when there is something to say'; there had been no joy from the Prudential, where 'first big effort failed'; in relation to Royal London, 'management factor here is unhelpful'; and at Westminster Bank, the situation was 'merger with Nat. Pro. announced since last note', which meant that it was 'probably in turmoil' and therefore the policy was 'do not press'. There was also a steady stream of visits, as when Twist in November 1962 tried to stir the Scottish investment community. General Accident, he found, 'does policy switches only – very seldom anomaly (Chairman thinks anomaly switches unethical)'. Scottish Amicable, by an edict of its board, used only one broker for gilts, not Phillips & Drew, but 'are glad to have ideas put (which should be rewarded ultimately by divided commission)'. Scottish Mutual used Pember & Boyle, Capel-Cure, Messels and Galloway & Pearson in gilts, but although all were 'well entrenched' Twist thought 'a little might be achieved'. Scottish Life's policy was discouraging: 'no gilt switching, no irredeemables'. Discussion with the investment manager of Scottish American Investment was somewhat more promis-

ing: 'Has Treasury 5½% 2008/12 and wants to get into lower coupons – talked about Funding 3½% 1999/2004 on run forward (which send regularly) and gave him the book. He was humble about lack of knowledge!' At Scottish Provident, the relevant figure was 'friendly enough but very well entrenched and set in his ways', mainly dealing with Mullens, while at Caledonian his counterpart was 'overworked and often simply cannot look at switch suggestions'. So it went on. The negatives easily outnumbered the positives – epitomised by Standard Life, where 'Pembers and Mullens do the policy moves and they do not job' – but Twist knew that just one conversation might lead to an enduringly profitable connection.

The gilt-edged department did not confine itself wholly to long gilts. By 1965 it was also dealing in quite an active way in a related class of security: bonds issued by local authorities. That section of the market had been rising in importance since 1955, when the Treasury, trying to restrain local authority borrowing, had required local authorities henceforth to raise some of their money on the open market instead of relying wholly on loans from the Public Works Loan Board. Phillips & Drew was one of the small group of firms that cultivated local authorities, partly through the pension fund connection, and encouraged the growth of the market in their securities, mainly 'yearling' bonds repayable at the end of twelve months.

Henry Cottrell pondered the possibilities in February 1966:

Several discount houses have commented upon their pleasure in dealing with us in L.A. bonds and have expressed the hope that, in due course, they might deal with us in gilts, although they cannot do so at present. . . . We believe that there is an agreement that the discount houses will deal with only a limited range of brokers in gilt-edged. We do not know the precise list, nor who fixes it. But we do understand that, a dozen years or so ago, Greenwells approached the Government Broker and sought his guidance. In the light of that advice they were accepted, and they took Tremlett and Noble from Grieveson Grant to start them up. . . . L.A. bond dealings are unquestionably unprofitable in terms of return

to the time of AFT [Twist]. It is, however, likely that, if we could get into the gilts as well, it would be profitable.

The gilts that Cottrell was referring to were short gilts, and he appended figures showing that the total turnover in short gilts for 1965 was £10,594 million (almost twice the turnover in long gilts), of which Phillips & Drew had a fairly paltry market share of 1.2%. In the past the firm had had few connections with the discount market, but soon after Cottrell's paper Twist reported that 'he was getting on Christian name terms with many of the Discount Market people', and the decision was taken that he would 'initiate, develop and direct our expansion into short-term gilts, which would probably involve up to six months' study and gradual progress before a direct approach was made to the Discount Market'. There was no assumption of automatic success, for Birks had already consulted Wedd Jefferson's John Robertson, who had told him that 'we would need two partners full time on this work' and that 'Cazenove and Panmure had both made a serious similar try in recent years and both had given up within six months'. Interestingly, Robertson had added that 'gilt-edged jobbers do not like the Discount Market and the thought that helpful hints to P. & D. would go on to Discount Houses would merely cut off all helpful hints to P. & D.'. From a departmental point of view, the obvious solution was to recruit a well-connected outsider, but Twist insisted that 'the "snob" attitude of Discount Houses was not primarily a preference for Etonians in Debrett'. Over the next fifteen months or so, Twist plugged away, getting market share in shorts up to 2.05% by May 1967. Later that summer Parker moved from equities to gilts specifically to take over the short end, and by May 1968 market share was up to 3.29%, prompting Henry Cottrell to comment that 'I'm satisfied that we are now running no lower than sixth or seventh in short-dated gilts'. He added that the firm was currently 'third in longs and first in local authority bonds' and that 'the Government Broker [Mullens] is obviously always going to be first in the two gilt-edged categories'. By August 1969 market share in shorts was up to 4.23%, and Parker was receiving invaluable support from David Harrold, who had been posted to gilts from equities.

Separate from the gilt-edged department in the 1960s was the fixed-interest department under Bavister. It was, relatively speaking, never a major player in the overall picture, though by the second half of the 1960s it was producing about 8% of the firm's commission – a performance significantly helped by access to computerised records of comprehensive debenture information, well ahead of other firms and with a print-out once a fortnight. Debentures were traditionally Bavister's main concern, but when company taxation and methods of raising capital were altered by the introduction of Corporation Tax in 1965, preference shares (which were also fixed-interest stocks) became attractive to investment trusts, and the fixed-interest market as a whole became much more active. In 1965 there was only a staff of five, mainly young and inexperienced, working under Bavister, but by 1969 he had thirteen in his charge. Market share fluctuated. In 1965 the firm was getting between 2% and 4% of the overall fixed-interest business; the following summer, a big block of business, done for the Church Commissioners, took the share to 5.92%, and revenue to £49,515, for the end-August quarter; and in 1968/9 market share was generally between 3½% and 4½%. By then there were almost a hundred active clients, and Bavister had done well to create a decent business out of the Stock Exchange's unconsidered trifles.

A more decisive figure in the firm's overall development, however, was Swan, who formally took charge of institutional equities after Rashleigh became senior partner. In October 1961 he described the doings of 'the equity table', which he claimed had 349 institutional clients (82 insurance companies, 200 pension funds, 44 investment trusts and 23 merchant banks), though by no means all were dealt for on a regular basis. The routine included a daily conference held at an almost shockingly early hour:

> The whole table with E.P.B. [Bazalgette] and Titmuss [another dealer] meet at Lyons for coffee at 9 a.m. We discuss the news, ask for prices, check limits and in happier times are prepared to take stock as soon as the market opens [at 9.30] and place it afterwards. We find this early start beats the broker who is not awake at this time. For the rest of the day

there is no clear pattern as we depend so much on the market.

Institutional equities had been in existence as a department since 1955, and Swan claimed that 'over the last five years our status has grown enormously and we are close to the top'. To this he attributed five reasons:

(i) Foremost is security analysis which has produced more clients and put our name on the map;
(ii) we are not speculative;
(iii) we are honest;
(iv) we do keep so many people in touch with the market;
(v) we have a feeling of enthusiasm about our business.

In the subsequent discussion of the report by the partners, Rashleigh's only point was to wonder 'whether we were not imposing too much on the staff by expecting them to attend at 9.00 a.m. for a preliminary discussion of the market with no offset at the end of the day'. However, 'it was not generally felt that this did impose much burden on the staff'.

Over the rest of the decade the department steadily grew (four partners and twenty-three staff by early 1969) and Swan remained in charge, despite being elected to the Stock Exchange Council in 1963 – the firm's first representative on it. In some respects he was ideal at running a desk of equity salesmen: extrovert and a natural motivator, he had the knack of making young people feel good if, in his eyes, they were really making an effort. But he could also be somewhat fierce, and in 1965 it was noted, probably by Henry Cottrell, that 'considerable alarm is often expressed by anyone asked to join the equity table' and that 'perhaps not enough training and guidance of a long-term nature' was being given to those 'who might be slow starters or going through a bad patch'. Perhaps by definition, however, life could be tough in the institutional trading departments, of which equities was the most populous. In 1968 the firm's own brochure (*A career with Phillips & Drew*) almost said as much:

Each man has an allocation of a small group of clients whom he aims to know personally. In the main it is telephone work,

but frequent face-to-face contact is encouraged. Given this, a quick mind and a good memory, he serves his client by continually putting forward investment propositions in which we have confidence and which the client is likely to accept. The department works as a team, in open-plan layout, with partners and staff working at adjoining desks. Each of the clients of these departments tends to use several brokers and the resultant competitive atmosphere is intense.

Swan himself, some years earlier, had privately outlined the qualities he most looked for: firstly, 'humour'; secondly, 'speed and accuracy'; thirdly, 'flair'; fourthly, 'devotion to job'; and fifthly, at least as important as any of the other four attributes, 'no egg heads'. In short, the equity table under this generous-spirited but sometimes abrasive Australian was no place for a shrinking violet.

Swan's memo of October 1961 contained a particularly revealing passage:

> It has always worried me that our equity business with insurance companies is so poor and shows none of the advance with other institutions. I know that there is the question of underwriting [that, in other words, through not being a corporate broker, and therefore having no significant quantities of sub-underwriting at its disposal, the firm was owed few favours], but I have my doubts as to whether that is the full explanation. I think that it is that on our table any person can ring the investment manager of, say, Rolls Royce, Fords, Courtaulds, etc, but we do not know the top man, with one or two exceptions, in the insurance companies.
>
> A similar position holds with investment trusts and merchant banks.

In the discussion of his report, Swan explicitly 'asked for more help from other partners in the way of top level introductions'. This was 'accepted', and Drew 'agreed to help with introductions to the merchant banks'. However, 'it was suggested that steady plugging, combined with occasional visits, might offer the most hopeful prospects for progress'. Put another way, there seems to have been only qualified

acceptance of the essentially personal explanation and remedy that Swan was offering – reservations that accurately reflected that the firm had not got where it had through the old-boy network, and that it was perhaps somewhat late in the day to start systematically on that tack.

Accordingly, over the rest of the 1960s, the equity table continued to plug away mainly at investment manager level. In November 1966 a departmental meeting discussed 'insurance companies with inadequate commission' and in the process proved that there was no such thing as a free lunch:

	Comments	*Action*
Beacon	A dead loss.	Do they deserve circulation?
Blackburn	Money mostly in mortgages.	Plug along.
Canada Life	Not active in British equities.	Mackenzie to come to lunch.
Equitable Life	Passmore (ex Kleinwort) believed to dislike P. & D.	To come to lunch.
Guardian	Shepherd knows it all.	To come to lunch again.
NFU	Hates being punted and out of mkt.	Research to ring up.
Pearl	Not unsatisfactory.	Reward with lunch.
Phoenix	Said they were doing little in equities.	Keep on trying.
Reliance	Money all going into properties, feel sure we're not missing out.	Schmidt to be lunched.

The following spring, Swan, in the company of Bavister, paid one of his regular visits to the Scottish-based investment managers:

SCOTTISH PROVIDENT INSTITUTION: *G.M. Dobbie.* He is cautious about the equity market and although he expects a fall he also expects the steel money coming from nationalisation to have an effect. He is very satisfied with both our research and literature, and our dealing facilities. We saw a review entitled 'Company Reports' by George Henderson &

Co in a green book, which looked very similar to P. & D.'s publication.

SCOTTISH AMERICAN INVESTMENT: *J.R. McLaren*. We had a long discussion on the economic outlook and the economy. He wonders how and when reflation will come. He likes our research output and we think that the amount of telephoning is quite adequate. It was a much more affable visit this time than before.

NATIONAL COMMERCIAL BANK OF SCOTLAND: *A.R. Kelly*. We found Mr Kelly very friendly but he is a great bear of the market and we heard why it should fall. We feel that he is not his own boss but he did say that he would let us know when he is in the market.

BAILLIE GIFFORD: *J.S.C. White*. We felt that we were not as welcome as we expected and we think that a few too many people have made recent visits and suggest that they are not called on for quite a little while. We felt that little had been achieved since the last visit and whilst they are obviously entrenched with their other brokers, it will be a struggle to break in substantially.

INVESTORS MORTGAGE SECURITY: *R.M. Carnegie*. Very affable but a down-to-earth sort and within a few minutes wanted to know which shares ought to be bought. The conversation was mainly about equities, of which he is a selective buyer, and he had very definite views on management. We believe that this client, who is a recent introduction, could be developed but should be handled with care. We consider it was a very successful meeting.

STANDARD LIFE ASSURANCE: *S.C. Keppie*. We have been visiting this client for the last three or four years and they are notorious bears of the equity market. We believe that if they did re-enter the market, P. & D. should get a reasonable share.

FIRST SCOTTISH AMERICAN: *W.D. Marr*. This was quite a worthwhile visit, although the business will not come easily as they are very well served by their brokers. Marr was very friendly

and said that he found our literature very useful. He had a high opinion of our Equity Book, though he does not always go with the conclusions. It is a case where slow perseverance may get us somewhere, and we suggest that no visit should be made again for some little time.

The client, in fine, was king.

Not long afterwards, Fison ran into John White of Baillie Gifford and over a drink or two discovered that that institution was very dissatisfied with the firm's equity side. The next time Bazalgette was in Edinburgh, in March 1968, he called in:

White reiterated his complaints about Beaverbrooks (put them in and said nothing when they went wrong) and Kennings (gave us a buying order which was incapable of execution and never heard any more). He said quite bluntly that had he not heard good things of us from friends in Edinburgh, he would have cut us off his list. He liked our literature, but criticized our after sales service. I said that we probably played it too cool with investment trusts, that they read our stuff, discussed it now and then, but primarily used us as dealers, and we did not like to bother them daily and hourly as we tended to do with other categories of client. I said that the main purpose of our visit was to find out how we could strike the happy medium with them.

He replied that while they did not, of course, have any new money, they were active dealers and seldom experienced a non-dealing day, usually dealing several times in a day. His requirements were (like most other people) clear recommendations to buy or sell, accompanied by a well-founded case, and to be kept well in touch after he had dealt.

I was very pleasantly received, but left in no doubt that we have to work our passage back.

Bazalgette also dropped in on the up-and-coming Edinburgh brokers Wood Mackenzie & Co. 'They say they pay London brokers £25,000 p.a.,' he reported, 'and would be happy to give some to us. They already get our circulation [research publications], so the rest is a matter of establishing dealing confidence.' He added, with the innate scepticism of some-

one who had spent many years on the floor of the Stock Exchange, that 'they were inclined to talk rather big, fifties and hundreds of this and that, and if they have half the business they say, they are really well worth cultivating'.

Yet for all its selling efforts in person and on the phone, backed by the high reputation of the research behind those efforts, the equity table in the 1960s found it frustratingly hard to achieve a greater market share than, at best, 2%. Henry Cottrell, in the quarterly management reports that he instituted in 1965, was continually glancing enviously at that market in equities, where the commission rates were so much higher than in gilts. In the end-November quarter of 1968 for instance, against the background of a strong bull market, he pointed out that 14.8% of all gilt-edged commission paid on the Stock Exchange had earned Phillips & Drew £180,867, but a mere 1.9% of commission paid on ordinary shares had earned them £308,000. A year later he estimated that Phillips & Drew stood second equal (with Greenwells) to the Bank of England in 'order of dealing magnitude in long gilts', but, he insisted, 'one cannot escape the repeated conclusion that we must concentrate our efforts at getting at the equity business which now passes us by'. He put the problem starkly:

Total equity commissions amount to about 85% of all Stock Exchange commissions, and we keep on fighting for 2% of that. During the past five years our income has doubled, because turnover has doubled. 1964 turnover would be inadequate to cover 1969 expenses. Our actual labour force – in people – has grown by only 38%. If we expand at the same pace over the next five years we shall still, in 1974, be under five hundred people, but we should need £5 million revenue – where will it come from?

Do we believe that rates of pay will grow more slowly? Personally I believe that the pace is still accelerating and I can see no reason to expect a slow down.

Do we believe that market turnover will double? Do we believe that the competition is too tough for us to penetrate further? Do we believe that we have shot our bolt?

I do believe that we have to regard this as the only problem for debate – but I also believe that there is no easy one sentence solution. It will be a combination of hard work, new

methods and bitter disappointments which will ultimately point the way.

Put another way, gilts were a wonderful cash cow – with that department's revenue/salary ratio invariably in double figures – but given the overall shape and structure of the market as a whole, Cottrell believed there was no alternative to trying to break the equity barrier.

Why then did the equity table, with its numerically superior resources to gilts, earn overall in this period only about a quarter of the firm's revenue? There were several plausible explanations. They included the firm's lack of contacts at the very highest level; the greater number of competitors in the equity market; the 'underwriting' point that Swan made in his 1961 memo; the resentment starting to be felt by some merchant banks towards the firm's fund management activities; a natural tendency on the part of some of the big institutional clients on the gilts side to spread their favours; and institutional reluctance to put new money into equities, whereas no cash was required for a gilt switch. Each of these explanations was rightly given some weight, but in the eyes of the equity table itself, as the decade unfolded, there was a further significant reason for its relative failure – namely, the research department, which was seen as insufficiently market-orientated and unnecessarily theoretical. 'Like a lot of ballet dancers, very touchy about this and that,' was how Swan in later years dubbed the analysts, genuinely proud though he was of the firm's research achievement, and almost certainly few of his salesmen would have dissented from that unflattering description. On the research side of the divide, some felt that performance would have been enhanced if Swan had been less resistant to the concept of introducing specialist salesmen. One way and another, it hardly made for a harmonious relationship between the two departments.

Weaver remained in overall charge of research until his retirement in 1969. From 1960 he was at last a partner, having been enabled to become a member of the Stock Exchange through the good offices of Bazalgette (making the most of his connections with Jock Hunter, senior partner of Messels) and Vanneck. The latter was about to leave for the more

congenial climes of Rowe & Pitman, but before he did so he used his considerable connections and charm to, in his phrase, 'roll the pitch' with the Stock Exchange Council. As ascetic as ever, with his close-cropped hair, Weaver was now reaching his apotheosis as one of the City's leading investment analysts. 'There is a tendency at times to limit the scope of investment analysis to the description of the individual security,' he wrote in his treatise on the subject published shortly after retirement, 'but this ignores the real objective of the work, which we take to be the construction and maintenance of a successful portfolio'. The treatise itself, entitled *Investment Analysis*, he modestly described as 'something of a sighting shot', given that it was 'a first text book on a subject which is only just beginning to be taught in business schools and colleges'; but the final chapter, on performance testing, ended with Weaver characteristically taking the intellectual high ground:

> Finally, we would urge all analysts, whenever permission can be secured, to publish their results and the methods by which they have been reached. It is only by continued discussion of methods in the light of actual results that an acceptable body of doctrine can be built up and the subject of investment analysis made worthy of serious study by rational men.

Was rationality enough? Back at the start of the 1960s, during the discussion following the Weaver/Fowler paper on the assessment of industrial equities, Ross Goobey had somewhat doubted it:

> The more he read papers such as the one under discussion, the more he was convinced that the measurement of the quality of management played a most important part in the assessment of industrial ordinary shares. The trouble was the difficulty of measuring the management. He was convinced that nothing could replace personal knowledge of the management and judgment of their capacities or, if that was not possible, enquiry could be made of people who were in a position to give judgment.
>
> The point might be illustrated by a story. Sometime previously, he had wanted to get information on a company in a

provincial city. He had gone through all the statistical processes similar to those described in the paper, but he still could not get into the bones of the problem. Accordingly, he telephoned a friend living in the same city, who was a leading chartered accountant and, therefore, could be expected to give a reasoned judgment. His friend told him all he knew about the company and added, 'The trouble with this company is that it is a bit old-fashioned. To sum it up, no member of the board has ever had an ulcer.' That was not to say that they should seek to have included in reports on companies by auditors a statement on the ulceration of the directors. It was, however, important to try to get information of a personal nature.

Nevertheless, as Ross Goobey fully conceded, 'one of the advantages of the statistical investigation was that it obviated personal bias'. The debate would run and run, stimulated to a significant extent by the evolution of Phillips & Drew's research methods.

The distinctive world of the research department is vividly recalled in the memoirs of Martin Gibbs, who from 1964 was in day-to-day charge of equity research. A qualified accountant, he came to the firm in 1959, in his late twenties, and quite early on found himself inadvertently in trouble:

All our work had to be submitted to Bill Nowell [in day-to-day charge of research at the start of the 1960s, following the sad illness and early death of Fowler] before it was passed for publication and he would make any changes he felt necessary himself, rather than giving comments back to the author. This was rather frustrating for the rest of us. Often one's work would lie unread on Bill's desk for several days. Then he would suddenly launch into a frenzied *whirr* of calculations, using his 'Facit' mechanical calculator which resembled an old-fashioned coffee grinder and involved turning a handle very rapidly a great many times. In due course one would see the printed analysis and see that Bill had increased all one's forecasts by 10% or more, so as to make the shares look more attractive.

One day Bill asked me to review Laporte, a medium-sized chemical company. This time he gave me a steer in the oppo-

site direction. He said he had spoken to a friend of his who worked at Laporte and was extremely gloomy about the outlook for the company. When I studied the company I agreed with his conclusions. Profits from both its main products, hydrogen peroxide for rocket propulsion and titanium dioxide for paint manufacture, appeared destined to fall sharply. I therefore wrote my analysis in this vein and recommended clients to SELL.

Many of them did so, to the great pleasure of the salesman who handled the business. However, the next profits from Laporte were sharply *higher* than the previous ones and the share price soared. Needless to say, the clients who had followed our advice were extremely upset and some of them complained to Jonathan Rashleigh. He called me in and ticked me off severely. His criticism was not so much that I had got the forecast wrong (he was completely cynical about analysts' ability to predict the future) but that I had risked the clients' wrath by encouraging them to sell shares which clearly could have gone up rather than down. 'Never sell good equities' was his maxim. Since the long-term trend of share prices was strongly upwards, and Phillips & Drew's clients were mainly pension funds who had a continuous supply of new money to invest, this was not too bad a policy. But it begged the question of what was a 'good' equity.

The end of the Laporte story was that, a year or two later, the company's profits and share price *did* collapse, just as I had predicted, but by that time everyone had forgotten my previous SELL recommendation.

The question of whether the analysts could or should make 'sell' recommendations was a vexed one, even though Phillips & Drew was not a corporate broker like Cazenove's or Hoare's. 'The general feeling,' agreed the partners after a long discussion on the subject in November 1961, 'was that a recommendation of sales of leading equities was exceedingly dangerous and that it was rarely possible to do it with confidence where the price factor was the main consideration, but that doubts on the industrial outlook or general competence of management does occasionally justify a selling recommendation.' Some years later there was a notable episode when Fred Wellings in the department was responsible for

the firm recommending a 'sell' of Wiggins Teape, entirely contrary to City wisdom and to the annoyance of the company. Within six months it was clear that the recommendation had been entirely justified. Nevertheless, at a departmental meeting in December 1968, the subject was again discussed, after Rashleigh had raised with Weaver the danger of damaging relations with clients by sending out letters recommending a sale. Part of his argument was that, anyway, 'the effect on the market would be such that little business could be done after the first substantial order had been completed'. For the department, Gibbs 'pointed out the benefits to the firm's standing that a successful selling letter can achieve, for instance Wiggins Teape and ICT'. Eventually, it was agreed that no selling letter should be sent out relating to any company 'to which we are broker and where we have a special close relationship'; while as for other selling letters, 'it was pointed out that no selling letter (or buying letter) was sent out except with agreement from the Equity Table, and after they had done what business they could on the telephone'. One should not exaggerate the unworldliness of the research department, but undoubtedly there was a purist – some thought arrogant – streak in it that was not readily compatible with more narrowly commercial considerations. It was not that Weaver imagined himself to be above the battle – 'the problem of bringing security analyses to bear more directly on business is a perennial one', he fully acknowledged in a 1961 memo on his department – but rather that there was a certain permeating ethos that derived from Weaver, the protégé of Perry, and lingered for quite a long time afterwards.

A frequent complaint on the part of the equity table was that the analysts did not pay sufficiently frequent visits, or even talk enough on the phone, to the firm's clients. Attempts were made to improve the situation, but grumbles persisted. There was also the view that analysts would be more useful to traders if both elements were operating within the same physical space. Against this, argued Weaver in October 1963, 'it is difficult for a trading department to provide the right atmosphere for research and all analysts would tend to become traders'. There matters remained until January 1965, when a committee comprising Rashleigh,

Henry Cottrell and Weaver proposed a 'loose form of pairing' between analysts and traders, on the grounds that this might not only 'improve inter-departmental morale', but also 'encourage the analyst end of the pair both to feed selling ideas into his trading partner, receive feed back on results and perhaps feel a greater sense of personal responsibility for the state of the order books'. Indeed, in words that could only have been written by Cottrell, 'a little healthy competition might also develop between pairs'. Gibbs, at the next partners' meeting, successfully blocked the proposal, asserting that 'the problem as regards the relationship between the Equity Table and the Analyst Department was 90% solved' and that 'regular meetings between the Analyst Department and the Equity Table were taking place and these would continue'. No doubt they were and would; but even after profit forecasts had moved away from a five-year basis and towards one or two years, the instinctive cultural divide between traders and analysts was not readily bridged.

The research department generated an ever more ambitious programme of publications, though in September 1961, the same month that there appeared Weaver's notable brochure entitled *Growth Yields on Ordinary Shares*, Rashleigh insisted that 'a much tighter control should be exercised over the companies to be analysed and only those included where there was likely to be a continuing buying interest'. By 1965 there were weekly buying recommendations, a monthly *Market Review* and *The 100 Companies* (later called *The Equity Book*), and quarterly industry graphs. There were also frequent industry reviews, partly reflecting the way in which the department was now (somewhat belatedly) organised into five teams of industry specialists, embracing capital goods, consumer durables, consumer non-durables, financials and miscellaneous.

There is no doubt that the effect of this literature on the outside world was broadly favourable. When Twist visited Scotland in November 1962, he discovered that he was 'welcomed almost everywhere, even in those offices who deal little with us', and according to him 'this was largely due to our literature, which was praised again and again'. That same year Henry Cottrell had lunch with GEC's Ken Smith, who told him that 'he came to Phillips & Drew largely

because of the quality of our research' and that 'they still regard this as being far and away the best in the City'. Interestingly, Smith added that, as far as the equity table was concerned, 'he was mildly disconcerted on occasion when it appeared that the front room had not really digested the proceeds of the research'. Over the next five or six years, the competition between stockbrokers to be ahead of the game in terms of research palpably hotted up, especially from 1965 when the press was allowed to attribute research, and as a result Phillips & Drew could no longer claim an automatic ascendancy, as it did in the late 1950s and early 1960s. Serious rivals – a seriousness that included a willingness to pay higher salaries than those on offer at Lee House – included de Zoete's and James Capel, and arguably both were ahead of Phillips & Drew by the end of the decade. Nevertheless, the firm's reputation remained extremely high in this area, and Jack Wigglesworth, attending the annual meeting of the British Association in September 1969 on the firm's behalf, was delighted when Sir Alec Cairncross, the government's economic adviser, 'said he thought P. & D. were good, which was nice not because it came from him but also because J.W. Martin of Central Board of Finance was within earshot!'

Inevitably there were misgivings, not only from traders, about a department that did not directly produce business. By the late 1960s 'circulation recipients' were expected to produce for the firm an annual commission of at least £1,000 as their side of the bargain, but it was not an easy system to enforce. 'In the last quarter,' noted Henry Cottrell in April 1968, 'Research absorbed 13% of the firm's salary bill and used 14.8% of all people. I cannot convince myself that this is an inadequate allocation.' However, granted the larger stockbroking context of a system of minimum commission that made it almost impossible to compete exclusively on the basis of price, it was imperative to look elsewhere in order to add value. In practice, as Ranald Michie persuasively argues in his history of the Stock Exchange, that primarily meant research – the area, after all, in which Phillips & Drew had made and was continuing to make its name. Other brokers might be starting to employ public relations firms, but such was the strength of its research that Phillips & Drew rightly felt no need to do so.

There was one other important element to the research effort. Michael Hall, who had read statistics at University College London and worked for Unilever and BP before joining the firm in 1960, was starting by 1964 to get seriously interested in the possibilities of using computers for the purpose of investment analysis. Whereas the Weaver/Fowler paper of 1960 had essentially focused on making profit forecasts on the basis of analysing balance sheets and so on, what he wanted to do was to convert those forecasts into what the share price was actually going to do. In due course, given a free hand by Weaver and Gibbs, and using statistical methods to analyse the data supporting share prices, he developed an eight-dimensional yield curve model that, for its time, was truly ground-breaking. By July 1965 he was producing, at this stage for internal purposes only, a weekly list ranking over 120 shares 'by the "computer method" of evaluation in order of attractiveness'. On 2 July the top-ranking six included Viyella, Gallaher, Pressed Steel, Dalgety, and Rediffusion (up from 87th position the previous week). 'We would re-emphasise that we still regard the computer ranking as experimental although the results so far seem quite encouraging,' noted Gibbs in an accompanying memo. That autumn a specialised computer was ordered (at a cost of about £650) for the purpose of computer-ranking calculations, and by 1966 the rankings were being made available to interested clients. Not everyone was enthusiastic. In its round-up of insurance companies in November, the equity table noted that one (Manufacturers Life) was 'believed active in Equities but don't like computer – prefer hunches, stories, etc,', while another (Royal) 'laugh at computer'. In January 1967 the results came through of an informal competition that GEC had been running over the previous year, in which sixteen stockbrokers were asked to select ten shares each. 'The fact that we came second is perhaps a little disappointing,' conceded Hall in his report, 'but we may console ourselves by the fact that little effort was required on our part in taking part in this competition whereas the selections by other brokers may well have caused some "head scratching" '. Hall added that GEC's man had 'made the point that some brokers find difficulty in choosing ten shares, whereas we would be quite happy to select fifty or more (looking

back to our pre-computer days I think that we would sympa-
thize with the other brokers' difficulties)'.

Later that month, Weaver and Hall submitted a paper,
called 'The Evaluation of Ordinary Shares Using a
Computer' and largely written by Hall, to the Institute of
Actuaries. They put in helpful context 'the advent of comput-
ers':

> Over the last decade, their use in business and industry has
> shown a remarkable increase and more recently this trend
> has itself been felt in the investment world. In the latter field
> the computer has, at least in the U.K., been mainly used for
> accounting purposes although on the gilt-edged side [includ-
> ing at Phillips & Drew] it has been used for the calculation of
> redemption yields and, in fitting yield curves, used in connex-
> ion with switching techniques. In contrast the computer has,
> until very recently, made virtually no impact in the field of
> equity investment and even now little attempt has been made
> to use it to make actual investment decisions (as opposed to
> the processing of historical data) in spite of the availability of
> powerful statistical methods.

Getting their retaliation in first, the authors noted how 'any
suggestion of a formalized approach to the evaluation of
ordinary shares inevitably meets considerable criticism from
those who regard investment as an art and not a science and
to ask what help a statistical approach can give to the solu-
tion of a problem in which individual judgment plays so large
a part'. The main body of the paper gave details of how the
firm's share-evaluation model related the dividend yield for
each company to such factors as historic and future growth,
earnings variability and dividend cover that, taken together,
enabled the model to give a qualitative assessment of the
relative cheapness of each share. 'There were those who did
not believe that there could be a rational system of share
selection,' acknowledged Weaver during the critical but not
unfriendly discussion. 'Those were the "random walkers". If
actuaries could not answer their case they would have to
abandon their claim to investment skill and merely invest in
the averages.'

For almost the rest of the decade all the firm's recommen-

dations were computer-based, while there were also various computer-managed funds, including the Barbican Investment Trust for private clients. The model's results continued to be quite good, but it was criticised for tending unduly to favour high-yield shares. Moreover, in the subsequent words of Gibbs, 'nobody likes to be dictated to by a computer'. It also cost the firm in terms of favourable publicity, with Gibbs noting in November 1969 that the *FT* had hardly mentioned Phillips & Drew that year, in his view 'largely because the present authors of the Lex column (particularly John Percival) do not see eye to eye with us over our "mathematical" approach'. It was the beginning of the end, for from the following month an alternative series of recommendations was started, based on the analysts' purely subjective judgment. Perhaps it was the inevitable price of being a pioneer, but it might have made a difference if the computer rankings had been introduced with less of a thunderclap.

Meanwhile, however investment decisions were taken, there was no stopping the pension funds. By 1967 almost half the British workforce belonged to occupational schemes, as pension funds, in their capacity as investors, increased their share of the equity market from 6.5% in 1963 to 9% in 1969. At Phillips & Drew, the pension fund department in the 1960s dealt mainly for medium-sized funds in the private sector as well as for a variety of local authority and other funds in the public sector. It continued to be run by Macaulay, whose two main supports during the decade were Sparks and Terry Cann, the latter having come to the firm in 1959. By February 1969 the department comprised three partners and seventeen staff, enjoying a rather less frantic way of life than in the institutional trading departments. 'The clients accept that we are their specialist advisers,' noted the firm's introductory brochure, and went on:

> They usually take our advice once they are satisfied that the advice is responsibly given and so long as the results continue to be satisfactory. So the whole atmosphere of work is more relaxed – although this does not mean that the pressure of work is any less. There is somewhat less telephoning and rather more letter writing, and this calls for an ability to get

to the heart of the problem and to present the case lucidly
and imaginatively. Correspondence is, however, often supple-
mented by meetings as may be appropriate.

Gradually, but only gradually, the department's work was
shifting from an advisory to a managing basis. It was a change
that Macaulay and his colleagues welcomed, though
inevitably it increased their responsibility. The department
consistently took a long-term view of things, a perspective far
removed from that of the 'go-go' fund managers of the late
1960s, and there was never any suspicion of 'churning'.
Somewhat cut off from research, it was not the most innova-
tive department in the firm, but it was becoming an increas-
ingly important one. Between 1965 and 1969 it earned
roughly 13% of the firm's commission, its revenue was grow-
ing faster than either the gilt-edged or the institutional
equity departments, and as Henry Cottrell observed in
January 1968, 'a revenue per head per day in the £70 area
puts the department clearly in the big league'. Among other
stockbrokers the firm's main rivals at this stage included de
Zoete's, Fielding Newson-Smith, Grievesons and Pember &
Boyle, but increasingly the most serious competition came
from merchant banks, perhaps above all Schroders and
Warburgs. Cottrell in July 1967 expressed pleasure that the
department's number of active clients had increased to 86
(compared to 74 a year earlier), in that 'having regard to the
steady pilfering by merchant banks, it is important to keep an
adequate influx of new funds and the record of active clients
is a check on this (albeit imperfect)'. Increasingly, there was
little love lost. Stockbrokers resented the freedom of
merchant banks to advertise for new business, while the
merchant banks for their part were becoming distinctly
resentful of an uneven playing field in which stockbrokers
did not need to charge a fee, whereas they had to charge a fee
as well as commission in order to make a profit. Phillips &
Drew's cause was not helped by Pip Greenwell, who in the
City's parlours was wont to publicise his view that it was not
the proper business of a stockbroker to run a pension fund.

From the firm's point of view, the single great shot in the
arm for pension fund business was the Trustee Investments
Act of 1961, which for the first time enabled trustees with

restricted powers, including those local authorities which had not promoted their own Acts, to put up to half of their funds into equities. Inevitably this opened up hitherto out-of-bounds investment possibilities, and the traditional policy of leaving the management of the fund entirely to an insurance company no longer seemed nearly so attractive. A further positive element in the picture was the reorganisation of local government in the mid-1960s, which created a raft of new metropolitan boroughs with their own high-potential pension funds. These local authorities were large enough to employ as many as three or four brokers each, meeting them at quarterly intervals and delegating responsibility to different brokers for different fields of investment: gilt-edged stocks to one, equities to another. Policy would be discussed at the quarterly meetings, but in the execution of it Phillips & Drew found itself given an increasingly free hand.

To start with, this was the case primarily in gilts, as the City of Manchester Superannuation Fund story showed. In July 1966, the day before the World Cup Final, Fison and John Perry (a colleague in gilts) were on Bobby Charlton's home patch:

> This visit was part of a carefully laid plan to ensure that when Grieveson Grant complete their two year trial period of gilt-edged switching in December 1966 we take over for the following two years. . . . We managed to obtain the information, for which we had in fact gone to Manchester, that after earlier losses Grieveson Grant in the first 18 months or so had achieved the switching profit of £11,000 on a portfolio consisting of £8 millions British Government stocks and £4½ millions Corporation stocks (though it was not clear what proportion of the latter was in marketable securities); there had actually been a net loss at a fairly recent stage. This, of course, is a rather poor result and is about what we had hoped for; if Grievesons had made a complete mess of it there would have been a risk that Manchester would stop switching altogether at the end of 1966.

Fourteen months later, having taken over the gilt-edged switching of the pension fund in February 1967 and already made a net gain of some £15,000, the two were back in

Manchester to see the City Treasurer, with whom they had 'an extremely pleasant meeting':

> The only point perhaps worth recording is that since Mr Page is very sensitive, as are his members, to the commission levels involved in gilt-edged switching, I made various points about the sort of operation we were carrying out and referred to the commission levels. My specific point was that one particularly big operation we have currently opened for them (in about £1.6 million money) might make the Fund a ¼ point profit if the market rises strongly but could make two points in a roaring bear market. After the main meeting, we spent a few minutes with Mr Fox, who I think handles the book-keeping side and is the man we ring at Manchester if we have any queries. A very friendly person who is very interested in what we are doing and in seeing the different types of operation we carry out as compared with Grieveson Grant. He commented that he was all in favour of gilt-edged switching, since he had received a modest salary rise from the Corporation as a result of the extra complexities involved.

It was Manchester that, two years later in 1969, became the first big local authority to move to having a managed fund on the equity side as well, with Warburgs as well as Grievesons sharing a third each of the task with Phillips & Drew. Eleven years after the original prestigious appointment on Manchester's part, it was a further significant move by Harry Page, one of the firm's key friends in the north.

In all the various aspects of institutional business, a huge amount of time was spent worrying about relations with clients. In 1962 there was established on a permanent basis the Institutional Clients Committee, whose brief was (in Rashleigh's words) 'close control over the correlation of service, or lack of it, given by P. & D. to institutional clients and the business arising therefrom'. From spring 1964 the ICC became increasingly active, looking at client relations both individually and generally in ways that attempted to go beyond inevitably rather narrow departmental concerns. At its meeting that October, for example, it not only scrutinised the contribution of particular clients across the board, but discussed appropriate tactics and etiquette on the occasion

of inviting an institutional client to lunch at Lee House. Various points were made:

> It has been fair in the past to assume that the benefit of having guests to lunch was the chance of showing them round and impressing them with our size and general image. For any guest this can be done once, but other reasons are needed to justify repeat visits.
>
> It is desirable that the host partner should be fully briefed about his guest – and, if possible, that partners generally should be much better informed than they are now.
>
> If guests are invited, normally with an end in view, this will mean some definite business discussion and perhaps frank questioning. To make the lunch into ninety minutes of intensive grilling – perhaps in the company of our guest's competitors – would be highly undesirable, but ten minutes quiet probing at an opportune moment would be quite fair – and expected by a guest. However, it would be left to the partner concerned to exercise judgment as to the extent to which he pressed home his attack.

Shortly before Christmas, Henry Cottrell circulated a memo detailing how many guests each partner had entertained at lunch in the course of the year. Macaulay was easily top with 70, followed by Fison (38), Rashleigh and Henry Cottrell himself (37 each). Cottrell added that 'those partners dealing with institutional clients who have low scores may like to consider whether they are making sufficiently frequent contact with their clients'. It was unfortunate that the Budget the following spring disallowed the cost of entertainment as a charge against tax. Rashleigh, though reputedly a Labour voter, was undeterred. 'My view,' he declared, 'is that whatever the Chancellor's intention, we cannot completely stop entertaining our business associates.' And he added that 'so long as we maintain relatively simple eating and drinking habits the cost advantage in eating out would not be sufficiently great to justify abandoning our luncheon room'.

There was also an increasingly systematic emphasis on visiting clients. In January 1965 the temporary committee formed by Rashleigh, Cottrell and Weaver made the position clear:

Visiting clients (as distinct from image projection to clients' bosses) should be hard work and not a pleasant social interlude. Our clients are busy people and if, after we have left, they wonder what we came to say, we have probably done harm, not good. A person visiting a client, therefore, should first get a thorough briefing (the Institutional Clients Committee proposals will lead to a central file giving a lot of background material rapidly). To show ignorance of your client gets a black mark. Next, one must decide what one wants to do at the interview. At the interview itself, one must balance between letting the client choose the subject and attaining your own ends. One must be particularly receptive to hints, especially of our weaknesses, of other brokers' activities or avenues that might repay exploration. Finally, upon return, a written report is essential.

There were few more assiduous compilers of such reports, or energetic visitors, than Fison. Some extracts from the account of his visit to Edinburgh in October 1965 give the authentic flavour of a hard-working man working for a hard-working firm in what was perceived as a competitive environment:

SUNDAY 10TH OCTOBER
Road-Building Companies – 10.00 p.m.
Met a young executive of Limmer and Trinidad in the airport bus who said the cut-back was just hitting them. Large projects deferred six months and then subject to review.

MONDAY 11TH OCTOBER
Midlothian County Council – 9.00 a.m.
Spent a pleasant hour with Mr Geddes (Treasurer) and Mr Brown. We have just completed first two gilt-edged switches. Mr Brown worried about drop in running income whilst switch open. B.H.F. [Fison] explained about redemption yield making up difference; anyway the fund is growing. Mr Brown merely agreed there were two ways of looking at it; Mr Geddes clearly grasps the whole concept, but did not help me to persuade Mr Brown. Mr Geddes was mildly critical of inconsistency in recent report by Pension Fund Department (details to R.I.M.M.). Offered me lunch at his

115

golf club (declined as lunching with S. Rose), then ran me over to my next call in his Jaguar.

Baillie Gifford – 10.30 a.m.

Saw Mr Dawson and Mr Hunter. Both denied being gilt men, but kindly talked gilts for an hour as they knew it was my subject. Pension fund gilts virtually all long. I said could stay long and switch or diversify now and use 'system' – the latter not described in detail. They agreed they would have to rely on us (or people like us) for all the technicalities, just deciding policy. I felt they were very sympathetic and it is just a public relations task to tip them over the edge into dealing.

Distillers – Noon

Visit specifically to sell 'system' to Stanley Rose. He appeared already 'sold', having received the handout in advance by post, so we discussed a few operating details, frequency of actual dealings etc. He then began to consider problems like whether the stock should be held in London, which sounds as though he accepts the idea completely. At request of J.K.T. [Taylor] asked if we were failing in the equity field as result of several rapid changes of personalities on equity table. He agreed we had 'slipped in the league table' but being a complete gentleman had no criticism to offer, merely agreeing that the personal relation was important. Took Stanley Rose to lunch.

Standard Life – 3.00 p.m. (My old office)

Saw Simon Keppie. Two large gilt holdings, Treasury 5½% 2008/12 and War Loan (already known). Untouched for years, might switch when accountants finally, if ever, agree the tax position. When switching will be delighted to bring us in. Would not switch into mediums now – inconsistent with liabilities. B.H.F. said these can be ignored for short-term large gain, left him with chart prepared for Cumberland. Keppie appeared very much above the battle.

Faculty Students' Society Meeting and Supper – 5.00 p.m. to midnight

Sat next to Jim Patterson, the Society's new Hon. Secretary, who is with Life Association of Scotland. Only four actuaries, too small an office to get the best staff, no actuaries in the investment department, but he kept breaking into questions about investment. Wanted to know if I was likely to call on

them. New money about £2 million p.a. Perhaps I had better make a return visit to tidy up this loose end.

TUESDAY 12TH OCTOBER
12.30 to 1.30am. Small party invited to Hotel proved about sixteen strong; Scots hard to shake off. Mostly drank coffee (including gentleman from Greenwell & Co); Peter Derby of Scottish Widows investment department (equities) was there.
Schroder, Wagg – 1.30 to 3.00 a.m. Invited I.L. Salmon FIA to share my bedroom (spare bed). Discussed equity switching, system, future of the profession etc. Under oath of secrecy gave him copy of 'system' handout, which will be handed back at lunch the week after next.
National Commercial Bank of Scotland – 10.00 a.m. Mr Kelly, a delightful person as reported [earlier] by B.H.F. and B.H.B. [Bavister], though a straight speaker. Gilt switching banned. Reason: some top brass ignoramus asked to see the open switching book, saw three out of four showing losses and cried 'enough'. Spent an hour on *100 Companies* and computer ranking. Says we have changed our methods far too frequently with no other explanation or other public relations over the last few years. Would still like full security analyses, though perhaps a little shorter. He also levelled the criticism (which I meet once somewhere on every trip) that it drives him wild to get a salesman who just reads out the Moodies card; also he has the feeling that he is always handed on to the newest and most junior man of the equity table; I told him to get the facts from the research department. He had become confused (as had other clients) by our rapid staff changes, and requested an up-to-date organisation chart. *Equity contact please arrange.* We discussed John Brown, and he agreed with our reservations about the shipbuilding. He had a go at me over the Butlins rating, which I defended. Somehow we got on to Joseph Sebag (with whom he spent a month after his month with us) and said he thinks their organisation, compared with our departmentalisation and specialisation, is a shambles. The discussion slowed down after 75 minutes, and I asked what he felt was the ideal interview length, and whether 90 minutes was too long. He said it was above average but reckoned a lot of brokers calling on him were just killing time. I told him I

would have preferred to visit the Forth Bridge to sitting in his office, and he said if I had mentioned it earlier he would have driven me over and we could have talked in his car.

Scottish Widows – Noon

Saw Mr Lunan (hobbies: badminton, gliding, mountain walking) who is their fixed-interest man and who had been at the party. Have not moved anything from longs to medium, but has put a little new money into Treasury 6½% 1976. Being kept busy by debenture placings. Took him to lunch in fish bar at the Café Royal – recommend it to Partners.

Caledonian Insurance – 2.15 p.m.

Had a pleasant hour with Mr Reid. He has done virtually nothing in gilts since the Budget, cannot fathom their tax position and will do nothing until he can; B.H.F. wondered if there is any help we can give all those life offices to interpret their taxation basis (thought for H.C.C.) [Cottrell]; would establish very valuable goodwill, and could even get a Press mention if we produced a definitive booklet. Although not dealing in gilts he welcomed my offer to keep him in touch with major market developments.

Returned to Scottish Widows to give them names of research department against initials. Their two copies of the *100 Companies* had not turned up and Mr Pike said they frequently had trouble with non-arrival of P. & D. circulations. I rang D.W. [Weaver] to send two more *100 Companies* and someone had better investigate this story. Left 4.00 p.m.

6.45 p.m. London Airport. Discovered I had used the 'financially' wrong car park. Must hide the cost amongst miscellaneous travelling expenses. For guidance of Partners who may not know I found there were very cheap off-airport parking facilities, involving delivery of passenger to airport on departure and delivery of car to passenger on arrival. Further details B.H.F.

No apology for length of report. These are hard times and any nuance may be vital to the Partner concerned and get one extra order.

If the trip had a disappointment, Fison perhaps reflected, it was in the failure to meet anyone useful in the airport bus after getting off the plane.

There was rather less sense of a thrusting meritocracy in the private clients department, which through the 1960s continued to be run by Jos Drew and Bill Hall. It was very much a world of its own, not integrated into the mainstream of the business, and the room in Lee House that Drew and Hall occupied was the only one with solid walls. Whatever the larger revolution in investment analysis, dealing for private clients was firmly considered by Drew, a stockbroker in the pre-war mould who never did anything but private clients' work, to be an art rather than a science. When the young David Walton Masters worked under him in the late 1960s, he was treated to five bits of timeless advice:

Trees do not grow to the sky.
It's never wrong to take a profit.
One tip is worth a million analysts' hours.
Bullshit always baffles brains.
If you've got breeding, it may help. If you've got brains, it may help. If you've got both, you're unstoppable.

Drew and Hall rarely ate with the partners, preferring the City Club; and, more significantly in terms of causing a certain resentment, they owned a big share of the equity but contributed relatively little to the profits. 'I do not believe that the partners are wholly behind the Private Clients Department,' remarked Rashleigh in July 1963, 'and I challenge partners to recollect how often in the recent past they have volunteered a confident recommendation of our private clients service to their friends or business associates in the same way that they might, for instance, push one of the other departments.' He added: 'I believe the reason for this negative attitude is not necessarily because the department is inefficient, but more likely because it is inbred and no member of it from the partners downward has ever had any connection with the institutional side, and in consequence no one has any clear idea of what makes it tick.'

Later that year Drew and Hall agreed, perhaps reluctantly, that Henry Cottrell should spend six months 'examining the whole running of the department, with a view to advising us on any improvements or economies which could be made'. Cottrell duly produced a report in July 1964. In it he

concluded that of the department's 5,000–6,000 clients there would 'always be a large group of small people upon whom we lose money' and that 'to devote more resources to them will merely reduce the partners' income and the staff bonus'; that there was 'no evidence of unsound advisory policies or practices', but that 'the new management technique of portfolio performance testing should be adopted as widely as possible as a tool of management'; that Hall's side of the department was contributing barely £3,000 a year to partners' profits, while Drew's side was actually running at a net loss; and finally, that the more small clients that could be pushed into the Barbican fund, the better.

The next year or two proved rocky indeed for the department, not helped by the election in October 1964 of a Labour government, draining away private client confidence. During the year 1965/6 the department's bargains (20,065) represented only 49% of the firm's total bargains, compared with 64% in 1963/4, and by late 1966 the revenue/salary ratio was down to an almost disastrous 2.1. Thereafter, however, things gradually improved. 'Profitable on any reasonable basis of assessment', was Cottrell's verdict in July 1967, and 'We are clearly progressing' in April 1968. Nevertheless, as he noted in October 1968, there persisted 'the problem of small uneconomic bank orders', in particular the fact 'that Barclays' branches shoot a lot of queries at us, and a whole lot of orders worth only £3 6s 0d commission apiece – so we lose all ways'. Accordingly, 'we propose to make the advice more of a "production line" operation to stop it distracting people with the knowledge and experience to handle more valuable bargains'. Overall, the department just about paid its way. Revenue in the year to August 1969 totalled some £232,000, a 160% increase on the year to November 1964. That, however, represented significantly lower growth over the period than in any of the institutional trading departments; while the department's manpower requirements by 1969 of three partners and some twenty-three staff made it almost as populous as the institutional equity department, which even with its somewhat disappointing performance was producing virtually three times as much commission. It remained an open question what would happen to the department if either there was a vicious bear market or there were no

longer Drew and Hall at hand determined to preserve it. The loans department under Michael Cohen was also becoming something of a world of its own as the 1960s unfolded. Back in 1957, responsibility for loans to local authorities had passed from the private clients department to the gilt-edged department, and in 1959 Henry Cottrell spent much of his time engaged in a tedious but fruitful trawl of the country's town halls. Revenue from local authority loans almost trebled in the financial year 1959/60 – up to £27,270 – and loans became a department in its own right, overseen by Cottrell but run on a day-to-day basis by Cohen. Lending to local authorities was, Cottrell assured his partners in October 1960, a high-quality business: 'It can cause little concern, it leads to pension fund business, the borrowers are all of trustee status (though temporary deposits are not) and our lenders are as near safe from default as anyone can be in this world'. The department was also by this time starting to lend clients' money to hire-purchase companies and, at short call, its own and clients' money to some discount and accepting houses in the City. 'We will not lend to anyone unless we believe them to be of unquestioned soundness,' added Cottrell. 'It is not worth taking an extra $1/16$ in the rate because you have doubts about the borrower.'

By July 1961 it was estimated that the firm had the third largest local authority money-broking business in the country, and the following March saw Cohen in typical action, visiting three local authorities in the north-west in the course of one Monday. They included the City of Liverpool, where he had a useful chat with one of the assistant treasurers, Trevor Jones, but particularly interesting was his session with the deputy treasurer of the County Borough of Birkenhead:

> Mr Lee said that he preferred our money service to that of either Long Till or Short Loan. Both he and other local authority officials greatly resent Long Till's patronising attitude and Mr Lee himself is greatly irritated by Short Loan's habit of booking personal calls to him, and then not being available when the call comes through to the borrower. He prefers our response to an order for money, which he found clear, to that of these other brokers who use rather vague expressions such as: 'We'll see what we can do'. When dealing

with them he does not get the feeling that they will definitely
find him the money for the day on which it is needed.

A year later, in March 1963, the department started to
become involved in the business of arranging inter-bank
deposits – like local authority loans, a vital part of the so-
called 'parallel' money market that was by now starting to
represent a huge challenge to the traditional discount
market. Clients included a wide range of merchant banks and
foreign banks, and Cohen noted in January 1964 that 'the
commission is earned on inter-bank deposits by charging
borrower and lender a running l/32nd'. Cohen continued to
find new clients. He informed his partners in April 1965 that
'we had started to place temporary money for Hogg,
Robinson & Capel-Cure who had previously used de Zoete
& Gorton exclusively': in that September that 'he was now
doing money business with BOAC'; and in October that 'we
are now dealing in short money for Peninsular & Oriental
subsidiaries'. Gradually, very gradually, the discount houses
started to stage something of a comeback. In May 1967,
commenting on the department having in the most recent
quarter produced revenue of £31,439 and absorbed salaries
of only £3,809, Cottrell's optimism was qualified: 'The main
problem is whether the others in the market realise how
profitable the activity can be. Steadily discount houses are
acquiring or setting up money broking subsidiaries and so far
they have not gnawed significantly at our business. But it
would be folly to look lightly on the threat they could repre-
sent.'

It was important, therefore, to continue to innovate, and
there were two notable examples in the late 1960s. In autumn
1968 the firm was in right at the start of secondary trading in
sterling certificates of deposit (CDs) achieving by summer
1969 an 8% share of the market, which Cottrell adjudged
'highly creditable'. He also helpfully explained how this
instrument worked: 'A lender wishes to lend money for ten
months. A local authority wishes to borrow for 366 days. A
bank will lend to the local authority provided we will issue
their CD for 366 days at an appropriate rate. So we take up
the CD ourselves, sell it to the lender, and arrange repur-
chase in ten months' time at a fixed price.' It was complicated

business but a significant development, and the firm became increasingly active in putting clients' money into sterling CDs, offering as they often did a better return than lending to local authorities. The other innovation, however, *was* a local authority loan, when in summer 1969 Cohen, in conjunction with Twist, pulled off a loan to Derbyshire County Council of DM50 million for six years from the London office of Investitions-und-Handelsbank, which was acting for a German consortium. It was the first foreign loan to a British local authority and created considerable publicity for the firm. Taking the period 1965–9 as a whole, the loans department produced almost a tenth of Phillips & Drew's gross commission. It was not exactly what most people thought of as stockbroking, but it was nevertheless valuable, quite apart from the various entrées, to both local authorities and City houses, that the business provided.

There was one other business-getting department at the start of the 1960s. This was the foreign (later called the overseas) department, which Fleming, assisted by Larkin, was in the process of building up after his move from research. Sadly, he died suddenly in the office in November 1960 at the close of a business day. As a result, Nowell, who had some German and Italian as well as four years' experience of business on the Continent, transferred from research to join Larkin. Progress, mainly in selling British shares to the foreign institutions but also in selling overseas shares to British institutions, was patchy. At a partners' meeting in January 1962, Swan 'suggested that the department was trying to cover too much ground geographically', Henry Cottrell 'raised the question as to whether settlement work in connection with overseas bargains now carried out by the department could not be transferred to the General Office', and overall 'it was agreed that the Overseas Department was partly in the nature of a service department but it was generally felt it should be expected at least to cover its own costs and not to be subsidised by other departments'. Soon afterwards the Stock Exchange let it be known that it was considering allowing stockbrokers to open offices abroad, and Larkin was asked to write a memo on the firm's policy if this came to pass. His conclusions were negative – that 'it would be unwise to rush in and open offices abroad immediately',

that 'it is unlikely that we should have the trained personnel available', and that anyway anything that could be done from a foreign office or offices 'can be achieved just as well from our London office' – and his partners concurred, though noting 'it might be that in the future considerations of prestige might compel us to reconsider the question'.

Over the next year and a half, morale in the department does not seem to have been particularly high, to judge by a report that Jimmy Morrell (who was doing overseas research for it) wrote in November 1963:

> The focal point of the department's activities in the past three years has been the prospect of the United Kingdom's entry into the common market. If this had come off, the demand for stocks would have risen strongly in both directions. The outlook for business deteriorated following the breakdown [in January 1963] of the Brussels negotiations. . . .
>
> Any client buying a foreign stock through P. & D. pays two commissions, one abroad and one to us. The only justification for doing this rather than going directly to the foreign market, is on grounds of superior service and dependable advice. . . . Recommendations invariably need to be in writing. For most clients – British dealing abroad, or foreigners dealing in London – there is little familiarity with foreign stocks. For this reason, it is very exceptional to be able to 'punt' a stock to the department's clients by telephone.
>
> Clients tend to be less active in their foreign holdings. Moreover, the range of stocks dealt in is narrow, and there is a reluctance to look at cyclical stocks. The proportion of a portfolio devoted to foreign stocks is generally small. . . .
>
> The department's staff has to maintain a general knowledge of U.K. stocks. Each member has in addition to maintain general knowledge for the countries he is responsible for. Also, the department has to cover up for absences due to holidays and foreign travel. The strain is considerable and has to be contrasted with other departments where the range of activities is much narrower. . . .
>
> Comparison with other departments leads staff to wonder whether advancement in the firm may not depend upon the luck of the department to which one is assigned. If advancement depended solely upon commission earning no one

would willingly serve in the overseas department. . . .
Members of the staff from other departments should be
drafted into the overseas department from time to time. The
difficulties of the department might then be more widely
appreciated. The overseas department's staff would willingly
transfer into other departments.

Morrell's complaints did not elicit enormous sympathy from
the partners, though the larger point was conceded. 'We must
admit that we are way behind in foreign investment,' wrote
Swan the following month. 'A lot of brokers do a lot of busi-
ness without any research department comparable to us. A
partner of Rowe & Pitman has just come back from at least
two weeks abroad; Cazenove have a good business. Hoare's
do a good business in America, without mentioning Vickers
and Japan and Europe, Strauss Turnbull, Simon & Coates.'
The chronology is a little uncertain, but what appears to
have happened over the next year or so is that the overseas
department ceased to function as a fully-fledged department
in its own right, though Nowell continued to take a particu-
lar interest in overseas matters. Realistically, was a big oppor-
tunity being missed? Some quite strong arguments would
suggest not: the 1960s was still the world of exchange control
and the dollar premium; the notion of a global 24-hour
market remained in the realm of science fiction; London
itself was an overwhelmingly domestic market; and, specifi-
cally in terms of opening overseas offices, the partnership
structure was not ideal to meet the costs involved. It is easy
now to forget just how insular the outlook was of the post-
war British investment community. 'Practically no interest in
Europe' was Twist's finding on his November 1962 visit to
the Scottish institutions, and that was even before de Gaulle
said '*Non*'. There may have been straws in the wind pointing
in the opposite direction – above all, the start of the
Euromarkets and the accompanying invasion of American
banks – but to claim that, at this stage, Phillips & Drew badly
missed out in terms of international business is perhaps a
case of jobbing backwards.
Finally, in this lengthy review of the firm's business in the
1960s, there was the question of new issue finance. In one
distinct sphere here the firm was near the forefront, namely

the local authority one-year ('yearling') negotiable bond. Following Treasury authorisation, Warburgs did the first one in February 1964; and Phillips & Drew started issuing them that summer, going joint with Morgan Grenfell. It was not only profitable business, despite having to share commission with Morgans, but also, as we have seen, had the important incidental effect of getting the firm much closer to the discount houses and the short gilts market. Among stock-brokers, the only other pioneers in this issuing were Grievesons, but Phillips & Drew quickly established a greater share of the market. By the beginning of 1966, out of £138 m quoted local authority bonds in existence, the firm had issued £34 m, almost a quarter.

During the decade as a whole, however, the larger question of whether the firm would have a future as a major corporate broker remained essentially unanswered. In September 1962, following what he called 'the embarrassing contretemps with Robert Fraser and Partners and Royston Industries', Rashleigh distilled his thoughts – typically conservative, in the eyes of some – on 'New Issues':

> Primarily we are substantial and successful stockbrokers and we should not engage in any business outside broking which seems to involve a real danger of damaging our image in the eyes of our institutional broking clients, present and prospective.
>
> We are keen to develop our new issue business but we can afford to be patient. . . .
>
> So far as public flotations of new companies are concerned, we have a strong preference for working with a merchant bank (at present Warburgs is our favourite).

Others were less cautious, and at a meeting a week later 'the partners did not feel as a general proposition that the services of a merchant bank were invariably necessary even in the public flotation of a new company and also in particular that Warburgs did not appear to merit any favourite treatment'.

The question continued to simmer, and in February 1964 Henry Cottrell advocated a systematically more aggressive approach to corporate finance (though that term had not yet

been coined). He pointed out that the firm had been 'given only one issue by a merchant bank of its own volition', argued that 'there is no need for us to press a client to bring in a merchant bank for a fixed-interest issue of up to £10 million', and as for equity issues took the line that 'we should always try to hold them for ourselves if we possibly can', given that 'rarely is the amount likely to be too large for us and, much more seriously, if a merchant bank gets in, they often stay in'. Interestingly, he cited the recent Ross Group issue, done by Kleinworts with Phillips & Drew and Borthwicks acting as co-brokers, and insisted that the firm would have had no difficulty underwriting the full £5.5 million. Indeed, 'my own view is that, if the thing is practicable, underwriting potential is certainly very much larger than this'. Nevertheless, Cottrell conceded, there would be a mountain to climb:

> All this talk of how to handle new issues is fine but first, how to get them? I think that the flow from merchant banks will grow only slowly and, in any case, our remuneration for such issues is relatively small. Self help is needed. We have had our successes in the past, but, as new ones come in, old names drop out. As a crude rule of thumb, you will get one new issue a year (including rights, scrip, debenture placing, etc) for every three companies to which you are appointed broker and our main problem is to get appointed broker. This involves getting down to meetings with directors, attending A.G.M.s, using contacts whether they be pension funds, private clients with directorships or solicitors and accountants who might help.

In the event, this suggested initiative failed to materialise – possibly because there was no one appropriate at hand at that particular moment to pick up the particular ball, but more probably because of continuing fundamental qualms, in particular about the fact that becoming a first-division company broker might be a severe embarrassment to the firm's research effort and indeed reputation. By the late 1960s the firm did have some two dozen company brokerships and between 1967 and 1969 was involved in sixteen new issues in the corporate sector, but this was small beer

compared to Cazenove's, Rowe & Pitman, or even Sebags, each of whom generally had much better relations with the merchant banks than, for a variety of reasons (not least the fund management tension), Phillips & Drew enjoyed. In an obvious sense it was a galling situation – corporate finance, including take-over bids and battles, was sharply on the rise as a City activity, while underwriting was on the whole easy money and the firm undoubtedly had the potential placing machine – but as long as there was this over-protective attitude towards research, Phillips & Drew would have to accept that it was not yet, in Perry's phrase, 'the complete stockbroker'.

While all this was going on, Rashleigh sat in his high-backed chair, a somewhat brooding presence who, some thought, spent an excessive amount of his time either reading the newspapers (often the *Daily Mail*) or attending to his own investments, especially the preference shares of the Sheffield-based building company Henry Boot. Unmistakably 'a tough hombre', in the expressive phrase of one of his successors, he was an autocrat by instinct who strongly resisted the formation of any cliques, but at the same time he was not an interferer and recognised the importance of devolving responsibility.

His main form of devolution was through a committee system that, in the main, functioned extremely well and, in organisational terms, put the firm appreciably ahead of most of the competition. By July 1962 it comprised the Staff Committee, the Institutional Clients Committee, the Research Committee, the House Committee (overseeing the dealing side), and the Premises Committee. Other committees followed over the next few years – including the Sports Committee, the Managed Funds Committee and the Computer Committee – but by far the most important was not established until early 1968, namely the Partnership Policy Committee (PPC). Its initial members were Rashleigh, Henry Cottrell and Weaver, and its duties were 'to examine the global pattern of the business of the firm and to make recommendations concerning the directions to which our main needs should be turned'. The PPC's establishment was in large part a reflection of the growth of the partner-

ship, something that happened in all the leading stock-broking firms following the abolition in 1967 of the legal maximum of twenty partners. By early 1969 there were twenty-four partners (full and salaried), and over the years the monthly partners' meetings would increasingly rubber-stamp the decisions taken by the PPC.

If there was one person in the 1960s who held together the business as a whole, however, it was not Rashleigh but the man sitting opposite him, Henry Cottrell. He kept tabs on all the different parts of the firm, a role that did not always make him hugely popular, and his work-load was prodigious. Traditionally in a stockbroking firm the greatest prestige was attached to deal-making and business-getting; but, much earlier than most, Cottrell appreciated the importance of management and financial controls.

During these years of rapid growth, not everyone stayed. The same day on which Geoffrey Redman-Brown, an Oxford graduate, arrived at Pinners Hall in September 1961, Jim McCarty also started; but whereas Redman-Brown's future lay at Phillips & Drew, McCarty was already moon-lighting as drummer for the Yardbirds, and it was not long before he became a full-time Yardbird. In the course of the decade, competition to attract and keep good staff became increasingly keen, and although titles like 'Principal Assistant' and 'Associated Member' were created in order to try to retain the loyalty of the most promising, in practice there were almost always some people frustrated by not becoming a partner soon enough or indeed at all. Pay above all was an increasingly competitive matter between the leading firms, and in January 1966 it was perhaps no surprise when Swan reported to the Staff Committee 'that Greenwells were unwilling to co-operate in an exchange of salary information'. From 1963 Cottrell kept figures on staff wastage and, at the end of the decade, found that 'of the people joining our service in any calendar year, 5.4% will have left by 31st December'; that 'of the people in our employment on 1st January who have less than a year's service, 22.9% will not last another year'; and that 'of the longer-serving people in our service on 1st January, 14.3% will leave by the end of the year'. Cottrell added that he was 'of the opinion that these turnover rates are not high by

commercial standards', but certainly some of the partners running departments on a day-to-day basis – such as Gibbs at research – felt that the firm did not pay generously enough to be sure of retaining the best staff.

There was also, more indefinably, the question of attitude. 'Over recent years,' observed Swan in November 1963, 'I think some of the partners have been concerned over the lack of enthusiasm of many of the staff directly or indirectly concerned with the trading departments.' He went on:

> The causes of this, I think, arise from our recent expansion both in income and staff. In the old days a man's efforts were more noticeable than today. An order then worth £50 is now more like £5 or £10 percentage-wise in the total day's take. In the old days we all knew if we dealt for A.R.D. Thomson, did a large gilt-edged switch, or did a large equity order. We all knew who did the security analyses. With our size, we seem to be moving towards a civil service approach of 9 a.m. to 5 p.m. and getting away from our purpose of stockbrokers. Below are a few examples typifying this mentality.
>
> *Research.* I wonder how many of them have been to the Box [where the dealers were based] or to the Public Gallery. The Stock Exchange was recently opened in the evenings. I went on one of the evenings with my wife and the only Phillips & Drew man I saw was Phin. J.K.T. [Taylor] asked one of them recently to do a note for him at about 4.45 p.m. to be sent to our clients that evening. He was told that this man went home at 5 p.m. I do not think any of them ever look at the order book either at the equity table or the gilts. Much of what has been said above applies to most of the departments.
>
> *Equity.* A similar position is here. With one or two exceptions, they do not seem concerned at how the rest of the firm works and, although reasonably good at arriving, go promptly at 5.30 p.m. Apart from reading the usual papers, I should not think they do any homework.
>
> *Private Clients.* I have had to interview through the Staff Committee some of the people and I have been very upset to see how parochial they are in their own department with very little knowledge of how the rest of the firm works.
>
> We have many members of the Investment Analysts Society. It would be of interest to know how many went to the

last two interesting meetings, i.e. Rank Organisation and Rolls Razor.

It may be that this state of affairs continues, but I think we should be aware of it. I have seen the new people joining other firms, and with this and other things one hears, I am convinced that we are going into greater competition.

Rashleigh broadly agreed with Swan's diagnosis – 'I do believe he has a case when he implies that there is a certain malaise amongst many members of the staff who do not appear to want to develop their investment expertise and investment contacts outside their narrowly defined office duties' – and it may have been as a direct result that, from January 1964, the staff was told on a monthly basis the estimated rate of bonus earned since the beginning of the half year. 'A dozen years ago we were small enough for everyone to know what was happening elsewhere in the firm and, if we did £1,000 in one day, everyone went home well pleased,' explained Cottrell. 'Now we are so large that no one on the staff can ever know whether hard work is really showing results until the actual bonus declaration.' But, of course, the firm continued inexorably to grow, and in 1966 there began a system of fortnightly lunches specifically 'to improve communications between partners and staff'.

That probably helped, as did the committee system generally, but there was one other area of disappointment. Phillips & Drew was undoubtedly more of a meritocracy than the great majority of other firms, and indeed at a partners' meeting in 1963 Rashleigh successfully enshrined the principle that 'in making new partners we should try to select the best man rather than necessarily choose the next man in a department requiring a partner'. However, if one happened to be born a member of the other sex, the key word was 'man'. In 1968 the membership of the Stock Exchange voted by over two to one against the admission of women, a discouraging backdrop for Bavister to suggest in January 1969 that a member of his department, Elizabeth Long (a former Olympic swimming finalist), should be made an unauthorised clerk and thus given access to the floor of the House. The Staff Committee cautiously approved, though asking partners and others 'in view of the repercussions publicity-

wise . . . not to make this matter public for the time being'. However, Swan soon afterwards 'reported that the Chairman of the Stock Exchange had advised that we did not pursue the question of a blue button for Elizabeth Long for the time being', having explained to Swan that 'following the recent expression of Members' opinion . . . he would feel compelled to vote against such a proposal'. Accordingly, 'the matter was therefore shelved for the time being'. Long herself left the firm later that year and emigrated to Australia. Women in Phillips & Drew probably got a better deal than in most stockbroking firms. But it was a deal with a very rigid ceiling, and up to the mid-1980s no woman became a partner, even though women were allowed to become members of the Stock Exchange from 1973 (and indeed, the firm's Patricia Book had become one of the first women members).

The annual graduate intake was increasingly seen as the prime source of future partners. The Education Act of 1944 had had the effect of broadening access to universities and, more recently, the Robbins Report had resulted in the creation of a large crop of new universities. At the end of the academic year in 1968, for example, twenty-four graduates (of whom five were women) had been recruited by the firm that year and were due to start work over the next three months. Oxford provided four, Cambridge two, and a total of eleven had read PPE, economics, mathematics or commerce. Seeking general promise rather than specialised knowledge, however, Phillips & Drew was prepared to look at graduates in any subject, and most years the class of degree taken by successful applicants covered the whole scale from first-class honours to an ordinary (pass) degree. The firm's approach became increasingly proactive, and in January 1967 there was initiated what became an annual all-day seminar 'for the purpose of improving the stockbroking image with appointments officers and undergraduates, and ultimately to improve our recruiting'. These were also the years when the phenomenon of the 'milk round' developed, and Phillips & Drew was one of the more energetic stockbrokers in sending representatives to the universities in order to compete for a good share of graduates.

Many who came to Phillips & Drew in the 1960s did so because they found something – or suspected there was

something – genuinely exciting and different about the firm. Wigglesworth, for example, was a Leeds man who came down from Oxford in 1963 and declined a rival job offer from the Bank of England, which he found rather stuffy in comparison with the more stimulating atmosphere he encountered during his interview at Lee House. John Lewis, a year later, was interviewed by three other stockbrokers (including Greenwells), but it was Phillips & Drew that seemed to him, already an actuary working at a life office, the most modern firm. Or take the case of Walton Masters, for whom the effective choice in 1967 lay between Hoare's and Phillips & Drew. At the latter he saw Weaver and Macaulay, with whom he discussed Restoration comedy and Joe Orton, and they seemed to him very nice, modest, progressive people; while at Hoare's, they were equally nice, but seemed to be living in the past, and there was much talk of the convenience of the office being only 'a number seven iron from Bank'. In practice, it was not all talk about the theatre. When Philip Williams, having done the Mathematical Tripos at Peterhouse and gone to the firm in 1968, first got his feet properly under the table in Lee House, in institutional equities, he received some moderately friendly advice from Larkin: 'Sit there. Keep your eyes open. Don't talk too much. You won't understand a thing at first.' Or as the firm's recruitment booklet put it rather more encouragingly at about the same time, 'partly because of the progressive atmosphere and partly because of the inherent nature of the business, it is generally the case that people in the firm find the work interesting and intellectually satisfying.'

Everyday life in Lee House was rather different from what it had been in Pinners Hall. In September 1962, six months before the move, Henry Cottrell circulated a memo on the question of office desks for Lee House. 'Grayburn and I are reinforced in our views,' he noted, 'and I think J.R. [Rashleigh] is now satisfied that though he still has a personal preference for wood, metal is more appropriate and satisfactory for our use.' The following February, on the eve of departure, Cottrell sent round another memo: 'As we move to Lee House, I would earnestly ask everyone to make a serious effort to keep the place looking as clean and respectable as possible. In particular I hope that the senior

people will bring pressure to bear on their juniors to main-
tain high standards.' Much enthusiasm, as Gibbs would
recall, greeted the move to the new, 18-storey building that
was part of the Barbican development:

> We thought our new premises were marvellous. The outside
> walls were largely glass and the interior designers had been
> asked to produce an open-plan system in most areas, using a
> minimum number of partitions, so that we had beautifully
> light rooms to work in. All the furniture was new, including
> our desks, and had been carefully colour-coordinated with the
> carpets. The whole effect made a striking contrast to the
> grubby dinginess of Pinners Hall. I remember Peter Swan
> enthusiastically exclaiming, 'We *must* keep it like this!'

It did not quite prove paradise – partly because the building,
like so many erected in the 1960s, stood up poorly to wear
and tear, partly because it was like a glass house and the
people inside tended to fry when the sun shone, and partly
because what should have been large open floors were
awkwardly obstructed by four huge pillars.

There was also the relative distance from the centre of the
City, a fact which directly prompted the not uncontentious
decision to hire an office car. Rashleigh, in December 1962,
defended the thinking:

> The main justification for the additional expenditure [esti-
> mated at £1,700 a year] will be the ability to offer clients
> transport rather than to put them on to the hard pavement
> for a walk of, at best, several hundred yards. I somehow feel
> that 'phoning for a hire car creates the wrong impression and
> is vulnerable to the risk that when conditions are worst cars
> are non-existent.
>
> There are a number of business occasions within the
> London area where we now use taxis or public transport
> where a car will save time and strain. Admittedly, one can
> 'phone for a car but in fact one does not and worse still some
> do and some don't.
>
> It may sound sybaritic but I'm sure that partners lunching
> at the Savoy, Gresham Club or City Club will be very pleased
> of a lift one way if the car is disengaged, and the dealers might

welcome a lift at the close of business.

A variety of subsidiary uses can be imagined.

The objectors I understand to say:

(i) that in some way it will make us soft and harm our image as a tough go-getting firm with no frills;

(ii) that it is an unwarranted expense;

(iii) that one car will soon become a fleet.

As official cars are common practice throughout industry which is a great deal tougher than we are, I am not unduly frightened by (i).

A Humber Hawk was duly hired, and the firm's image does not seem to have suffered palpably.

In Lee House itself, as elsewhere in the City, office technology was gradually changing. Summer 1964 saw the arrival of a round-the-clock telephone-answering service. 'If, at the end of this announcement, you dictate a message,' part of the announcement explained, 'it will be recorded and, as soon as the office opens, it will be transcribed and passed to the partner concerned.' For those thinking of ringing NATional 4444 outside normal business hours, a letter to clients pointed out that 'as this is new equipment in this office, we have no experience of its reliability and, for this reason among others, we must reserve discretion to ourselves as to our action upon receipt of messages'. Typewriters were also entering a new phase. 'We are turning increasingly to electric machines,' noted Cottrell in August 1965. 'The cost is high but the results in greater speed, lower fatigue and better work appear to justify the cost.' The upshot seems to have been a certain amount of keeping up with the Joneses, as the phrase then went, for the following year the committee that concerned itself with office administration expressed the wish that 'heads of departments should satisfy themselves that in each case replacement of an existing model by an electric would be justified otherwise than as an exercise in relative prestige'. In October 1966 the same committee was told by Grayburn that 'there was a need for more calculators' and that 'there was a very good case for the electronic type both from the noise point of view and speed of operation'. He added that four types of machine were on the market, three of them Japanese and one British, and perhaps rather surprisingly it

was the British model (Anita Electronic Calculators) that was plumped for. Much more significant by the late 1960s, however, was the impending arrival of monitor screens in the office showing up-to-date official market prices. The Market Price Display Service, as it was called, became fully operational early in 1970, following an initiative by the Stock Exchange itself, and Phillips & Drew was among the founder subscribers. A dozen 23-inch sets were initially ordered, of which four went to equities and three to private clients. It was the start of what would ultimately be a momentous shift away from the floor of the Stock Exchange.

Above all, however, it was the arrival in the office of the computer that signalled the dawn of what would be irresistible technological change. The firm had been hiring computer time since 1958, initially for the purpose of calculating yields; and in May 1963, two months after the move to Lee House, a memo by Cottrell on 'Mechanisation' discussed the next move:

> Over the years Grayburn and I have seen many computer propositions. Broadly speaking they have fallen down for one or more of the following reasons:
>
> (a) Cost.
> (b) Size, weight and space needed.
> (c) Not of suitable capacity for our job, being either inadequate or vastly too great.
>
> We have never seen a system which was designed for a stockbroker's office and it seemed too great a load on us to take a computer and discover all the ancillaries needed – and to design the applications. So we waited till someone else had done it.
>
> IBM have now introduced a system, specially designed for stockbrokers. Orders have been placed already by Scrimgeours and Hansfords [B.Hansford & Co] for delivery next Spring.
>
> The basic scheme takes input, roughly as the slips leave our trading departments. With this input it proceeds as follows:

1. To sort out all the detail such as number of copies, addresses, etc. prior to preparation of contract (now done by filing).
2. Preparation and printing of contract note.
3. Shared commission ledgers.
4. 'Tickets' for cash bargains.
5. Day book.
6. Checking list.
7. List book.
8. Jobbers ledger.
9. Clients' accounts.
10. Ticket accounts.
11. Dividends.
12. Option register.

Work has already been done on further applications and they can be added easily:

a. Daily clearing house lists.
b. Clearing house ledger.
c. Clients' holdings.
d. Portfolio valuations (exactly as we now do with IBM).
e. Commission analysis (as we plan to introduce on our punched cards).
f. Foreign tax certificates.
g. Gilt price ratio statistics (as we now do with Norwich).
h. Depreciation percentages for investment trusts. (Two brokers already do this, one daily and one weekly.)

Some of these we already do and the introduction of a computer would replace the punched card installation as well as outside contract jobs.

Cottrell concluded by recommending that serious consideration be given to obtaining an IBM computer that would perform these ancillary as well as basic applications.

This was accepted, and IBM in August made its formal pitch to the Premises Committee, comprising Drew and Macaulay as well as Cottrell and Grayburn:

Major advantages of installing a 1440 System

1. You will be using the most efficient accounting system on the market, and will be in a position to benefit from periods of market activity or a general expansion in your business without additional staff or overtime expense.
2. At current levels of business this system will represent cost savings which will increase with an expansion of your activities.
3. You will become experienced in the use of computers which will, before long, be operated by all progressive companies in every field. This will permit you to improve the quality of your service to your clients.
4. The 1440 will enable you to obtain detailed analyses of the sources of your income, and their relative profitability, and to react quickly to any changes which may be occurring.
5. Exploitation of the Data Processing experience already in your firm can be used to develop statistical programmes on your own machines.

For their part, Cottrell and Grayburn anticipated that the installation of an IBM 1440 would produce staff savings of sixteen, ten of whom would come from the general office; while granted that, at the outset anyway, the computer's mainly back-office work would occupy barely one-half of its working day of eight hours, there would probably be elbow room for it to add value on the research side. The partnership did not oppose the Premises Committee, and that autumn an order was placed for delivery in early 1965. The cost was estimated at some £80,000, but in the event was more like £100,000.

During 1964, as preparations were made for the arrival of the fabled monster, day-to-day responsibility rested with Bill Holmes, a particularly able clerk in the general office. 'It was intended to test our programmes as far as possible outside before our own computer was installed,' he reported to the Premises (Mechanisation) Committee in February, 'so that when our computer was installed initially it would take over precisely the same functions as the present punched card installation, and then further stages would be introduced as fast as possible depending on the snags encountered, starting

with contract notes'. This, broadly speaking, was how it worked out. The computer was installed by early summer 1965, contract notes for private clients were produced on it from that August, and over the next few weeks other departments followed. 'Under the old system, if two slips come down late, all the previous bargains get checked, contracts done, called over, stamped etc., and when the last two come they can be whipped through fairly quickly,' Cottrell explained to his partners. The computer will handle contracts in batches: a batch of two will take 15 minutes at least while a batch of 50 might take 25 minutes, so we are trying to run a batch at around 3 p.m. and a batch at around 5 p.m.' In order to allay any unease, he added that 'there is, of course, no desire to stop people dealing' and that 'we will keep the computer and all necessary staff going to midnight if we are still dealing up till 11.30 p.m.'.

By October the computer was performing real functions for almost five hours daily, as well as testing programmes for almost another four hours. Two months later the programmes to read the client's name (at the top of a contract note) from disk instead of repunching it for each contract became operational. 'This,' Holmes explained, 'would mean that the punch girls would be less heavily pressed by the extra load of the scientific work.' Moreover, not only was Michael Hall's share-ranking programme running by this time, but a stand-by arrangement was in place with Messels (which had also acquired a computer) in case the systems failed at Lee House. It was a sensible precaution, for computer usage started to become pretty heavy in the course of the winter. Total computer running time in March 1966 was 384 hours and 27 minutes, and Cottrell noted that 'this heavy operating load involves regular evening working and a number of all-night and weekend sessions'. Accordingly, 'it was agreed to authorise Mr Grayburn to make suitable arrangements over amenities, with particular regard to refreshments and a music programme, whether by radio or Muzak'.

Inevitably, in such a new field, there was a large amount of guesswork involved. Cottrell admitted as much in an important report in June 1966. Asserting that 'one can only be amazed that a decision taken on so little knowledge has

worked out so well', and asking 'Should our next computer be ordered so blindly?', he went on:

> Our 1440 is already running 80 hours a week, it is not yet handling clients' accounts or dividends. But it is handling an enormous range of work, some not even mentioned by IBM (sold transfers) and some much more complex than we then knew (computer ranking was not then introduced).
>
> The kernel of the problem is the definition of our policy on computers over the next five to seven years and will involve judgements as to how large a system we need, what facilities should be included, whether we shall aim to have a comprehensive system or try to handle certain jobs outside, what changes in the methods of working of the trading and research departments must be allowed for (e.g. new ideas on gilts are bound to come, we do not want another machine which is inadequate months after delivery), what changes in the methods of working of the trading and research departments can be imposed in the interests of more efficient working and, finally, whether we should run the 1440 as long as possible with as many 'patches' as are necessary or whether we should contemplate earlier replacement. . . .
>
> This is truly a decision for the partners, a very large amount of money has already been spent and we are talking, probably, of much greater sums. Further, the decisions taken may very well impose organisational and even trading patterns on the firm for a large part of the next decade. These are totally different orders of magnitude from buying furniture.

That was something no one could dispute, and matters came to a head at a meeting of the partners in September:

> HCC submitted a paper on Forward Planning. He explained that he was thinking tentatively of a replacement computer being delivered in the Spring of 1970, having been ordered in the Spring of 1968. In order that any such order should be properly considered, he had started the forward evaluation. This was aimed not primarily at choosing a manufacturer but at establishing the extent of the computer services which would be needed during 1970/75. As a first step the paper set

out to produce a broad outline of the size of firm and business at which we were aiming.

In the discussion, there was considerable scepticism, first, as to whether it was ever possible to produce such long range thoughts with a degree of reliability good enough to justify their use as a basis for policy and, secondly, even if the exercise were worth doing, whether the expansion contemplated was reasonable.

Despite these heavy reservations, it was agreed that the exercise of probing the future in this way should continue, provided that it definitely took second place to maximum exploitation of the present computer, particularly with regard to General Office work.

A meeting of the Computer Committee in late October suggested that it was indeed sensible not to ignore the here and now. Gibbs 'raised the question of punch errors' in relation to the share rankings, though Perry of IBM 'pointed out that an error rate of one card in five hundred was very low'; it was pointed out that until recently 'there had been some 700 bargains which were invalid for some reason not identified and this accumulation went back to January'; and Cann on behalf of the pension fund department 'described a series of failures over the valuation programmes which were causing long delays over the end-September valuations as well as quite uneconomic duplication and repetition of effort'. Another problem was reported by Holmes to the committee in early December. 'There had been an occasion recently when someone had operated the emergency pull-switch', and 'as a result it had taken at least 2½ hours to get the various circuits back in step so that the machine could run'. He added that 'there were suspicions as to who the offenders were, but the suspects denied all knowledge'.

Not everyone, within and without the partnership, was convinced about the merits of the computer. 'This had not been properly sold to the staff,' noted Swan in May 1967 in his précis of comments arising out of a recent staff lunch, 'as they see many people in the General Office still working overtime and the broad difficulties of a computer are not properly appreciated.' That same month, in an attempt 'to establish whether we are anywhere near breaking even over

the computer, whatever that means', Cottrell was somewhat on the defensive. In terms of the general office, although there had been 'a saving of some 21 people', he emphasised that he was 'far from satisfied' in that 'we do not get the proper benefit until a fully integrated system is going' and 'priority has been given to investment records and valuations until recently'. As for investment records, 'it is costing some £25,000 a year and the savings of girls is probably not worth much more than a tenth of that'. Moreover, in terms of key criteria ('speed of access, reliability of data, lack of confusion in the output, and ability to link the various users and suppliers of data smoothly'), he declared that 'every one of these aspects is now worse – and in some cases much worse – than in pen and ink days'. Valuations were better, with no staff economies but an improved quality of product. Mainly, though, Cottrell looked to business-getting to justify the computer:

> We shall never make a computer into a great success by savings in filing girls or contract clerks. The real profit should come from the help it gives in getting business.... If I may take one example, we spend £4,000 on a debenture job for BHB [Bavister]. It is common knowledge that his share of the market, his turnover and his commissions have all grown rapidly. But what is due to the more profitable employment of the team, what is due to general strengthening of the team and development of people, what is due to the expanding market and, finally, what is due to the computer job? I don't know how to price these items, but I do know that BHB would not agree to the job stopping. So I assume that he thinks it is worth at least £4,000 a year....I believe that similar arguments apply elsewhere and I would argue that, one way or another, we probably already make a clear profit on this area.

There was a clear need, Cottrell recognised, to increase expertise, and that autumn an accountant called John Simpson was recruited with a view not only to his becoming Grayburn's successor in due course as comptroller, but also to his making the computer a particular speciality.

By June 1968 the computer had a total running time for

that month of 535 hours and 41 minutes, close to capacity, and soon afterwards Cottrell put forward a submission concerning 'The Next Computer'. An IBM 360 was his strong preference, though Simon & Coates, Mullens, Sebags and Cazenove's had all recently backed Britain by buying computers from ICL. A complicating factor was the client relationship with ICL's pension fund, but commission from this source was in decline – possibly, Cottrell thought, 'due to our having an IBM' – and he was inclined to discount it as a consideration. In due course an IBM 360 it would be; but in either case, Cottrell stressed in September 1968, 'the profitability or otherwise of the next computer will depend upon the machine being increasingly orientated towards aids to business-getting – primarily via research'. If that really was his hope and expectation, the enforced return barely a year later to subjective forecasting of equities must have been a considerable disappointment. It is inconceivable that a forward-looking firm like Phillips & Drew could not have been involved in the computer revolution of the 1960s, but as that decade ended the results of a considerable investment of time, money and anxiety were not yet self-evidently glittering.

Very professional, broadly meritocratic, and sustaining an ethos in which teamwork was preferred to stars, Phillips & Drew had at this stage in its history a unique reputation in the City. By 1968 the firm was securing almost 5% of total Stock Exchange turnover, and it was a remarkable, wholly deserved achievement. Could it be maintained?

In the report produced in January 1965 by the *ad hoc* committee comprising Rashleigh, Cottrell and Weaver, there was a particularly striking passage:

More could be done in meeting clients and in use of outside societies. We have the feeling that honour is now thought to be satisfied if there is a tolerable flow of guests to lunch and a duty analyst attends SIA meetings. (Other departments often send no representative at all). Our view is that a man goes to the Society of Investment Analysts (or any other similar meeting) not only for what the speaker will say, but to get to know and to be known to the frequenters of that body. It means long, tedious and wasted evenings and sometimes one

misjudges and joins a body with no business value. We cannot force people to act in this way, everyone is entitled to his 9.30 to 5.30, but it is inevitable that the people who put their shoulders to the wheel and work hard extra-murally to project the firm's image will make more rapid progress than those who do not.

We are aware that this is sometimes seen as a struggle between firm and family for the man's evenings but we think it fair to comment that few highly paid people (say over £5,000 a year) are able to give all their evenings to their families all their lives. Indeed, many wives of such men have to play quite a substantial part in business entertaining.

This may be hard graft but it is essential if we are not to turn to recruiting blue-blooded, well-connected Old Etonians. And it is the way in which succeeding generations of 'top brass' in Phillips & Drew can be on intimate terms with succeeding generations of 'top brass' elsewhere.

Four years later Bavister was given the task of drawing up a list allocating the responsibility of individual partners for specific institutional clients. His accompanying remarks to those partners concerned also brought out the unavoidable importance of the personal element:

It is expected that the partners named will not merely put these clients on his luncheon list but will make an effort to visit them in their offices – or on the golf links, etc, – and to endeavour to cultivate those at the higher levels and generally supervise and monitor business progress. It is realized that the task may prove onerous, particularly in some instances, but with increasing competition on our traditional research side, we have to look at other aspects of the broker-client relationship.

Considered more globally, the firm was arguably operating under a double pressure. On the one hand, the increasingly general acceptance in the City of the importance of research meant that the firm no longer had that field more or less to itself, while on the other hand, the awkward – if rarely articulated – truth remained that the City was *still* in many ways an old-style environment in which undue weight was

attached to connection and inside information, neither of which was (to put it mildly) Phillips & Drew's *forte*.

Yet whatever the precise balance to be struck between these two differing approaches to doing business, one thing that was certain was the firm's almost remorseless attention to detail. When Sir Roy Harrod gave one of his regular talks on 'the current economic situation' in November 1964, to an audience of about thirty from the firm and some twenty invited investment managers and others, Henry Cottrell's advance instructions included that visitors were to have 'prior charge' on the black chairs at the front of the board-room, that Wigglesworth would take notes in order to produce a written summary afterwards, and that in order to avoid any embarrassing silences during the discussion 'every person attending should have done sufficient homework (e.g. have read the last two or three Harrod memoranda) for him to be reasonably certain of having at least one pertinent question to put'. No event was without a business dimension. 'The Durlacher party had taken place,' recorded the part-ners' meeting in April 1967, 'and was generally considered to have been a great success. Certain comments made by their partners had been noted and were being investigated.' Even in the brave new world of the 1960s, this was not how the great majority of stockbroking firms went about such matters. Phillips & Drew was, in a word, different.

[5]
Volatility in the 1970s

Mirroring the Heath government's ambitious but fatally flawed 'dash for growth', in which inflation was accepted as the price of expansion, the City of the early 1970s had a somewhat feverish atmosphere. These were the years of easy credit, paper empires and new-style financiers, epitomised by Jim Slater. There was a huge amount of take-over activity, while the FT 30 peaked in May 1972 at 543.6. Later that year the Queen officially opened the new Stock Exchange, built on the site of the old one, which had been pulled down in 1967. The intervening five years, in the so-called 'temporary market', had not been particularly enjoyable for either jobbers or brokers. 'We had these rather cramped conditions with a low ceiling to the market,' Birks recalled, 'and the gilt-edged market was in a sort of horse-shoe, so the Akroyd & Smithers pitch was out of sight as far as I was concerned from our telephone and I know I didn't like that.' The new building – comprising not only a purpose-built trading floor but also a 26-storey tower – represented a major addition to the City's rapidly evolving skyline. If this not entirely unbeautiful new building had a message, it was that the City had at last decided to embrace the forces of change and modernity. Events would show that it was not yet a whole-hearted embrace, but at least it was a start.

From spring 1972 there was a new senior partner at Phillips & Drew to help meet the challenges of the new age. Rashleigh suffered a mild coronary in August 1970 and not long afterwards decided to step down. An election took place in April 1971, with Henry Cottrell and Macaulay as the two

candidates to succeed him. During the informal campaign that preceded the voting, the initial expectation was that the role of Macaulay was little more than to ensure a contest. Cottrell, after all, had sat opposite Rashleigh for over a decade; he had taken charge while Rashleigh was convalescing the previous autumn; and he had joined the firm several years before Macaulay. In fact, reflecting Rashleigh's own preference, there was a significant shift of opinion towards Macaulay, though in the event not quite enough. Cottrell won (by one vote) partly because he was seen by most as the obvious successor, partly because he had the powerful backing of the gilts element behind him, but perhaps above all because he somehow represented the future – computers and all – more convincingly than Macaulay.

Over the next few years it became fairly generally agreed that Cottrell, for all his unstinting devotion to the firm's wellbeing, was not of quite the high calibre of senior partner that Rashleigh had been. Recalled by Gibbs as 'hyperactive' and 'constantly whirring the handle of his coffee-grinder calculator', he was, it was felt, less good at standing back, seeing the big picture, and taking the big decisions. He had a less assertive personality than Rashleigh's, he was at times inclined to search for a consensus when none was possible, and – fairly or unfairly – he was somewhat resented on the grounds of not having been a business-getter since the late 1950s. Yet the fact remains that it was Cottrell who, amidst some distinctly testing times, continued to hold the business together, to try to plan for the future and to ensure that Phillips & Drew, unlike many stockbroking firms, was in no danger of falling apart. Cottrell may have lacked the natural *gravitas* of the born senior partner and, indeed, was probably more fulfilled as Rashleigh's number two. However, he did a perfectly sound job, deserving more credit than was accorded either at the time or subsequently.

As inflation began to grip hard from the early 1970s, compounding the effect that competition from other employers for staff had had on salaries from the mid to late 1960s, there would have been serious headaches for whoever was in charge. 'The underlying thesis of this report,' declared Cottrell in his Quarterly Management Report for May 1970, 'is that – like so many industries – we have run harder and

done more business, only to see all the increased revenue absorbed in higher labour costs, so that increases in non-labour costs have gone to reduce profits.' Salaries as a proportion of revenue were steadily rising. Whereas in the November quarter of 1968 they had stood at 27%, in the corresponding quarter two years later they were at what was then a record high of 42.5%. Cottrell in the autumn of 1970 struck an understandably plaintive note: 'One of the problems of being a partner in a fluctuating business is that you cannot decide whether it is worse to drive on, pig-headed, ignoring the fact that times have changed, or to panic into doing real long-term harm because of the short-term problem.' Broadly speaking, against the background of a largely booming market, the firm did drive on, and by the year ending May 1972 was rewarded with pre-tax profits of £2.13 m, twice the size of the previous year. During the second half of 1972, however, the steam started to go out of the boom, inflation was rampant, and for the year ending May 1973 the firm's pre-tax profits were down to £1.02 m. By then the firm was employing 478 people (compared with 379 in 1969/70), and in the quarter ending May 1973 salaries were running at a disturbing 47% to revenue (compared with 27.8% in the corresponding quarter a year earlier). But of course, boom and bust were well-known features of life on the Stock Exchange, and in the summer of 1973 few imagined that the collapse of the 1972 boom, if appropriate measures were taken to control costs, would cause more than momentary gloom.

Within the business, a significant development was the decision – based on an inspiration that Rashleigh had while shaving one morning – to merge the equity and research departments into one large department. Implemented in about 1970, this did not dispel overnight the friction between traders and analysts, but it did make a helpful difference. Institutional equities remained, however, a relative weakness – and one that meant that the firm did not benefit as much as it might have done from the boom of the early 1970s. In the quarter ending February 1972, for instance, turnover in equities for all firms combined rose by 39%, but for Phillips & Drew by only 24%. 'In the Stock Exchange at large,' noted Cottrell, 'equity business produces 80 or 90 per cent of all

commission, in P. & D. 45 to 50 per cent.' Or take the extremely busy three-week account settled on 12 April 1972, when the three most active equity stocks (in terms of number of bargains cleared) were Shell, ICI and Watney. In those three stocks the firm's market share – as measured by number of shares cleared – was respectively 2.48%, 1.87% and 1.93%. Overall, the 2% barrier remained an obstinately difficult one to clear, and at times in 1972/3 market share was probably as near to 1% as 2%.

Nevertheless, it was less as an admission of failure than because he was spending an increasingly large amount of his time on Stock Exchange Council work that Swan decided to step down from July 1973 as head of institutional equities. Cottrell in October 1972 mulled over the succession question. Neither Taylor nor Gibbs seemed quite right, the latter 'because there are fears of his judgment being excessively research – rather than sales – orientated'; Bazalgette was a possible 'compromise candidate', but 'the weakness here is that it would be seen as a complete rejection of our carefully fostered research image'; and eventually, it was decided to transfer Parker from gilts. For all his considerable analytical intelligence, he was neither by background an equity man nor by temperament a salesman, and he was perhaps somewhat uncomfortable in the role, though over the years he did much to bridge the gap between the traders and the analysts.

Gibbs, meanwhile, was continuing through the early 1970s to run the research team. Two systems of share evaluation (computer ranking and subjective) ran awkwardly in tandem, with a study in December 1972 finding that over the previous three years 'both the subjective and computer systems have shown useful gains relative to the equity market' and that 'there appears little to choose from these results between the two systems, although the subjective appears to have been slightly the more consistent'. Ultimately, though, the computer ranking system was doomed. 'The analysts found it far easier to speak with conviction about their own recommendations than those of the computer ranking,' Gibbs later wrote, adding: 'We were in danger of becoming the laughing stock of the City for continuing to pump out lists of theoretical recommendations that no investment manager would follow.' Finally, 'we

converted the weekly computer ranking to an information sheet, which showed the actual and forecast yields and P/Es for each share, together with a mass of other data, but which included only one evaluation of cheapness or dearness, the analysts' subjective one'. The literature, of course, continued to pour out, and in May 1971 the increasingly prestigious *Market Review* gained an extra dimension after Gibbs persuaded Bazalgette to start writing a monthly column, the humorous but also insightful 'View from the House'.

Research in general was becoming an ever more crowded field. Michael Hall, visiting Warburgs in November 1971, was gratified to find that in that bank's view 'we are the only people to be trying to forecast equity markets on any objective basis'; but Roger Corley of Clerical Medical was less complimentary when he lunched at Lee House the following March. According to Cottrell:

His view can be reduced as follows:

1. Five years ago, P. & D. was clearly outstanding in research. We had a well oiled machine, assembling and processing published data and no one else was of our quality.
2. Since then we have tinkered and modified, but effectively we still have the same machine. He could name eight or ten other brokers which are unrecognisable as the same firms they were five years ago. We have not deteriorated – others have passed us.
3. His view of our weakness is that we have a large number of inexperienced analysts. In his opinion, a competent analyst cannot be trained from university. One must get a man in his thirties who has ten to fifteen years' experience in the right levels of the relevant industry and then start to teach him investment research. He doubts whether one can maintain a team of such people to cover all industries and feels that brokers who specialise in particular industries will always have the edge because they have one or two individuals of this type.

Ironically, Hall only a few days earlier had visited Hill Samuel, which had told him that it intended to give the firm much more of its equity business on the grounds that Phillips

& Drew 'look at a large number of the big companies rather than specialising in certain sectors'. In practice, the firm had so much made its reputation on the back of research that, realistically, across-the-waterfront was the only option. It came, however, at a certain price – one that would be exposed with the imminent dawning of league tables.

The pension fund department, under Macaulay's quiet but authoritative guidance, was as usual less in the spotlight. By spring 1973 it was managing (with varying degrees of discretion) some 200 funds, having a market value in excess of £500 million split roughly equally between private and local authority funds. As pension fund assets generally grew – by 1973 having a total market value of £12.2 billion compared to £8.1 billion in 1968, and being responsible for 16% of the UK equity market compared to 6% in 1963 – so the battle to service them became increasingly intense. In that context, the merchant banks were not only frustrated by the unevenness of the playing field, but now became increasingly irate about the level of stockbrokers' commissions. Initially they received no joy from the Stock Exchange itself, and the merchant banks retaliated by setting up ARIEL, a computer-based system that would transact large deals between subscribers and thereby by-pass the Stock Exchange. In the event, the Stock Exchange did bow to pressure and significantly reduce commission rates, but the playing field still continued (to Phillips & Drew's advantage) to slope. Manchester had always been an especially prized local authority as far as the department was concerned, and in spring 1972 it was a reassuring moment when Warburgs and Grieveson Grant were removed from their duties but Phillips & Drew was not. Performance was crucial, and by this time or soon afterwards Sparks was appreciating – earlier than most of his competitors and as a result of work by Gibbs on inflation accounting – the value of favouring real, inflation-accounted earnings, which as the market turned down from early 1973 had the particular advantage of keeping his managed funds clear of the capital goods sector.

In general, the competition from the merchant banks came mainly in the private sector, where they had most of their contacts, but that did not mean that there was any complacency in relation to the local authorities. In the early

1970s an important role was played by Twist, who after decid-
ing to retire from the partnership while still only in his early
forties, worked for the firm on a consultancy basis and paid
many visits to local authorities. His main purpose was bond
and money business, but he took the opportunity to cement
or cultivate relations over the superannuation funds. There
was also the vital question of the pending local government
re-organisation, due to take effect in 1974, and when Leslie
Abernethy retired as treasurer of the Greater London
Council in June 1973 he joined the firm on a consultancy
basis in order to aid what proved to be the very successful
efforts at ensuring that the firm did not lose out through the
process. By then the pension fund department had a new full-
time recruit in the person of Michael Hall, who through his
mastery of the computer introduced far more systematic
portfolio evaluations, something that the department over
the years had somewhat shied away from. Since performance
was likely to be scrutinised ever more closely it was a timely
arrival, though in personal terms the department would
never again be quite the close-knit place it had been for well
over a decade.

In the early 1970s the firm remained at most only a minor
force in corporate finance, though it did sustain its speciality
of issuing (with Morgan Grenfell) local authority negotiable
bonds. New issue income in the year ending May 1971 was
£35,540, of which just under a half came from the local
authority bonds. Cottrell talked in 1972 of getting annual
revenue from new issues up to £150,000 within five years, but
it is unlikely that many saw it as a realistic target.

There were no such optimistic predictions about the
private clients department, though changes were afoot there.
In December 1972 it was announced that Drew would be
retiring the following May, followed by Bill Hall in May 1974,
and that from July 1973 the new head of the department
would be Taylor. Drew and Hall, however, remained associ-
ated with the firm on a consultative basis, and Hall in partic-
ular was active in developing the firm's increasingly signifi-
cant offshore business in Jersey, against the background of an
unsympathetic political and fiscal outlook on the mainland.
The sound, very likeable Pincham had been the most plausi-
ble candidate from within the department to become head of

private clients, while by this time there were two members of the younger generation operating effectively there. Walton Masters (reporting to Drew) was a skilful picker of shares who was more willing than most to defy the conventional wisdom – not always a recipe for lasting popularity in the generally highly ordered world of Phillips & Drew. Howell Harris Hughes (reporting to Hall) was a consciously professional stockbroker, who with his colleagues tried in the 1970s to begin to turn the business from purely agency broking into something akin to fund management, in other words on a discretionary basis; he and his colleagues also, amidst that decade's economic turbulence, sought to utilise the firm's 'macro' analysis, including its views on interest rates (affecting gilts) as well as on the outlook for equities. Whatever the talents available to it, however, the department was never at this stage going to become the powerhouse of Phillips & Drew.

That honour traditionally fell to the gilt-edged department, which by the early 1970s was under Bryce Cottrell and also, at the all-important long end, under some pressure. In 1970 the firm's peak market share in longs was 10.68% (compared with 12.15% in 1969), in 1971 it was 9.62%, in 1972 9.2%, and during the first half of 1973 7.84%. Or put in terms of share of 'institutional' turnover (i.e. excluding the Bank of England, government departments and so on), the firm's peak quarterly share was 19% in 1970, 16.8% in 1971 and 15.3% in 1972. These were hardly negligible shares, however, and Twist in a report on the department commissioned for a partners' strategy conference at Eastbourne in early 1973 sensibly eschewed a note of doom:

> As in all other markets competition is getting tougher. Apart from the traditional 'enemies' a number of brokers who previously did not deal in gilts have come and in many cases made substantial investment in resources and research. Some seven years ago Laurie Milbank burst in on the gilt market from their position as leading Money Brokers and Messels have recruited the three Deadly W's (Wright, West and Wood, N.). Other firms now taking gilts seriously include Capel-Cure, Carden, Colegrave, Gilbert Eliot, Kemp-Gee, Kitcat, Laing & Cruickshank, Rowe & Pitman, Strauss and

Vickers da Costa. This is not surprising in that profit margins in gilts are still probably much higher than in most other sectors. Our commission/salary ratio is still nearly 10 without any Colonial Mutual contribution. If we did not do gilts I am sure this conference would be discussing whether we should not try to set up a department.

Added value was becoming increasingly important, and one way in which Phillips & Drew provided it from the early 1970s was through the role of Stephen Lewis as a specialist gilts economist. He may never have attained the public stature of Pepper, but he had an incisive mind and became increasingly highly regarded by the institutions, perhaps not least because he was not a zealous monetarist. With gilts entering a period of expansion – partly following the Bank of England's introduction of its new, more liberal policy of Competition and Credit Control in 1971, partly as government began to borrow very heavily – the department's importance within the overall scheme of things at Lee House was perhaps greater than ever before.

No one would have denied it was the long gilts that really counted, but it was all to the good that Twist was able to declare by early 1973 that 'the position in shorts is wholly encouraging'. He went on:

Our share of the market in 1972 was 8.80 per cent compared with 3.86 per cent in 1970 in spite of the fact that in that year Kinsey [Philip Kinsey, with the firm since 1964] won almost all the Crown Agents' short business (and they had a lot of shorts in those days) and Colonial Mutual were also heavy in shorts. National Discount was our best 'house' and we lost out in the take-over [by Gerrards]. Now, we are probably second or third in the 'professional' market and deal for Barclays and National Westminster, the two more enterprising banks. The problem is that this business is run on a perilously low margin of human resources.

That may have been so, but some able individuals had put Phillips & Drew into this healthy position, against the competition of brokers including Sebags, de Zoete's, Greenwells, Grievesons and Panmures. The team's immedi-

ate boss until 1973 was Parker, though his particular *forte* was local authority debt, in the secondary as well as the primary market; Harrold, as the firm's real pioneer in short gilts, continued to apply his trading skills for several years; the gifted if somewhat mercurial Kinsey was a significant business-getter before moving to equities; Judith Nunley was renowned for her charm and miniskirts, valuable attributes in such a personal market; and Tony Morgan did the dealing. There were, as the 1970s unfolded, two other key figures. One was Peter Harrison, who after four years with de Zoete's joined the firm in 1970. He was an old Etonian and, reputedly, the background to his recruitment was a conversation between Rashleigh and a senior figure in the discount market (or possibly the gilt-edged market), in which Rashleigh asked why his firm had hitherto failed to gain more than a very small share of the short end of the gilts market and was told that the only way in which it could break through was to employ an old Etonian. Harrison was also the nephew of the then Government Broker, Sir Peter Daniell, so he came with a double qualification, to which he added a likeable character and a mention in despatches from Borneo. Perhaps because he was not a drinker, he worked particularly hard at building up client relationships, especially with Union Discount, Alexanders and Barclays. His helpmate, from about 1973, was Richard Lawrence, whom Harrison had recruited from Wedds and who understood how jobbers worked – including why a jobber would make a price to some brokers, but not others. Harrison tended to have a longer-term view of the market than Lawrence, sometimes up to a whole week, and together they complemented each other very well.

But if short gilts were shaping into a success story, there were two distinctly fraught problems that Cottrell faced in his early months as senior partner. The first concerned the back office. The old order was due to change in the second half of 1972, with Grayburn as comptroller to be succeeded by Simpson, who would become administrative partner, and K.C. Griffiths to be succeeded as office manager by Holmes, but by the winter of 1971/2 the general office was in a state of virtual collapse under the pressures of business induced by the 'Barber boom'. Accordingly, the set of accounts that

155

Spicer & Pegler produced for the year ending 31 May 1972, the day before Cottrell succeeded Rashleigh, contained a considerable number of qualifications. Spicer's formal report to the Stock Exchange would not have made comfortable reading in Lee House:

> We are unable to confirm that we have obtained all the information and explanations which were, in our opinion, necessary for the purposes of our audit due to the absence of analysis of certain items in both the client and market accounting records and the incorrect allocation of certain transactions and cash movements to individual accounts. A major factor has been the adoption of a new computer system designed to increase the efficiency of the firm's accounting procedures. The problems inherent in such a change have coincided with a very high volume of business with the result that the firm has not yet attained its planned objectives.

There followed, embarrassingly, a two-and-a-half page, double-column list of clients' accounts with a debit balance in excess of £500 unpaid. However, added Spicers, 'our clients are of the opinion that no provision against the above balances is necessary'. It was fortunate that, at this invidious juncture, the firm was in possession of a recently granted account at the Bank of England, a reflection of its acknowledged stature in the gilt-edged market and a great help in quelling the doubts of the discount houses in particular. Eventually, as the market became quieter, the new back-office regime took control, and the computer system settled down, the difficulties were sorted out. The major mistake, in retrospect, was delaying the recruitment of Simpson and the promotion of Holmes (the first clerk to become a partner), but few could reasonably have anticipated the frenzy in the equity market.

Cottrell's other problem, likewise affecting the firm's standing in the City and highlighting the value of having a Bank of England account, was the loans department, and in particular its activities in the secondary market in sterling CDs. 'Some taking of positions was authorised when first Sterling Certificates of Deposit were introduced,' his quarterly management report had noted back in early 1970, 'but

as different possibilities arise, new risks and new scope of profit are appearing. Some discussion is afoot as to how best to inform the partners of what is being done, so that limitation of risk can fairly be balanced against allowing adequate rein for entrepreneurial skill.' No doubt steps were taken, but there remained an anxious note to Twist's report on the department two years later: 'As the size of the operation grows I think that it becomes harder and harder to assess, say, the relative profitability of Local Authorities, Interbank and CD operations by "feel" so as to decide which activities to expand and which to cut back.' Moreover, with specific reference to Cohen's deputy Brian Brett, he added that 'more detail should be made available for the CD dealing and unsecured borrowing operation so that the state of P. & D.'s book is readily understood even if BB is unexpectedly absent'. Twist's report was presented on 1 March 1972, shortly after Brett had been given authority by Cottrell, who was about to become senior partner, to go for a higher profile in the money market. This was in order to maximise the firm's chances of being chosen by the Bank of England to become one of the three additional money brokers in the gilt-edged market, hitherto the preserve of Cazenove's, Laurie Milbank and Sheppards. In the event, Phillips & Drew was one of fifteen unsuccessful candidates (the three firms chosen were Hoare's, James Capel and Rowe & Pitman), news broken to Cottrell by the Government Broker in July 1972. 'I protested,' Cottrell informed his partners, 'that we had been given no opportunity to meet, or discuss or make any submissions in the light of our money activities. He assured me that the Bank had gone to unlimited trouble to make their own enquiries and that there was no point in pursuing the matter further: I therefore withdrew politely.' Over the next month or two, it gradually became clear that Brett had exceeded his authority and had been running a book of some £7 million, seven times the size that Cottrell had permitted him. The upshot was that Brett left the firm and that Cohen, who in the eyes of Cottrell and others had been negligent, lost his department (to Fison), a sad turn of events after all that he had done to build up this side of the firm's business. To modern eyes they seem somewhat trivial sums, even allowing for inflation, but Phillips & Drew was a

deeply risk-averse firm, which, as a matter of principle, had always shunned proprietary trading.

In Lee House itself, there was still an element of 'two worlds' in the early 1970s. Not very long after arriving on the premises, Harrison complained to Parker that whereas the partners were treated to soft paper in their lavatory, those below the salt had to make do with the harder, less yielding 'Bronco' variety. Perhaps only an old Etonian would have dared to raise the point, and accordingly a change was made. Almost certainly a matter of more pressing concern to the staff as a whole was the question of how the overall cake was shared out. Matters came to a head in late June 1972. 'It is reported that there is very considerable discontent among a large number of the staff at the bonus,' the chairman of the Staff Committee informed Cottrell, and went on:

> It compares very unfavourably with Cazenove, Greenwell, Scrimgeour, Colegrave and other large firms. It is not felt that our salaries are ahead of other firms and for the bonus to be reduced from 35 per cent to 33⅓ per cent at a time of intense business such as has been witnessed in the past six months is not understood. The chart in the office makes the level of bonus in line with indications but does not explain its relationship with other firms. The staff do not seem to appreciate the relative stability of our bonus compared with other firms. It was felt that some form of explanation should have accompanied the notice handed to staff rather than the bare statement which was given. For instance, the way overheads increase.

Cottrell and the PPC responded quickly, and that December a new profit-sharing scheme was announced. Not only would the existing bonus scheme be improved, with the fixed percentage of profits that determined allocation being increased by 50%, but new 'participation' arrangements were to be introduced whereby 'in addition to the bonus staff who have reached a salary of not less than £3,168 (this figure will be adjusted annually for general changes in salary levels) will qualify for an additional share of the firm's profits'. Therefore, added Cottrell in the notice, 'because of the higher gearing which this scheme introduces, total incomes

will fluctuate more widely in line with changes in profits than has been the case in the past'. In fact the scheme's implementation was delayed by the Government's pay policy, but at least the response had been made.

Improved turn-out was perhaps the price to be paid for higher remuneration, to judge by a notice that appeared on all boards in November 1972:

> It is a matter of concern that the standard of dress of a small minority of staff throughout the firm from time to time falls below what one would reasonably expect in a professional environment. Male members of staff are expected to wear suits to the office, and open-necked shirts without ties are not acceptable. With lady members fashion changes will always be with us, but co-operation is asked for by keeping the fashions moderate.

By this time there was little left of the original enthusiasm for Lee House as a working environment. When a member of the computer department, John Smith, left the firm in 1971, he took the opportunity to complain to Cottrell that 'rather than spending God knows how much on tinned music to produce marginal improvements in punch output, the money could better be spent on making the programmers' office, which is generally considered to be hot and humid, more suitable for producing programs than cacti'. Cottrell, in his marginal annotations to the letter, was unapologetic: 'They are the best conditions in the whole firm.' In fact, there was about to be an exodus. Since the early 1960s a handful of stockbroking firms had relocated their back offices outside central London, and by 1973 Phillips & Drew had decided to follow their example. In that year part of the back office temporarily moved to Romford, and from early 1974 almost the whole of the back office was to be in Brentwood. The obvious advantage was lower costs. The obvious disadvantage was the possibility of reduced control, communication and perhaps motivation.

Meanwhile, for those aspiring to be something in the City rather than something in Essex, the graduate recruitment programme continued unabated. Parker and Gibbs interviewed W.R. Hutton, from Bristol University, in May 1971:

'Mature, well turned-out man. Sound tho' talkative on general economics, weak on P/E ratios. Had travelled widely and intelligently. Sporting and debating activities. Well worth an offer for inst. equities (trading division).' First in research and then as a trader, Will Hutton was to spend six years at Lee House, where he enjoyed the prevailing ethos but became increasingly disenchanted with the City at large. Journalism lay ahead, and above all the authorship in 1995 of the best-selling, hugely influential *The State We're In* – in which, rightly or wrongly, the City is cast as the main villain of the piece.

The Phillips & Drew culture that Hutton knew was still fairly austere: no fleets of cars, relatively few pictures on the walls, and a strictly controlled corporate hospitality budget. When delegates from the local authorities gathered at Torquay in June 1971 for the annual Institute of Municipal Treasurers & Accountants conference, Cann observed that 'at least seven money brokers and at least three stockbrokers – de Zoete & Bevan, Grieveson Grant and Pember & Boyle – were dispensing bottled joy this year' and that 'the form varied from taking a central room through using a suite to trips round Torbay'. Hitherto, he added, the firm had felt 'able to afford to remain aloof here', but he wondered how long that could remain the case. More generally, there remained the question of how to get the firm's name better known and reach out to a wider world than was possible solely through the regular programme of research publications. One useful avenue was seminars, and by the early 1970s the firm was twice a year making presentations on consecutive days to UK institutional clients in Edinburgh and London. These comprised presentations on the economic outlook, the prospects for interest rates, the valuation of the equity market and, usually, a special industry study. About once a year the firm would also put on similar seminars in European financial centres, and in the words of Gibbs, 'the organiser of these seminars was always the enthusiastic Peter Swan, who liked to produce a travelling circus that would perform in three cities, such as Amsterdam, Paris, Frankfurt, Zurich or Milan, on three consecutive days'. At Milan in May 1971 the particular focus was the implications of Britain's impending entry into the Common Market, and

the Italian paper *24 Ore* reported that 'the enthusiasm of the speakers was echoed by the participants'. The firm also organised the occasional one-off seminar or conference, for example that held at Barber Surgeons' Hall in November 1972 to examine 'The Effect of an Incomes Policy on Corporation Profits', with Jim Ball and Terry Burns as the expert speakers.

Yet were this and other similar ventures enough? Within the firm, those who felt that over the years there had been insufficient exploitation of, for example, Jos Drew's many City contacts or Swan's membership of the Stock Exchange Council had an opportunity to crystallise their views in September 1973 when the PPC decided that if Pincham were elected a Liberal MP at the next general election this would be incompatible with his remaining a partner of Phillips & Drew. 'If you become an MP,' protested Bazalgette to Cottrell, 'you become at worst, reasonably well-known, at best a national figure. This firm is long on technical expertise, but short on well-known or well-connected people. The election of one of our partners as an MP could not but be beneficial to us.' Bazalgette failed to prevail, and as a result of his political aspirations (even though he was never elected an MP) Pincham was compelled to leave the partnership and take on a consultancy role. As it happened, however, the firm *was* about to become much better known – partly because the world was about to change fundamentally, partly because it already had the right man in place to take advantage of that change.

The sequence of events that began in October 1973 has almost passed into City legend: the Yom Kippur War, the quadrupling of the price of oil, the three-day week, the secondary banking crisis, the miners' strike, and the fall of the Heath government. Labour returned to power at the start of March 1974, at which point the FT 30 stood at 313.8 (compared with over 440 five months earlier). The rest of 1974 saw no improvement from the investor's point of view: record inflation, an acute squeeze on corporate profits, the re-election of the Labour government, and the FT 30 in a state of virtual free-fall, down to 146 by the first week of 1975. The Stock Exchange suffered badly. At the start of

October 1974 *The Economist* estimated that in the first nine months of the year the gross income of stockbrokers from trading in equities was down by £22 m – to £74 m – in comparison with the same period in 1973, though commission from gilts was up by £3 m to £17 m. Worse followed over the next few months, and the securities industry as a whole contracted by about a quarter in the course of 1974. To some it seemed as if the end of capitalism was nigh, and to say that large parts of the City were gripped by a mood of what E.M. Forster once called 'panic and emptiness' would not be much of an exaggeration.

On the whole, nerves held at Lee House – although when Gibbs decided not to sell any of his own or his wife's shares, this was, he would note, 'much to the horror of some of my partners'. At one point, moreover, salaried partners were asked to contribute to the firm's capital, but they declined. For the business as a whole it was undoubtedly an extremely difficult time, especially in the institutional equity and private clients departments. The very worst month was August, when the firm traded at a loss. It is true that later that year a modest half-yearly bonus was paid – unlike in most firms – but inevitably there were compulsory redundancies. Most were in the newly established general office in Brentwood, and these were handled well by Cottrell, who was successful in ensuring that most of those who lost their jobs were outplaced, many with the Gas Board. By early 1975 the workforce as a whole was down to about 350, whereas two years earlier it had been almost 500. As with the global economy, the long era of seemingly automatic expansion had suddenly come to a halt.

In fact, whatever the travails, all the indications are that Phillips & Drew increased its market share during 1974. Certainly, it was going to be one of the survivors, whereas many other firms that year sought protection through merger and indeed some were actually hammered. Unsurprisingly, several approaches were made to Phillips & Drew. Two years previously the firm had rejected an initiative by the increasingly troubled Sebags – largely on the grounds of incompatibility of style – and now there were discussions with Norris Oakley, Grievesons, and Laurence Prust, in each case not at the instigation of Phillips & Drew.

Norris Oakley, it quickly transpired, was in too parlous a financial state to be seriously considered; matters did not get very far with Grievesons, who were also talking with Rowe & Pitman; but a merger with Laurence Prust – in effect a take-over – was a serious possibility. That firm's main attraction was a strongish corporate finance side, with some 100 client companies, and the senior partner, Philip Darwin, made a favourable impression on Cottrell when negotiations began in October 1974. In the end, however, Phillips & Drew set out terms at the start of 1975 that Laurence Prust found unacceptably severe, and negotiations ended. 'It would be in no one's interest to form a firm which was insufficiently lean and competitive to keep above water in the coming months,' Cottrell told Darwin and his colleagues, adding that if Laurence Prust 'brought in long-serving staff who had to go a few months later, it would be much more embarrassing for them, as well as for us'. The logic was unimpeachable, and of course the new issue market had been virtually dead for over a year, but arguably it was a missed opportunity to get into the first division of corporate finance, albeit at the wrong end of the table.

Some firms in 1974 succumbed to the natural temptation to make drastic cuts in their research departments, but Phillips & Drew sensibly maintained its research capability (except in overseas shares). Gibbs, however, was becoming increasingly preoccupied with the issue of inflation account-ing, and accordingly he handed over day-to-day running of the research team to Keith Percy. The firm's involvement in inflation accounting – an increasingly urgent response to how high inflation undermined the traditional 'historic cost' system of producing accounts – began in March 1973 when one of its senior analysts, Richard Cutler, co-authored an article in *Accountancy* entitled 'The Impact of Inflation Accounting on the Stock Market'. This showed the estimated effect of applying the inflation-accounting proposals recently put forward by the Accounting Standards Committee to the earnings of 137 companies in the Phillips & Drew *Equity Book*. Later that year Parker, a Fellow of the Institute of Actuaries, was asked by that body to submit a paper on the subject, and his obvious co-author, with more specialist knowledge than he had, was Cutler. A draft had been started

when, for personal reasons, Cutler decided to leave the firm, and Gibbs (as a fellow-accountant) agreed to step into his shoes. In April 1974 the Parker/Gibbs paper, as it soon became known, was submitted to the Institute. Its title was 'Accounting for Inflation – Recent Proposals and their Effects', and it began with a maxim attributed to Keynes: 'It is better to be vaguely right than precisely wrong'. The main body of the paper not only updated Cutler's March 1973 calculations, but lucidly discussed possible alternative methods of allowing for price changes in company accounts. There was also a stirring conclusion:

> Inflation is socially divisive. Individuals who have savings largely in money assets and who are weak in wage-bargaining power become poorer; those who have real assets and have exercised their power to borrow and are economically strong become richer. Nobody should wish other than success to Governments which attempt to restrain inflation, but they are unlikely to be able to eliminate it completely, and to the extent that some inflation is countenanced by Governments, they should be prepared to reduce its divisive impact. . . . To compensate in every situation where a person is at risk from inflation would undoubtedly reduce the strength of public support for anti-inflation policies, but it seems possible in practice to draw a dividing line between the personal sector and the corporate sector. We regard inflation accounting as a desirable move, particularly if it leads to a fairer distribution of tax between companies which gain from inflation and those which lose from it, including many sectors of manufacturing industry. . . . Until publication of inflation-adjusted accounts by companies becomes general practice, investors and creditors are strongly advised to make their own estimates of the impact of inflation on individual companies.

The discussion was largely favourable, there was some press coverage over the next few weeks, and Gibbs in particular acquired the reputation of being an expert on this important, sometimes contentious subject.

His work also assumed a historical dimension, and in the January 1975 issue of *Market Review* he published what became a celebrated article on the Weimar hyperinflation, in

which he analysed the German stock market between 1919 and 1923 and drew out some possible implications for the mid-1970s. Among other things he concluded that 'the German experience provides some evidence for our thesis that unless the Government goes for wholesale nationalisation it will have little alternative but to allow the majority of leading companies to come through an inflationary period with their real assets largely intact'; while 'as regards particular sectors of the market, the main lesson of the German hyperinflation was that one should prefer industrials to banks and other financials'. Gibbs conceded, however, that 'one should beware of trying to draw too many conclusions from an analysis of one hyperinflationary situation', in that 'the chances of the UK experiencing billion percent rates of inflation seem absolutely minimal'. So they did, but pushing towards 30% was quite dramatic enough for most investors and others.

An increasingly important member of Gibbs's team during the first half of the 1970s was Paul Neild. A Lancastrian who spoke both bluntly and fluently, he had read economics at Liverpool before doing a thesis at Manchester on technology in underdeveloped countries. He spent five months under Weaver in the late 1960s, before going abroad for two years to write his doctoral thesis, an econometric study of the New Zealand labour force. Returning to Lee House in 1971, he was soon afterwards deputed by Gibbs to be the firm's first full-time macro-economist – still an unusual position in a stockbroking firm. Then, in October 1974, he produced the first number of *Economic Forecasts*, a monthly publication at first written almost entirely by himself. In it he predicted that whichever party won the imminent general election there would be a return to a formal wages and prices policy, but he did not believe that such a policy would prevent rapid inflation, slow growth and rising unemployment in 1975. 'The respected stockbroking firm' was how Tim Congdon referred to Phillips & Drew in an article in *The Times* on this first issue, and Neild quickly mastered the knack of ensuring maximum press attention for his monthly analysis of the economic outlook. In particular, he knew that most journalists were appreciative of a one-page press release, and in Robert Walker at the Press

Association he also had an important ally in feeding the press. The larger macro-economic outlook was propitious for Neild's work, as turbulence and uncertainty reigned; and whereas the more academic forecasting bodies, such as the National Institute for Economic and Social Research, tended to make economic forecasts on the basis of no change in policy, Neild made it his business to try to stand in the politician's shoes and come up with forecasts on a 'most likely outcome basis', in other words forecasts that *included* policy changes. Neild was poised, as the traumatic 1974 drew to an end, to make Phillips & Drew almost a household name.

There was, meanwhile, very little macro-economic analysis in Bazalgette's monthly column, but it enjoyed an appreciative following. At the start of 1975, noting that it was 'the year of the Rabbit in the Chinese calendar' and that 'never in my ageing life have I ever known the turn of the year to be overlaid with such unvarying gloom in all quarters', he looked ahead in highly characteristic tones:

> A unanimous consensus, whether in the City or elsewhere, is nearly always wrong. Remember when the FT Index was over 500? 750 was a dead cert. then, and the go-go boys (all gone-gone now) said 1000. I have just a tiny little feeling growing in me somewhere that the most redeeming feature of the present situation is that everyone is agreed that stark and unmitigated disaster lies ahead. We have very nearly discounted all these perils in our minds, our daily lives, and even possibly in share prices. If we haven't, well it can be only a matter of time before President McGahey is occupying that stately mansion at the end of the Mall, and quite a lot of you chaps are immured in the London Lubianka.
>
> If what I have said to you strikes anything of a chord in your manly breasts, do not rush madly into the equity market just yet with every penny you still have. Wait awhile for your opportunities, which will undoubtedly present themselves. Your reward will probably come in 1976, for that, as any Chinaman will tell you, will be the Year of the Dragon.

Bazalgette's quiet optimism was broadly justified. Over the next two and a half years the equity market recovered, with the FT 30 reaching 477.4 in May 1977, its highest level since

June 1973. There were, however, plenty of alarms on the way, against the background of a largely gloomy macro-economic outlook. A particularly difficult year was 1976, involving sterling crises and the Government's humiliating recourse to the International Monetary Fund, and Neild was in his element commentating as events unfolded. In April, following Healey's Budget in which tax cuts were informally predicated on successful wage negotiations with the TUC, he issued a press release in which, while not disagreeing with the underlying thinking, he criticised Healey's 'poor presentation of the entire concept of linking tax cuts to wage restraint', described the arithmetic of the offer to the unions as 'badly judged', and argued that as a result of these errors Healey 'may have jeopardised his chances of ultimate success in achieving a norm which stabilised the currency'. Eventually a 4½% pay norm was agreed to by the TUC – ½% more than Neild had forecast – but foreign holders of sterling remained apprehensive, even after public expenditure cuts in July of £1 bn. 'We are hoping that sterling will now stabilize for the rest of the year,' Neild wrote that month, 'although we think the Government is being optimistic in hoping not to have to go to the International Monetary Fund before the end of the year.' Unfortunately, he was right. An acute sterling crisis in September led to the Government seeking a $3.9 billion loan from the IMF, a loan whose domestic price was a massive deflationary package in December. By then, however, the worst was over, and 1977/8 saw the economy recovering, as company profits and consumer spending started to return to pre-1974 levels. The reluctance of organised labour to abide by pay norms was an increasing worry, culminating in the 1978/9 'winter of discontent', but in the eyes of the equity market it was a worry more than outweighed by the new boon of North Sea oil – a boon which some (but not Neild) believed would restore the British economy to its long-gone glories.

There were few months in which the press did not quote, often at some length, from Neild's *Economic Forecasts*, but where he and the firm really hit the publicity jackpot in the mid to late 1970s was through his increasingly frequent appearances on television. He was friendly with Peter Sissons, who started using him for ITN's lunchtime news

programme; it was not long before he became one of ITN's principal economic pundits on Budget days; and with Budgets in that era far more than an annual occurrence, the sight of television crews outside Lee House became a familiar one. It was also a considerable fillip to the firm's reputation when, on at least one occasion in the House of Commons, Healey quoted Neild's series of figures on wage settlements. Healey himself was the firm's guest at lunch one day, and the occasion was thoroughly convivial. As the Chancellor let himself go, as recalled by Gibbs, 'there came a moment when, having described how he had told someone to "sod off!", he thought he might have overstepped the mark'. Cottrell was sitting next to him, so Healey 'turned to him and asked, "What's the Phillips & Drew expression for sod off?" '. Cottrell, perhaps not surprisingly, was unable to supply an alternative.

Elsewhere on the research side in the second half of the 1970s, Gibbs was senior research partner and continued to hammer away at the problem of inflation accounting, an involvement that included writing at least two major articles in *The Times*. In 1977 he was also asked to write a report for the Transport and General Workers' Union, which was in the process of submitting a pay claim to Fords. He agreed to do so, and his report (included in the union's formal submission) found that the claim by the company to have made only £5.6 m 'seriously understates the real profits of the year since it ignores the effect of inflation on the company's net liabilities'. It was not a piece of work that endeared Gibbs to his 'more Conservative partners and their clients', who 'felt that, by helping a trade union so publicly, I had effectively gone over to the enemy side'. Managing the pension funds of Labour-controlled local authorities was one thing, but this, it seemed, was another.

Meanwhile, away from such high-profile matters, Percy was making significant changes to the way in which day-to-day research was done. The firm had been given a jolt by the start of the annual survey of the relative standing of stockbrokers' analysts, as conducted and published by Continental Illinois on the basis of the opinions of investment managers. The survey began in 1974 and, although Neild was invariably top of the economists' section, Phillips & Drew failed to

come in the top eight of the overall rankings for the first four years. By 1978 there was some improvement, with the firm coming sixth – behind Kemp-Gee, Wood Mackenzie, James Capel, Hoare Govett and de Zoete & Bevan. To some extent these disappointing evaluations reflected how the firm believed, partly because of the importance of the pension fund department, that all sectors had to be covered, whereas other firms were more able to specialise, for example Wood Mackenzie in oils; there was perhaps also an element of resentment on the part of some of the institutions surveyed about the firm's extremely strong pension fund business. But even allowing for these extenuating factors, it was clear that there was room for improvement. Percy's response was to make the research effort more commercial – not only persuading analysts to talk more to clients and pay more company visits, but also starting *Equity Market Indicators*, a monthly publication that complemented Neild's *Economic Forecasts* and was based on consultations with thirty to forty institutions. In Weaver and Gibbs there had been, for good as well as ill, something of the academic *manqué*. Neither could remotely be described as impractical, but Percy had his eyes more undeviatingly on the bottom line.

By June 1978 there was a new senior partner. Cottrell had decided to retire while still in his fifties, wanting to develop an active business life after Phillips & Drew. This he successfully did, accepting directorships in a number of quoted companies. He had also become somewhat dispirited by complaints, which he felt to be unreasonable, about the distribution of the profits to existing partners and the pension provisions for retired partners. During the election to succeed him, which took place in 1977, the two serious candidates were Swan and Bazalgette. Most expected Swan, by this time a senior member of the Stock Exchange Council, to win. For all his many positive qualities, however, various factors went against him: a view that he was insufficiently analytical to be senior partner of such an analysis-driven firm; worries that, although naturally far more ambassadorial than Cottrell, he would be too autocratic; and generally a sense that his rather emotional approach to life might not make him the safest pair of hands. Bazalgette, by contrast, was a thoroughly safe pair of hands: a high reputation in the

Stock Exchange (where he was one of the two Honorary Market Officials, the first port of call for arbitration in any dealing dispute); a great fund of common sense; and, in a somewhat understated way, a leader's manner. Inevitably, of course, there was a concern that, having been senior dealer for so long, he was out of the swim as far as the main body of business-getting in the firm was concerned. Indeed, if Twist had not left the partnership in 1970, he might well have succeeded Cottrell. In 1977/8 the expectation was that Bazalgette would only be a caretaker senior partner, probably doing the job for two or three years. In the event, he did it for five, and by general consent did it very well. He was better than Cottrell at taking a view; he could tick off a junior partner to salutary effect but without leaving any bitterness; he proved an excellent judge of character; and perhaps above all, with the disastrous examples of Sebags and more recently Greenwells in mind, he was determined to maintain unity, especially important as the size of the firm and the partnership inexorably increased. Phillips & Drew in the late 1970s was, he believed, a rocket still going up, and his main goal as senior partner was not to get in the way of that rocket. It may have appeared a negative approach, but it had many positive consequences.

By the time that Bazalgette became senior partner, the business – in line with the market as a whole – was well into its post-1974 recovery curve. The figures tell the story, even if one needs to make an allowance for inflation: for the year ending May 1975 the firm's trading profit was £1.35 million, and over the next four years that rose successively to £2.13 million, £2.83 million, £3.34 million and £3.63 million. In real terms that latter figure represented something of a dip, but it was an encouraging fact that in the quarter ending May 1979 the firm's share of overall market turnover was up to 5.32% compared with 4.64% in the equivalent quarter two years earlier. The size of the firm's workforce was also once again increasing, up by May 1979 to over 400, having been down to under 350 four years previously. Few who had lived through it would forget the experience of the mid-1970s, but it was reasonably clear as the decade approached its end that that apocalyptic time had not, after all, presaged the end of the world.

It was helpful to be, as Phillips & Drew was, a firm with an historic strength in gilts. 'On average over the six years 1970 to 1975,' noted Pepper of Greenwells in 1976, 'the UK gilt-edged market provided 73% of the government's domestic borrowing, compared with 43% for Switzerland, 39% for the US and 37% for Germany'; while over the next few years, the British government managed to borrow £8 billion annually through the issue of gilts. It was a market, in other words, where there was potentially much business to be done. Inevitably, that meant that at Phillips & Drew the gilt-edged department was absolutely pivotal in the firm's continuing profitability. Take the quarter ending May 1979: gilt revenue in seven figures; twenty-nine staff earning salaries of £91,440; total expenses of £337,862; and a handsome surplus of £703,935. Well over half the gilts revenue continued in the late 1970s to come from the long end, where in 1977/8 share of market turnover fluctuated between 6.4 and 8.9%. This was the province of Bryce Cottrell and John Lewis, backed up by Stephen Lewis through his *Gilt-Edged Research* newsletter. At the same time, Harrison continued to improve the situation in shorts. In 1977/8, including dealings in local authority bonds and overseas government stock as well as in short gilts, market share was never less than 12% and at times exceeded 15%.

Meanwhile, the fixed-interest department, still a separate department despite the advice of a Spicer & Pegler management survey, where Bavister had been succeeded by Redman-Brown, remained a useful contributor, although it was not helped at any time in the 1970s by the highness of interest rates, which meant that a lot of company stock was redeemed and very little issued. By about 1977 Redman-Brown was taking the view that it was time to enter the fast-growing Eurobond market, though as agents rather than as principal. Accordingly, the Hon. Philip Howard, who was already experienced in that market, was recruited to set up a small trading and research unit. Initially it did not make a huge impact, partly because the Eurobond market was essentially a principal's market and partly because the partnership was reluctant to commit major resources to it, but it was nevertheless a significant departure, helping to increase the firm's expertise in an area that many in the City, still wholly

171

orientated to the Stock Exchange, barely understood.

In equities, something of a turning-point occurred in December 1975 when, following internal dissension at Greenwells, Paul Smallwood and Roger Pearson were recruited from there at partnership level. Not everyone was happy, but it proved an entirely beneficial infusion. Pearson was a capable young Glaswegian who worked well with the firm's Scottish clients, but the real prize was Smallwood. 'Paul was probably the best-known and best-liked stockbroker of his time,' Gibbs recalled. 'If you walked down a City street with him, almost everyone you passed would smile and say, "Hello, Paul".' Hard-working, shrewd, and incredibly well connected, he was in his early forties when he came to Phillips & Drew, embodying the very best qualities of the old City and none of the worst. He not only brought in a number of institutions, but also wholeheartedly encouraged the efforts of Percy to make the research side more commercial. By mid-1976 the institutional equity department, under the overall direction of Parker and manned by such able operators as Peter Stott (a particularly driving salesman), Chris Marsh and Tim Brown, was achieving a market share of 3.1%, though over the next three years it found it impossible to get beyond 3.6%. In other words, it was doing markedly better than in the 1960s and early 1970s, but it was still not *quite* achieving take-off. The customer remained sovereign, and Smallwood at the time was struck by the animosity felt by rival fund managers, such as Schroders and Gartmore, towards the fund management at Phillips & Drew, an animosity that inevitably impacted on the equity side, which was at the sharp end.

One other aspect of the department's work in these years should be mentioned. In 1978 the Stock Exchange began a market in traded options, representing a further opportunity for diversification. Michael Freyd was mainly responsible for the firm's active involvement in this new area, and in the market's first year almost £50,000 commission was achieved, virtually all of it from institutions, led by the Mars pension fund and the Co-op Insurance. It was a market that would struggle over the years to shake off its Cinderella status, but from the firm's point of view it was another step in providing a complete service, an indispensable aspiration as the gap

began to widen between the big stockbroking firms and the rest.

The quarterly surplus produced by the equity department tended to fluctuate greatly, as low as £13,832 in the quarter ending February 1979, as high as £334,288 in the following quarter, but the pension fund department provided, as usual, a steadier flow of revenue. Its quarterly trading surplus rarely fell below six figures, but was equally rarely above £200,000. The larger picture was, of course, encouraging. Even allowing for inflation, pension fund assets were increasing at a remarkable rate: from a total market value of £12.2 billion in 1973 to £35.4 billion in 1978. It would take the publication in 1980 of Wilson's report into financial institutions for this quiet revolution to permeate the wider public consciousness, but for the professionals it was already becoming a conditioning fact of investment life.

At Phillips & Drew itself, the retirement of Macaulay in 1977 had major implications. Opinion was divided as to whether Sparks or Michael Hall, who had been increasingly active on the private company side, should succeed him. In the end, the decision was taken to split the department into two, with Sparks (supported by Cann) in charge of the public sector and Hall (supported by Bird) in charge of the private. Sparks already had a good hand to play, following the dextrous handling of the recent reorganisation in local government, and it was Hall who made most of the fresh running in the late 1970s – in particular, making a positive virtue of performance testing and, through very professional presentations, pitching hard for new business. In 1978, for instance, thirty-three presentations to prospective clients produced nine new funds, including Dunlop, Electrolux and Woolworths. By the quarter ending May 1979, an extraordinarily productive quarter, there was little to choose between the two arms of the pension fund department in terms of trading surplus: £162,386 from the public sector, £168,204 from the private. These were gratifying figures, at the end of a quarter of a century in which the department had, in effect, been the firm's huge, tame, utterly invaluable in-house institutional client. Even so, few could imagine the phenomenal growth that lay ahead in this area of fund management.

In complete contrast, the larger backdrop for the private clients department was more disheartening than ever. By the end of 1975 individual investors held only 37.5% of listed UK equities, as measured by market value, in stark comparison to the 65.8% at the end of 1957 or even the 47.4% at the end of 1969. There were some bright spots, including the innovative, more systematic approach towards the management of charitable funds that was being adopted by Harris Hughes, but overall the figures were fairly dismal. In the nine quarters from March 1977, a trading loss was made in five of them, and it may well have been that the department was kept on only because of fears about the firm's image if it was terminated. Things were little better in the money (or loans) department. Until mid-1976 it was barely running at a profit. There then followed two good years (profits of £94,716 and £134,709); but 1978/9 was a disaster, with a loss of £49,060. Rising interest rates, combined with the Bank of England's 'corset', did much of the damage. Moreover, after the problems of 1972 there seems to have been little inclination on the part of the partnership to pump large resources into the department, notwithstanding Fison's development of new lines of business, such as the secondary mortgage market.

Another patchy performer in these years was the corporate finance department, created in 1975 to take over certain operations previously carried on in different departments. These included the issue of fixed-interest stock as well as the raising of equity capital. The thinking was sound, but early results were disappointing, with a loss being made in each quarter from May 1977. By spring 1979 the firm was broker to thirty-one companies, only four more than two years previously. There was clearly much to be done if the firm was to become a force in this potentially remunerative as well as prestigious field. Indeed, if there was to be a major new area of future growth, some believed by the late 1970s that it lay on the international side, hitherto largely quiescent. Here the prime moving force was Walton Masters, who in the wake of the 1973 oil shock became increasingly interested in the Middle East and painstakingly started to build up relationships there. In the mid-1970s he was abetted in Kuwait by Kinsey, who while on secondment spent a considerable amount of time setting up the securities investment depart-

ment of the newly formed Industrial Bank of Kuwait. Kinsey's early death was a great blow to the firm, but the work that he and Walton Masters did in the Middle East sowed the seeds for a full-scale international department which, backed by Bazalgette, was poised by spring 1979 to go into action.

Exchange controls were still in place on 3 May 1979, election day. 'The vision of the future held out by Labour is grey and drab and stifling of individualism,' argued the *FT* that morning in its endorsement of the Tories, declaring that 'the time to arrest the trends of decades of post-war history is now'. The Tories won comfortably enough, and although some in Lee House may have been disappointed, few in the City as a whole were. Bazalgette, who as senior partner continued to contribute to the firm's *Market Review*, was carefully apolitical in his next column, although he did have an eye on the aesthetics of the situation: 'Perhaps it is only because I am an ageing connoisseur of mature blondes that I advance the opinion that Prime Minister Margaret is a distinct improvement in female pulchritude on the mid-Oriental and far-Oriental ladies who have preceded her to the wicket.' He also hoped that Mrs Thatcher would take the lead in a related matter:

> Heaven knows that recent female fashions, particularly in length of hemline, have been decidedly unacceptable, and it is my hope that all this will now change for the better. Let me remind you that when hemlines rise, so traditionally does the Stock Market. It is not the prime function of this column to tender investment advice, but you may feel inclined on this to get in, or if already in, to stay in.

[6]
All Change in the 1980s

The City may have welcomed the change of government in 1979, but the deep industrial recession of the early 1980s meant that the UK equity market made few spectacular advances during those years. Eventually, in October 1982, the FT 30 at last made it across the 600 barrier (fourteen years after first reaching 500), and the 700 milestone was passed as quickly as May 1983, reflecting justified market confidence in a Conservative victory at the impending general election. Ever onwards and upwards the rise went, though with pauses each summer, and in January 1985 the Index attained the magic four figures. At Phillips & Drew the profits for partners during the five years from May 1979 roughly mirrored the market's larger trends: £3.69 m in 1979/80, £5.15 m in 1980/1, £4.78 m in 1981/2, £9.34 m in 1982/3, and £8.89 m in 1983/4. The firm's fundamental orientation remained domestic – though that was starting to change – and accordingly it did not benefit as much as some City businesses from the abolition of exchange controls in October 1979. Nevertheless, profits by the mid-1980s were starting to approach 'serious money', to use the phrase that was about to be coined. Nor, by this time, was there any doubt that the firm enjoyed premiership status. City Research Associates issued a report in 1983 that examined the institutional market in UK equities, gilts, and foreign equities, and gave equal top ranking, on 5% market share each, to four firms: James Capel, Phillips & Drew, Scrimgeour Kemp-Gee and Greenwells. They were followed by Cazenove's and Rowe & Pitman on 4% each, Pember & Boyle and Mullens on 3%

176

each, and Simon & Coates and Williams de Broe on 2% each. Moreover, Phillips & Drew's overall penetration of the institutional market, at 69%, was higher than any of its competitors. It was a tribute to many painstaking years building and fostering connections with Britain's institutional investors.

The scale of the enterprise inexorably increased. By May 1984 there were fifty-five partners, of whom thirty were managing partners, in other words contributing capital, and twenty-five were executive (salaried) partners. One of Bazalgette's main concerns after he became senior partner in 1978 was that the firm's capital, some £½ million, was becoming inadequate to the size of the business; and helped by Simpson, as well as by his own force of personality, he was able to persuade the partnership to make 'voluntary' contributions, from the increasing profits, to capital reserve, which was invested in short-dated gilts. By 1983 the capital as a whole was up to some £2.3 million, adequate for agency broking though not for the responsibilities of being a principal. Staff numbers likewise grew: 451 in May 1980, 518 in May 1983, 613 in May 1985. Many of those staff were in the general office at Brentwood, where although there was reasonable efficiency there had started to develop by the end of the 1970s something of a 'countryside culture'. Matters were not helped when Holmes became seriously ill in 1983 and failed to recover. However, by this time the firm had recruited a new finance and administration partner to succeed Simpson, and one of his main tasks was to improve communications between Lee House and the general office. This was Hugh Eaves, who in the 1970s had run the back office at Panmure Gordon, winning a reputation for the application of tight financial controls; and now, in the early 1980s, he spent much of his working life travelling to and fro between the City and Essex. Lee House itself was by this time becoming not only shabby but also even dangerous, with the glass panels having a tendency to fall off in high winds. In September 1983, shortly before the 21-year lease on it expired and to everyone's relief, the firm moved (as masterminded by Bill Dyson) to an undistinguished but generally efficient block at 120 Moorgate. A mass of new technology was installed, then and over the next year or two,

and on at least one occasion the power supply became seriously overloaded, causing the transformer in the basement of the building to 'bubble'. Fortunately, a meltdown was averted.

Shortly before the move to Moorgate, a new senior partner took office. Bazalgette had decided that May 1983 was the appropriate date to retire, feeling that it needed a younger man to take the firm into what already seemed likely to be a fast-changing world, and in 1982 the usual electoral procedures were followed. The managing partners had a four-way choice. Bryce Cottrell (unrelated to Henry Cottrell) had been in charge of gilts since 1969; John Lewis had also come up on the gilts side, working closely with Cottrell; Parker had been in charge of institutional equities since 1973; and finally, there was a joint ticket offered by Birks, the senior gilts dealer who had recently succeeded Swan on the Stock Exchange Council, and Michael Hall of the pension fund department. Lewis and Birks/Hall dropped out in successive rounds, and in the decisive third round Cottrell secured fourteen votes to Parker's eight. A forward thinker though perhaps not a visionary, and personally liked by almost everyone, Cottrell had his critics, mainly on the grounds that he sometimes had difficulty communicating his thoughts. Temperamentally not an autocrat, and conscious of the value of the PPC, which since about 1980 had been chosen on an elected basis, he appreciated that only through the creation of a consensus could the firm hope to pick its way through the rapidly changing City of the mid-1980s without in the process damaging or even destroying itself.

Cottrell's work had always been on the gilts side, whose chief dealer from the early 1980s was Peter Packard, formerly understudy to Birks. By 1980/1 the gilt-edged department had thirty-three clients each generating for it an annual revenue of over £37,500. These included such familiar institutional names as Colonial Mutual, London Life, and Royal London; two more global presences in the form of World Bank and the Soros Fund; three discount houses (Union, Allen Harvey & Ross, and Gerrards); and two, but only two, merchant banks (Warburgs and Kleinworts). Overall, in terms of the department's £5,076,000 commission that year, the leading contributory sectors were insurance

companies (£1,471,000), overseas banks (£718,000), company pension funds (£615,000), merchant banks (£465,000), discount houses (£445,000), and public-sector pension funds (£423,000). It is worth adding that the Lloyd's insurance market contributed £319,000, reflecting John Perry's efforts at ensuring the firm's leading position in short gilts there. As for share of market turnover, there tended to be a greater fluctuation in short gilts, which between 1980 and 1982 bottomed at 12.3% and peaked at 20.6%. In the case of longs, the parameters were 7.3% and 9.6%. In that same period, institutional equities managed a market share of above 4% (but always below 5%) in nine out of the eleven quarters for which figures are available – a broadly encouraging performance in what was, from the point of view of achieving market share, undoubtedly a more competitive market than gilts. Following the changes initiated in the mid to late 1970s, on the research as well as the selling side, the mechanics were in place to take much fuller advantage of the equity boom of the mid-1980s than had been possible in the last great equity boom back in the early 1970s.

Whether investing in equities or gilts, no rise was more irresistible in the early 1980s than that of the pension funds. According to Phillips & Drew's own calculations, whereas at the end of 1979 the total volume of investment funds of UK pension schemes was just under £40 bn, by the end of 1983 that figure was up to a remarkable £103 bn. This growth, according to the *FT*'s Barry Riley in February 1984, had been caused largely by 'capital appreciation, following a phenomenal run of good years in the securities markets'. Pension fund assets were by this time responsible for 27% of the UK equity market, compared with 6% in 1963 and 16% in 1973. At Phillips & Drew, where pension fund management increasingly operated on a discretionary as opposed to advisory basis, it was the private sector under Hall that particularly flourished in the early 1980s, producing up to 13% of the firm's revenue. Then, in 1983/4, the four senior figures in pension fund management – Sparks, Hall, Cann and Bird – all decided, for a variety of reasons, to leave the firm. This left a huge gap into which Percy stepped, extremely effectively as it turned out and helped by the wealth of younger talent that he inherited, including Crispian Collins, John Hemingway,

Bill Horwood, Jim McCaughan, John Marsh and Paul Meredith. In particular, Percy set in train two very important changes. One was to set up fund management as a separate company (Phillips & Drew Fund Management Ltd) and move to separate premises; the other was to begin the negotiations that would lead to every client being switched from fixed commissions to fees. Enormous growth lay ahead in the rest of the decade, but already by the mid-1980s the firm was in a strong position. In its February 1984 survey on 'Pension Fund Investment', the *FT* listed the leading fund managers, with value of funds at end-1983. The top six were Warburgs (£4,850 m), Schroders (£4,500 m), Phillips & Drew (£3,500 m), Flemings (£3,300 m), Barclays (£3,000 m) and Morgan Grenfell (£2,965 m). The next stockbroker on the list was Pember & Boyle, lying twelfth on £1,289 m.

Pension fund management services produced about a fifth of the firm's total revenue in 1984, roughly two and a half times that generated by the private client and trust fund department, as it was now called. The new name was intended to reflect the growing importance of the charities and trust fund business, as well as a belief within the department that, if necessary, the traditional private client business should be shrunk into profitability, concentrating only on the larger clients. Indeed, under Harrison (who had moved across from short gilts in 1983), the broking operation was changed in the course of 1984/5 to a fee basis: this resulted in the department losing, with few regrets, about 30% of clients, but only about 5% of revenue. Nevertheless, Harrison's main brief was to develop the retail approach, albeit aimed at those of middle or high net worth, and 1985 saw the launch, amid some publicity, of the Phillips & Drew Trust, which involved securing a banking licence. Unfortunately, lacking critical mass and arguably distribution capability, true retail business proved elusive.

Meanwhile, Percy's successor as head of research from 1983 was Kenneth Inglis, an actuary recruited from Scottish Provident at a point when an outsider was considered likely to bring greater client awareness to the published output. By this time the firm was enjoying an improved position in the annual survey of investment analysts, conducted by Continental Illinois until 1984 and subsequently by Extel. In

1979 it came fifth (one place up on the previous year), in 1980 it was up to fourth, and in 1981 to third. That was where Phillips & Drew stayed for the next three years, before nudging up to second in 1985. From 1980 the top place was occupied by James Capel, with Scrimgeour Kemp-Gee second until being supplanted by Phillips & Drew. Neild's economics unit, meanwhile, continued to top the macro-economics section, and during these years his recruits included such future eminences as Gavyn Davies, David Morrison and David Robins. A brief sample of entries under the firm's name in the *FT*'s index for 1981 gives some flavour of the contributions being made by Neild and his team: 'says the current recession is likely to be sharper than the depression of 1929/31'; 'forecasts gloomy economic outlook'; 'little scope for tax cut foreseen'; 'predicts £3 bn overshooting of Government spending targets'; and so on.

Neild during these years was a less than convinced believer in Thatcherite economics. As early as June 1979, in his commentary on Howe's first Budget, he issued a warning:

The UK economy is in long-term decline. The new Government has embarked upon a high-risk economic strategy in an attempt to reverse this decline. We hope it succeeds. However, accelerating prices combined with a deteriorating world background are likely to seriously undermine, if not totally engulf, policies aimed at maintaining firm monetary control through either a transfer of resources from the public to the private sector or a shift in the burden of taxation from direct to indirect. This comment holds, no matter how desirable such policies might be. *When faced with inflation well into double figures and a developing global recession, experience suggests that the ability of the Government to dictate events is at the longest short-lived.*

Neild was little more sanguine two years later, in March 1981, when Howe in his third Budget controversially stuck to the Medium-Term Financial Strategy, in the process provoking the wrath of 364 academic economists. Forecasting that unemployment would go to well over 3 million and that public spending would be swollen through higher social-security payments, he took the line that the effect of Howe's

Budget would be to delay recovery until late 1981, a recovery that anyway might well, he believed, peter out during 1982. Neild's analysis was not only at odds with that of de Zoete & Bevan, who believed that the recovery was already materialising and was going to be sustained, but also, *The Times* noted in April, 'directly contradicts the recent assertion by Mr Nigel Lawson, Financial Secretary to the Treasury, that the Budget is not contractionary'. The world was changing – and, irrespective of the rights and wrongs of the particular policy-making debate, there is a sense in which Phillips & Drew had been more at home in the Keynesian, corporatist, UK-orientated 1970s than it was in the monetarist, free-market, global 1980s.

Nevertheless, the firm did make a significant response to the abolition of exchange controls in 1979 and the internationalisation of finance that ensued. Traditionally there had been an inward flow of business – foreigners buying sterling assets – but what was, in modern terms, new after 1979 was the large-scale outward flow of business, as British institutions started looking abroad for investment opportunities. It was above all that outward flow that Walton Masters, with the help of George Gray, was determined to exploit through the recently formed international department. He realised that this could be done only through high-quality research into overseas markets, supplemented by an ambitious programme of internationally orientated seminars at home and abroad, and it was not long before regular publications included *World Investment Review, International Bond Review, Currency Trends* and *World Capital Markets*. Part of this work involved an attempt to look systematically at the relative risk involved in investing in different overseas markets, with Iain Allan to the fore in comparing bond and equity yields across the world, and overall the quality of this research and analysis was significantly ahead of that of other firms, even those with offices abroad.

Yet for a variety of reasons, including some back-office problems caused by unusual situations, the international department failed to capitalise on a promising start and by 1981 was starting to lose the confidence of the partnership. In December that year, Walton Masters nominated £750,000 as his net target revenue for the second half of the financial

year, a similar figure to that achieved in the first half. Fairly or unfairly, that sort of revenue was not felt to be adequate recompense for employing a staff of two dozen or more. In 1983, accordingly, Walton Masters was effectively deposed and the scale of the department's operations reduced, though the firm (on Parker's initiative) did open a successful office in New York in February 1984 which was staffed initially by Richard Watkins, Hector Sants, and Denis Eliot, and which was a member of the National Association of Securities Dealers. 'It is a great pity that the department ever went to the ground floor', noted Parker in his internal report in May 1983 on the problems of the international department. 'The move, however unavoidable, reinforced the feeling that the department was a separate entity. . . . and the emphasis on departmental ambitions regardless of cost tended to deprive the department of the support, comfort and trust that would otherwise have been available from the firm as a whole.' That was one possible perspective; another is that Walton Masters had not received the long-term backing that he should have, especially when heavy investment in research and people, following early profitability, failed to produce instant results. There were other possible factors involved, including an element of turf wars and perhaps some resentment at Walton Masters becoming a departmental head in his mid-thirties; but whatever the precise mix of reasons it was an unfortunate turn of events. The future was global, and Phillips & Drew was not as well situated by the mid-1980s as it might have been.

A happier development was the merger of two departments into a single fixed-interest and money market services department, under Redman-Brown. The department, in which Ken Humphries was a significant figure, enjoyed a share of up to a fifth of the fixed-interest market; following their creation in 1980 it played a major role in primary issues of so-called 'bulldog' bonds, in other words the issue of sterling-denominated stocks in London by overseas borrowers. Drawing on the expertise of Keith Bridge (recruited after his retirement as chief executive of Humberside), it was also to the fore in various specialist local authority funding schemes, including in 1985 controversially raising £30 m on the security of the housing stock for the almost bankrupt and

notoriously left-wing Liverpool City Council.

However, where the firm most notably scored in these years was through the creation, at last, of an effective, fully functioning corporate finance department. This was, in the main, the achievement of Gibbs, who by 1980 needed a new challenge. He tackled the task with characteristic thoroughness, marketed his department's services both internally and externally, and above all appreciated that by plugging into the Unlisted Securities Market that had just started, he could avoid a state of probably unrewarding dependence on the merchant banks. The department's presentations were especially effective, and by mid-1984 the firm had, in three and a half years, increased its tally of corporate clients from thirty to seventy, including Tesco and British Airways – the latter appointment partly reflecting Bill Seward's high standing as a transport analyst. The department was, moreover, producing increasing profits – £521,000 in the year to May 1984, £969,000 in the following year – and altogether it was remarkable progress. Indeed, if Gibbs had been able to persuade Bazalgette to push harder for Carr Sebag and its hundred-plus corporate clients when that recently merged firm was effectively up for sale in 1982, Phillips & Drew might even have come close to joining the very first rank of corporate brokers, alongside Cazenove's, Hoare's and Rowe & Pitman. Of course, it was not solely Gibbs's achievement. Alistair Alcock, a key member of the department, was there before Gibbs arrived; Chris Gooding moved from the private clients department to provide an invaluable 'after sales' service; Twist, after much helpful consultancy work in the area of local authority finance, returned to the firm in 1983 on a full-time basis in effect as Gibbs's deputy; and that same year Gibbs recruited from the corporate finance department at Schroders an able accountant called Christopher Stainforth. Stainforth was not only able but also an old Etonian, and in due course he helped recruit another old Etonian, Gavin Simonds, who came from Rowe & Pitman.

There was one market in which it was harder than most for the old school tie to make an impact. Financial futures had begun in Chicago in 1972, and by 1980 a City working party had been established to explore the possibilities in London. It was at a buffet lunch at Phillips & Drew in December that

year that a member of the party, David Burton of Warburgs, bumped into the Bank of England's Eddie George and had an encouraging chat about the potential usefulness of a long gilt contract in the putative new market, and the following February the Bank finally gave its go-ahead to the new market – what became the London International Financial Futures Exchange, generally known as LIFFE. Another member of the original working party (and a future chairman of the Exchange) was Jack Wigglesworth, who had spent eight years at Phillips & Drew before going to Greenwells in 1971. A prime cause of his leaving Phillips & Drew had been disappointment at John Lewis, also in the gilt-edged department, being made a partner ahead of him, even though Lewis had come to Lee House a year later. There was therefore a certain piquancy that Wigglesworth now in 1981 asked Lewis to add his technical input to the design of the gilt contract. This he was happy to do, and despite certain anxieties on the part of the Stock Exchange the process proved relatively smooth. Indeed, the Stock Exchange in general was less than wholly enthusiastic about the new market – which would not be single capacity – and tended to discourage its members from joining. Nevertheless, twenty-seven firms did join, including Phillips & Drew. This was largely at the instigation of Lewis, who pushed the PPC into taking a positive approach and committing a reasonable amount of resources. His argument was couched less in terms of immediate prospects of huge revenue than in terms of the greater credibility that the firm's bond side would gain, abroad as well as in London, if it could talk sensibly about futures.

When LIFFE opened in September 1982, the day-to-day running of the firm's operation was in the hands of Robin Baldwin (recruited from gilts) and David Borrett (who had been a money broker before joining the firm at the end of the 1970s); and after six months, *Futures World* included Phillips & Drew Futures Ltd in its list of 44 members (out of a total of over 250) that were the most active traders. For all connected with LIFFE it was hard going in the early months and indeed years, and Clara Furse, on the financial futures desk at Phillips & Drew, would recall how when one early day she carried out for a client a 70-lot order in gilts she was as a result 'an absolute star'. A breakthrough occurred on

13 January 1984, as the exchange for the first time exceeded 10,000 contracts in a day, and Phillips & Drew was one of six members, and the only stockbroking firm, that put its name to a congratulatory advertisement in the *FT*. Few then imagined the huge success that LIFFE would become, but what was already clear was the way in which, bringing together members from the Stock Exchange, the clearing banks, the merchant banks, the discount markets and the commodity markets, it was having a marked impact in breaking down traditional City barriers, cultural as well as functional. It also had a strongly international flavour, with almost half its members overseas-based. It is difficult to gauge to what extent LIFFE was a catalyst of the momentous changes that lay immediately ahead; but undoubtedly it was a harbinger of them. Even if there was very little money to be made from broking in a very competitive market that did not have a fixed scale of commissions, it can only have benefited Phillips & Drew to have been in at the start, and in such a positive way.

The main stages in the process leading up to the momentous 'Big Bang' in October 1986 need only brief recapitulation here. The story began in 1975 when 'Mayday' on the New York Stock Exchange saw the abolition there of fixed commission rates. Three years later the Office of Fair Trading began to investigate the Stock Exchange's rulebook, with a view to challenging it in the Restrictive Practices Court. While the case and counter-case were prepared in the early 1980s, the Stock Exchange found itself in a state of semi-paralysis. Fears that international business was by-passing the London equity market did, however, persuade the Council in June 1982 to allow outsiders to take a stake of up to 29.9% in member firms. Thereafter the pace of events quickened, as the Bank of England came to the conclusion that the Stock Exchange needed to reform itself rather than wait for a court case, due in 1984, that it would almost certainly lose. The result, as brokered by the Bank, was the famous Parkinson-Goodison accord of July 1983, by which the Government called off the case in return for the Stock Exchange promising to dismantle minimum commissions by the end of 1986. Later that month Bryce Cottrell was one of the senior part-

ners who gathered to question Goodison about the agreement. He summarised the discussion for his partners:

> Most firms still seemed in a state of shock and the few questions came from Cazenove, de Zoete's (2), Greenwells (2), Greig Middleton, Hoare Govett and ourselves (2). The Chairman was at pains to point out that many details were still to be settled and the Government Broker would give little clue to the Bank's approach, except to say that they would be very exercised if the market fell into disarray. The points that did emerge were:
>
> 1. Most firms seem pretty worried.
> 2. Nearly everyone including the Chairman seemed dubious if single capacity would be workable with negotiated commissions. Cazenove's made a particular point of this. Goodison said it would all depend on the Bank's monitoring.
> 3. The Compensation Fund would stay. This would attract people to the central market and the new liquidity rules would take care of the cowboys.
> 4. The Council felt that they would be able to eliminate anticipatory commission cutting.
> 5. It was stressed that all new members would be subject to the present rules as amended.

The general expectation was that commission revenue from long gilts would go into particularly steep decline, and according to the *Wall Street Journal* in September, 'particularly hard hit will be such firms as W. Greenwell & Co and Phillips & Drew, whose business is heavily concentrated in the government bond market'. By this time it was starting to become increasingly clear that not only was single capacity indeed incompatible with negotiated commissions, but also that the pressure to maintain London's competitive edge as an international financial centre was such that the member-firms of the Stock Exchange would have to open themselves up further to outside capital. For London's securities houses, so long cushioned from market forces, it was time for some fundamental thinking.

At Phillips & Drew – where relatively little contingency

planning seems to have taken place prior to summer 1983 – there was an early acceptance that if the firm was to remain a heavyweight in the London market, especially as the gilt-edged market seemed likely to take shape, there was no alternative to becoming a market-maker (as jobbers were to be styled) as well as an agency broker. This in turn meant that a major infusion of new capital would be required: ideally £50 million, certainly at least £25 million. Even so, the initial mood of the managing partners that autumn was very strongly in favour of maintaining, if at all possible, the firm's independence. During the winter of 1983/4 two possible ways of doing so were explored. One was to raise the necessary capital by selling all or part of the fund management side. However, quite apart from understandable qualms about doing so, not least from some of those on that side, there was a tendency to believe the merchant banks' assiduous propaganda over the years, to the effect that no stockbroker could compete in pension fund management once there was a level playing field; and consequently, there were doubts as to whether selling fund management would raise the kind of money required. The alternative route to securing independence – and the one that Cazenove's would ultimately take – was that of raising capital from the institutions, in return for a share of future profits. Again, there seem to have been within the partnership fundamental doubts about the credibility of the case that the firm would be able to present, and in the event no serious attempt was made along these lines. Gradually the 'independence' movement lost its momentum, and by about spring 1984 a consensus was beginning to emerge that in practice the inescapable route, assuming the firm was not willing to downsize dramatically, was that of acquisition by an outside business, almost certainly a bank.

Almost all the other broking and jobbing firms had reached the same conclusion, and indeed by this time the 'sale of the century' was already under way. Warburgs bought into Akroyd & Smithers in November 1983, Barclays into de Zoete's and Wedd Durlacher in March 1984, and Samuel Montagu into Greenwells that same month. It seemed a seller's market, and few banks were paying under the odds. Phillips & Drew, for all its pride in its past, was no Cazenove's, in terms either of personal wealth or of a tight-

knit family ethos. Moreover, not only were the older partners somewhat nervous about the prospect of keeping their capital in a business operating in a world without fixed commissions, but there was also pressure from some of the retired partners, partly reflecting concern about pension arrangements, partly in consequence of Rashleigh having engineered a clause in the partnership agreement so that, if a retired partner left a deposit with the firm, he would be entitled to a share of the proceeds should the firm ever be sold to a third party. Overall, it was perhaps a reluctant decision – one that had to be unanimous, given the terms of the partnership deed – but the emotional and practical logic of the situation pointed only one way.

The actual task of identifying and negotiating with possible appropriate buyers was left largely in the hands of Cottrell and Eaves, with a significant advisory role being played by Schroders. Many names were canvassed, even more were rumoured, but during the summer there was only really a handful of serious contenders. They included National Westminster, Bank of America, Chase Manhattan and Morgan Grenfell. Talks with National Westminster foundered mainly on that bank's unwillingness to put a sufficiently high valuation on the firm's fund management business, although it may also have been unconvinced that Phillips & Drew had the requisite international vision. In the case of the two American banks, there appears to have been a fairly widespread feeling at 120 Moorgate that if either gained control there might be a tendency to hire and fire, to parachute people in, and even to get out of London if the going got tough. Both banks, especially Bank of America, had also been exposed to the recent Mexican lending crisis, and that added to doubts. As for Morgan Grenfell, which like Phillips & Drew was leaving it later than most to arrange its dispositions, there were anxieties about its command of adequate capital and an awareness that too many jobs might overlap. In the event, when the managing partners came to make their choice towards the end of September 1984, it was an entirely different contender – one that had only very recently entered the lists – that, by a decisive margin, they backed.

Union Bank of Switzerland, already good clients of the firm, had approached Phillips & Drew in August. From the

start its representatives made a favourable impression, offering not only hands-off management but also investment in the firm's future growth backed by £120 bn of assets and a Triple A rating. These initial impressions were no doubt endorsed by Sir John Wraight, who since retiring as Ambassador to Switzerland in 1976 had been a consultant to the firm. The cultural fit seemed right, negotiations proceeded smoothly, and on 5 November 1984 it was announced that UBS was acquiring a 29.9% stake, to become a 100% stake once the Stock Exchange's rules were further changed, as they soon would be. 'We weren't the highest bidders,' UBS told the *Wall Street Journal.* 'It was a combination of price and concept that made the difference.' For his part, Cottrell told the *FT* that the deal 'gives us the maximum scope for taking advantage of the changing markets', in particular the remodelled market in gilts, where the firm intended to become a market-maker through the injection of at least £40 million of capital by UBS. The deal surprised some in the City, reflecting in part a successful operation at keeping it under wraps, but reaction was broadly favourable to Phillips & Drew's choice. 'Of all the City's leading stockbrokers, its substantial lead in pension fund management surely makes it the most natural partner for a Swiss bank,' argued 'Lex' in the *FT*. 'It may lose the business of other Swiss banks, as it has lost the business of merchant bank competitors. But it has the promise of access to lavish capital resources, combined with assurances of continued authority.' The column's headline was 'Swiss role for P&D', and it was with that rather feeble pun that Phillips & Drew's history as an independent firm effectively ended.

This is not the place to give an authoritative or even informed account of what happened to Phillips & Drew after its loss of independence. Those involved in the events of 1985 onwards are probably still too close to them to offer dispassionate assessments. What cannot be denied, however, is the extraordinary achievement of Phillips & Drew during the preceding half-century. A triumph of ability, integrity and sheer hard work, it stands as a unique success story in the history of the modern City.

Appendix 1

PREMISES OF THE FIRM

1895 2 St Michael's House, St Michael's Alley, Cornhill
1896 70 Cornhill
1901 4 Bishopsgate Street Within (later 4 Bishopsgate)
1914 Palmerston House
 (51 Bishopsgate/34 Old Broad Street)
1937 Capel House, New Broad Street
1941 Pinners Hall, Austin Friars
(1959 *General Office at* 1/2 Great Winchester Street)
(1962 *General Office at* St Alphage House, 2 Fore Street)
1963 Lee House, London Wall
(1974 *General Office at* Regent House, 1 Hubert Road, Brentwood)
(1981 *Jersey Office at* 60 Halkett Place, St Helier)
1983 120 Moorgate
(1984 *Fund Management at* Triton Court, Finsbury Square)
(1984 *Jersey Office at* 17 Bond Street, St Helier)
(1984 *New York Office at* Tower 56, 126 East 56th Street, New York, NY)

Appendix 2

PARTNERS

G.A. Phillips & Co. to 1905, thereafter Phillips & Drew

1885	George Allen Phillips (1895–1905; 1907–1914)
1895	Harvey Richard Drew (1895–1933)
1896	George Francis Farnham (1896–1902)
1901	Geoffrey Harvey Drew (1905–1952)
1896	James Hill Fawcett (1902–1905)
1910	Norman Clayton Walters ACA (1910–1941; 1942–1948)
1910	Kenneth Dingwall (1910–1933)
1921	Thomas Reeves (1923–1937)
1922	Henry Gadsby (1924–1931)
1933	David Harvey Drew (1933–1945)
1927	John Cecil Stafford Charles MBE (1936–1955)
1935	Sidney James Perry FIA (1936–1959)
1936	Thomas Bruce Ismay (1937–1952)
1937	William Herbert May (1942–1955)
1936	Neville Hamlyn Williams (1947–1960)
1946	Lionel Slaney Potter ACA (1947–1961)
1946	Jocelyn Harvey Drew TD (1949–1973)
1949	Jonathan Rashleigh FCA (1950–1972)
1950	Charles Hannibal Italo Locatelli ACA (1951–1955)
1952	Henry Claude Cottrell FIA (1952–1978)
1947	Arthur William Beard (1952–1963)
1947	Henry Robert Hall TD (1955–1974)
1954	Peter Harrison Swan DSO DFC (1955–1982)
1924	George Victor Street (1956–1959)
1955	Ronald Ian Murray Macaulay FFA (1956–1977)
1959	Anthony Frederick Twist (1959–1969; 1984–1985)
1959	Ralph Alexis Vernon Fleming ACA (1959–1961)

Appendix 2

1960 Denis Weaver FIA (1960–1968)
1959 The Hon. Peter Beckford Rutgers Vanneck AFC (1960–1961)
1960 Peter John Cropper (1960–1961)
1948 Evelyn Paul Bazalgette (1960–1983)
1960 Bernard Howard Bavister (1960–1975)
1960 Charles Larkin (1961–1974)
1960 John Kirby Taylor (1961–1984)
1962 Michael Stanley Cohen FCA (1962–1982)
1962 Peter William Parker TD FIA (1962–1985)
1958 Bryce Arthur Murray Cottrell (1963–1985)
1963 Bernard Hayden Fison FIA (1963–1985)
1961 George Teasdale Birks (1964–1985)
1964 Philip Martin Domville Gibbs FCA (1964–1985)
1965 Harry Hougham Sparks (1966–1984)
1965 Michael Graham Hall AIA (1967–1984)
1965 Brian Brett (1968–1972)
1965 Terry James Cann (1968–1983)
1965 William Clayton Nowell FCA (1968–1975)
1963 Roger James Pincham (1968–1976)
1966 Austen Robert Priestley Bird (1970–1984)
1967 Geoffrey Michael Redman-Brown (1970–1985)
1971 John Grant Simpson FCA (1971–1981)
1968 Clifford John Lewis FIA (1971–1985)
1969 Sir Robert James Craufurd, Bt (1972–1976)
1968 David John Harrold (1972–1985)
1968 John Inglis Foy Perry (1972–1985)
1964 Peter John Barnes (1973–1977)
1969 William Romney Cooper Dyson (1973–1985)
1969 Philip Sullivan Kinsey (1973–1974)
1969 Peter Andrew Stott (1973–1985)
1972 Peter John Woodville Harrison (1973–1985)
1972 Hywel Merrion Harris-Hughes (1974–1985)
1971 Edward Valentine O'Sullivan (1974–1985)
1972 Keith Edward Percy (1974–1985)
1973 David Ralph Walton Masters (1974–1985)
1968 David Herbert Terence Bates (1975–1985)
1975 William Thomas Henry Holmes (1975–1984)
1975 Frank Edward Leonard (1975–1985)
1975 Paul Graham Neild (1975–1985)
1957 Paul James Cranston Smallwood (1976–1985)

1976 Andrew Roger Lees Pearson (1976–1985)
1977 Richard Leslie Lawrence (1977–1985)
1972 George Ritchie Gray (1977–1985)
1978 Timothy Frank Brown FCA (1978–1985)
1978 Philip John Williams (1978–1985)
1970 Terence Walter Buckland (1979–1985)
1979 William Terence Seward (1979–1985)
1973 Charles Hugh Eaves FCA (1980–1985)
1980 Michael Freyd (1980–1985)
1979 Kenneth John Humphries (1980–1985)
1980 Stephen John Lewis (1980–1985)
1980 Richard Cyril Campbell Saville (1980–1985)
1981 Crispian Hilary Vincent Collins (1981–1985)
1981 John Hemingway (1981–1985)
1981 The Hon. Philip Esme Howard (1981–1985)
1981 James Balfour Hyslop (1981–1985)
1981 Christopher Alan Marsh (1981–1985)
1981 John Bernard Marsh FCA (1981–1985)
1982 John Napier Allan FFA AIA (1982–1985)
1982 Robin Sandford Baldwin (1982–1985)
1982 William John Horwood (1982–1985)
1982 Alun Price Jones (1982–1985)
1982 Paul Michael Charles Meredith FIA (1982–1985)
1983 Michael David Bayliffe (1983–1985)
1983 Jonathan Alfred Bradley (1983–1985)
1971 Peter Malcolm Caulkett (1983–1985)
1983 Paul Anthony Constance-Churcher (1983–1985)
1983 Alan Hall Gregory IPFA (1983–1985)
1983 Ralph Douglas Leicester (1983–1985)
1970 Peter John Packard (1983–1985)
1984 Kenneth William Ballard Inglis FFA (1984–1985)
1984 Alistair Robert Alcock (1984–1985)
1984 David John Bailey (1984–1985)
1984 Robert Alan Brown (1984–1985)
1984 John Patrick McCaughan FIA (1984–1985)
1981 Sean Victor McHugh (1984–1985)
1984 Neil McKenzie Rae (1984–1985)
1984 Hector William Hepburn Sants (1984–1985)
1973 Andrew Howard Stewart (1984–1985)
1979 Colin Richard Cavill (1984–1985)

Appendix 2

The figures in the left-hand column indicate the date of membership of the Stock Exchange. Post-nominal letters refer to qualifications etc. held while a partner in the firm.

Appendix 3

SPORT AND OTHER ACTIVITIES

ATHLETICS With the full support of his partners, Bernard Fison enthusiastically encouraged and supervised many sports, but athletics, in which he was ably backed by Chris Marsh, was probably the main one. Phillips & Drew won the Stock Exchange inter-firm Championships eight times between 1965 and 1984, including a record four times in succession from 1965 to 1968. The finals took place each year at the Duke of York's Barracks in Chelsea. Fison himself recalls his team's speciality:

> The sprint relay became our province, based on baton-changing over many evenings. One race is worth recording. The Duke of York's track was less than 400 yards round, so the various races started all over the place. The Stock Exchange, uniquely, ran its relay over two laps, from mid-track to mid-track (the groundsman eventually refused to mark it out). The bends were amazingly sharp, and very loose, so it was impossible to sprint past someone. In 1963 the race was won by Rowe Swann, led by the club champion, John Cash. He entered the final bend in front of me, and by the time I pulled out to have a go on the 40 yard 'straight' he was over the line. I concluded that he who enters the last bend in front, wins. Thus the next year I ran the penultimate leg, against the scrubbers, some in plimsolls - we had team spikes, bought by the firm. To hide the tactic I stood as if to run last, and, after the gun, crossed the track. I handed Pat Phillips, our slowest, a modest lead, and, to the roars of the P&D supporters, Patrick fell across the line with Cash coming up like a train at twice the speed. A heroic victory.

SWIMMING Leading figures in the firm's swimming performances – like the athletics, taking place on an inter-firm, competitive basis – included James Hyslop, Bob Brown and Elizabeth Long, the latter an Olympic finalist in 1964.

CRICKET The annual game between Lee House and Brentwood, after the general office had gone rural, was intended to keep the people in the two locations in touch with each other. Organised by John Taylor, and played at Brentwood, it was a limited-over game that took place regardless of the weather. Lee House usually won. In addition to the Brentwood fixture, the firm played one or two clients such as Ready Mixed Concrete, Save & Prosper, and M & G Securities, occasionally sacrificing competitiveness to client goodwill.

CHESS Although there was no chess league, there was a Stock Exchange knock–out competition, invariably won by Phillips & Drew or Grieveson Grant. Moreover, following an initiative by Frank Leonard, the firm for some time sponsored the King's Chess Championships, played at County Hall. Participants included such Grand Masters as Karpov and Spassky, the latter accompanied by an 'interpreter' who was in reality his KGB minder, charged with preventing him from defecting.

POLO During the mid 1980s the firm sponsored the Phillips & Drew Cup and the Phillips & Drew Trophy, played in August at Smith's Lawn, Windsor Great Park. The initiative came from David Walton Masters, an accomplished polo player, and the days proved excellent value in terms of entertaining clients.

RUGBY The firm included some first-class players, and each year a few games were played on Sundays, with the team captained by Chris Marsh.

SOCCER Stock Exchange league soccer flourished up to and including the 1960s, with up to twenty matches being played on Saturday mornings on Wanstead Flats in East London. Managed in the 1960s by Graham Menzies, and captained by Peter O'Neal, Phillips & Drew was regularly one of the leading teams. Interest thereafter declined, in both the firm and

the Stock Exchange generally, but there were still one or two cup victories, as well as an enjoyable trip to Cologne in 1973 that included a win against a local side in Koblenz.

SQUASH The firm participated in the annual Austin Reed City Squash Competition, though it rarely progressed far. The firm's leading player was Paul Smallwood, who on one occasion organised on behalf of clients a demonstration match involving the world champion, Jahangir Khan.

GOLF Paul Bazalgette organised several matches a year, on his home course at Rye, including an annual fixture against the Church Commissioners.

NETBALL Phillips & Drew's female staff, under the leadership of Judy Bradbury, played regularly and with growing success in Stock Exchange leagues, mainly in Paternoster Square during weekday lunchtimes.

BRIDGE The firm's leading player was Philip Williams, and from the mid 1970s regular client opponents included the Prudential and Hawker Siddeley. Progress was only chequered in the Stock Exchange league, but there was some satisfaction in defeating Grieveson Grant for three years running.

MOTOR RACING Martin Raymond of Phillips & Drew was Formula Three champion, won the Le Mans Class Three, and the six-hour race at Brands Hatch. Tragically, he died at Brands Hatch on 16 March 1980 when two other cars collided and then crashed into him as he was walking away from his own broken-down car.

SPONSORED WALK Fison recalls, from the mid 1970s, 'what was almost certainly the greatest day-out the firm ever had':

The Save The Children Fund announced it was holding a twenty-mile City sponsored walk. Four times round a five-mile course: St Paul's, Fleet Street, Embankment to the Tower of London, Fenchurch Street, Moorgate, St Paul's, with reporting stations on all the corners. I appointed liaison officers in every department, and whipped up enthusiasm. We opened the firm's dining-room for food, first aid and families, and out of 300 staff about half took to the streets on a Sunday.

We raised some £1,500, which was about half the total . . . I would like to think it was a magnificent demonstration of the sort of people we were.

Appendix 4

'A SIGN THAT "COMMUNITY" HAS HAD ITS DAY'
Tony Jackson
(*Financial Times*, 7 December 1996)

One of the quietest and most agreeable retreats in the City of London is a small park just north of London Wall. Much of its charm lies in the contrast with its surroundings, for London Wall itself is a noisy dual carriageway, lined with 1960s architecture of vintage ugliness.

In a corner of the park, between a fragment of the medieval city wall and a duck pond, stands a handsome lime tree. It was planted in 1979, according to a plaque at its foot, by a Mr so-and-so of Phillips & Drew.

Now, here is a voice from the past: a City worker, recommending himself to posterity in terms of his employer. These days, the idea seems so quaint as to deserve explanation.

Back in the 1970s, the stockbroking firm of Phillips & Drew was a venerable City institution. Like other broking firms of the day, it could offer long-term employment and the chance of a partnership. Then came Big Bang, and Phillips & Drew was absorbed into a Swiss bank. Most of its partners retired early on their winnings.

Contrast the City of today. In the post-Big Bang world, stockbrokers are in a state of perpetual flux. At any time, they may receive a compelling offer from a rival firm, either that or the black bag, which is the City term for redundancy. Identifying themselves permanently with any given firm would strike them as bizarre. You might as well put up a plaque with your rented address on it.

Indeed, few would identify themselves permanently as stockbrokers. No one can be sure of surviving in the City much beyond the age of 40. It is a young person's game: a phase in one's career, not the career itself.

It was not always so. The park in which the lime tree stands is named after the building next to it: Barber-Surgeons' Hall. The City is full of such halls, homes to the medieval guilds, or livery companies. Today, many are little more than dining clubs. But their members carry the names of London's antique professions: cutlers and carmen, tilers and plasterers, blacksmiths and weavers.

It is not so long since Londoners were identified by their jobs even in death. Southwark, where the *FT* has its headquarters, was once a centre for the brewing industry. Hence the curious bronze plaque in Borough High Street, just south of London Bridge, commemorating 33 'men of the London hop trade' who died in the First World War.

The passing of this tradition – the sense of being rooted in a job or profession – has a good deal to answer for. It has become a cliché of the 1990s to talk about job insecurity. It is equally a cliché for economists to say this is irrational, that according to the data, people on average stay as long in their jobs as they ever did. But that is beside the point. What is new is not the fact of impermanence, but the sense that permanence is somehow unnatural. No one, we are told, has a job for life. Even if you end up possessing one, you will have the nagging feeling that something is wrong.

What has changed has less to do with security than individualism. The man who puts up a plaque with his company's name on it does so in a spirit of community. The company represents not just a pay cheque, but a group of people with a shared history.

All the pressure is now all the other way. Employers urge their staff to think of themselves not as permanent fixtures, but birds of passage. The company cannot promise you employment, just employability. Do a good job, and if the company does not want you, someone else will.

It seems implausible that this kind of individualism can last for ever. The great majority of people are not highly paid, rootless professionals, connected to their peers by a wireless modem and an airline ticket. Nor are they self-sufficient

enough to get by without a sense of society and continuity. If employers cannot offer that, so much the worse, in the long run, for the employer.

And if people cease to regard their jobs as worth recording, so much the worse for London. Today's workers are surrounded by memorials to their predecessors: street names, pub signs, the now defunct markets of Covent Garden and Billingsgate.

In the heart of the City, close to St Paul's cathedral, is a pub with the baffling name of the Dandy Roll. Though few of its clientele could tell you so, a dandy roll is an obscure gadget used in making paper. The pub is so called because until 20 years ago, the building round the corner was the headquarters of one of Britain's biggest paper makers, Wiggins Teape.

The company moved on, but the name remains. As it happens, the pub stands in Bread Street, which in the Middle Ages was the centre of the baking trade. One way or another, the world of work has a curious durability. Perhaps the Phillips & Drew man had history on his side after all.

*

The London Wall plaque reads:

> *TILIA TOMENTOSA*
> *(Silver Lime)*
> *planted by*
> *Mr J.T. Brown of*
> *Phillips & Drew*
> *3rd July 1979*

Index

205

Index

Index

Index